SUNSHINE MUSE

SUNSHINE MUSE

Contemporary Art on the West Coast

Peter Plagens

Praeger Publishers
New York · Washington

To the Artists

Published in the United States of America in 1974
by Praeger Publishers, Inc.
111 Fourth Avenue, New York, N.Y. 10003

© 1974 by Praeger Publishers, Inc.

Library of Congress Cataloging in Publication Data
Plagens, Peter.
 Sunshine muse.
 Bibliography: p.
 1. Art, American. 2. Art, Modern—20th century—
California. I. Title.
N6530.C2P55 709'.794 72-86433
ISBN 0-275-46630-2
ISBN 0-275-71660-0 (pbk.)

Printed in the United States of America

Contents

Acknowledgments

A book like this is a *de facto* expression of gratitude to everyone who put something into the record, especially other writers, some of whose books, catalogues, and articles are mentioned in the Bibliography. To them, I say, "thank you," and I hope that this book will be similarly useful in the future. Then, there is a large group of kind people who sent me something—a photograph, a quote, an answer to a question. Because I needed so much and they, therefore, are so numerous, I hope this sentence will in some measure express my appreciation. I would, however, like to single out a few individuals who, in my osmotic accounting, did more than their share: Betty Asher, Frank J. Thomas, Ed Moses, Walter Gabrielson, Brenda Richardson, Helene Fried, Dan Tooker, Duane Zaloudek, Newton Harrison, and Joyce Wisdom. Finally, there is one person who suffered through this manuscript in its various stages and who is responsible for many of its virtues and none of its faults: John Coplans.

 Sunshine Muse was written, in part, with the support of a grant in art criticism from the National Endowment for the Arts, Washington, D.C., and I am most grateful for the encouragement and assistance it provided.

California. *8:* Courtesy of the artist. *9:* Courtesy of Shifra Goldman. *11:* By Frank J. Thomas.
13: By Patricia Faure. *14:* Courtesy of the Sidney Janis Gallery, New York. *15:* By Peter
Plagens. *16:* By Moulin Studios. *17:* By Eric Pollitzer. *18:* By Robert Mates and Paul
Katz, courtesy of the Marlborough Gallery, Inc., New York. *19:* By Marshall Berman. *20:*
Courtesy of the David Stuart Galleries, Los Angeles. *21:* By Oliver Baker. *22:* Courtesy of
the artist. *23:* By Hy Hirsch, courtesy of the artist. *25:* By Soichi Sunami. *26:* Courtesy of the
Willard Gallery, New York. *27:* By Adolph Studly, courtesy of the Willard Gallery, New
York. *32:* By Condit. *33:* By Condit. *35:* Courtesy of the San Francisco Museum of Art. *36:*
Courtesy of the *San Francisco Chronicle*. *37:* Courtesy of the *San Francisco Chronicle*. *38:* By
Colin McRae. *39:* By John Schiff, courtesy of the Staempfli Gallery, New York. *40:* Courtesy
of the Alan Gallery, New York. *41:* By Frank J. Thomas. *44:* Courtesy of the artist. *45:* By
Frank J. Thomas, courtesy of the artist. *46:* By Frank J. Thomas. *47:* By Frank J. Thomas.
50: Courtesy of the David Stuart Galleries, Los Angeles. *51:* By Roy Flamm, courtesy of
The Metropolitan Museum of Art, New York. *52:* Courtesy Hearst Newspapers. *54:* By
Gordon Peters, courtesy of the *San Francisco Chronicle*. *55:* By F. W. Quandt, courtesy
of The Oakland Museum, Oakland, California. *56:* By Charles Brittin, courtesy of Hal
Glicksman. *57:* Courtesy of the artist. *58:* Courtesy of the Los Angeles County Museum
of Art. *59:* Courtesy of the artist. *60:* Courtesy of the artist. *61:* By Frank J. Thomas.
62: By Frank J. Thomas. *63:* By Michael Katz, courtesy of the Dwan Gallery, New York.
64: By Frank J. Thomas. *65:* By Walter Russell, courtesy of the Dwan Gallery, New
York. *66:* By James Mitchell, courtesy of the San Francisco Art Institute. *67:* Courtesy of the
San Francisco Art Institute. *68:* Courtesy of the Hansen Fuller Gallery, San Francisco. *69:* By
Colin McRae, courtesy of the University Art Museum, Berkeley, California. *70:* Courtesy of
the San Francisco Art Institute. *71:* By Frank J. Thomas. *72:* By Frank J. Thomas. *74:* By
Ik Serisawa. *76:* By Ik Serisawa, courtesy of the artist. *77:* By Gerhardt Photos. *78:* By Frank
J. Thomas. *79:* By Frank J. Thomas. *80:* By Frank J. Thomas, courtesy of *Artforum* magazine.
81: By Frank J. Thomas. *82:* By Frank J. Thomas. *83:* By Frank J. Thomas, courtesy of the
Nicholas Wilder Gallery, Los Angeles. *84:* By Frank J. Thomas, courtesy of the Nicholas
Wilder Gallery, Los Angeles. *85:* By Lutjeans. *86:* By Rudy Bender. *87:* Courtesy of the
Lanyon Gallery, Palo Alto, California. *88:* By Frank J. Thomas, courtesy of the André Em-
merich Gallery, New York. *89:* By Frank J. Thomas, courtesy of the Michael Walls Gallery,
New York. *91:* Courtesy of the artist. *92:* By Ann Freedman, courtesy of the André Emmerich
Gallery, New York. *94:* By Frank J. Thomas, courtesy of the Nicholas Wilder Gallery, Los
Angeles. *95:* By Frank J. Thomas, courtesy of The Oakland Museum, Oakland, California.
96: By Frank J. Thomas, courtesy of the artist. *98:* Courtesy of the Felix Landau Gallery, Los
Angeles. *99:* By Frank J. Thomas. *100:* By Frank J. Thomas. *102:* By Frank J. Thomas. *103:*
By Frank J. Thomas. *104:* By Eric Sutherland. *106:* By Frank J. Thomas. *107:* By Frank J.
Thomas. *108:* By Joan Waggaman, courtesy of the Los Angeles County Museum of Art. *109:*
By Frank J. Thomas. *110:* Courtesy of *Artforum* magazine. *111:* By Frank J. Thomas. *112:*
Courtesy of the artist. *113:* Courtesy of Fourcade, Droll, Inc., New York. *114:* By Frank J.
Thomas. *115:* By Seymour Rosen. *116:* By Frank J. Thomas. *117:* By Frank J. Thomas, cour-
tesy of Artist Studio, Venice, California. *118:* By Martin Silver, courtesy of the artist. *121:* By
Frank J. Thomas. *125:* By Frank J. Thomas. *126:* By Frank J. Thomas. *127:* By Schopplein
Studio, courtesy of the John Berggruen Gallery, San Francisco, and the artist. *128:* By Bruce
Henson, courtesy of the artist. *129:* Courtesy of Betty Gold, Los Angeles. *130:* Courtesy of the
Los Angeles County Museum of Art. *131:* By Frank J. Thomas. *132:* By B. Hyams. *133:* ©
Walt Disney Productions. *134:* By Colin McRae. *135:* By Henry Segall, courtesy of the Lanyon
Gallery, Palo Alto, California. *136:* By Joe Schopplein, courtesy of the Esther Robles Gallery,
Los Angeles. *137:* Courtesy of the Dwan Gallery, New York. *138:* Courtesy of the Los
Angeles County Museum of Art. *139:* By Geoffrey Clements, courtesy of the Hansen Fuller
Gallery, San Francisco. *141:* Below: By Helen Harrison. *142:* Courtesy of the University Art
Museum, Berkeley, California. *143:* Courtesy of the University Art Museum, Berkeley, Cali-
fornia. *144:* By Frank J. Thomas, courtesy of the Los Angeles County Museum of Art. *145:* By
William Bros. *146:* By William Bros. *147:* Courtesy of The Vancouver Art Gallery. *148:*
Courtesy of the artist. *149:* Courtesy of the Sonnabend Gallery, New York/Paris. *150:*
Courtesy of the artist.

1. The Seasonal Garden

The history of modern art, more than modern political history, exists in the present because most of its subjects—paintings and sculptures—are in the same physical shape as they were when they came off the easel or onto the pedestal. As objects, they run headlong into American frontier philistine pragmatism: If it doesn't help clear the land, defend against the exploited natives, or make an instant buck, it isn't worth the bother. What art *can* do, however, is mitigate urban ugliness. America's greatest art center (New York) has been ugliest longest; Los Angeles's most important art appeared (1962–68) only after the city suffused itself in smog and trash architecture. By contrast, the Bay Area (with its spectacular scenery) remains a dicey ground for occasional good stuff, and the coolly lush Pacific Northwest has produced no substantive modern art besides Mark Tobey's.

If you believe in Modern Art History and its obligatory riders (that good art deals with dialectically derived "issues," that good art bends the short-run course of future Modern Art History), it follows that the best breeding ground for good art is where competing ideas, esthetics, and artists are thickest and where regional niceties are thinnest—New York. Whatever climatological, geophysical, and even demographical charms with which that city was once blessed have been buried for at least twenty-five years in a Sargasso Sea of money, crowding, and state-capitalist architecture. New York has as little regional character as a big Air Force base—but also as much hardware and mission action. The "regions" (provinces, outposts, boondocks, heartlands, Middle America, etc.), on the other hand, are short on white-hot overpopulation, edifice complexes, and career fights-to-the-death. The art they produce is either initially schizophrenic or rendered so when it hits the big time. Should it be gauged against the "mainstream" (deliberately art-historical art produced where it counts—New York) or should it be sized up from

exactly the opposite point of view (quaintness, funkiness, antihistoricality —in short, for its regional character)? Serious artists living in the regions must choose: Am I playing the mainstream game, and, if I am, am I chicken or foolish for not moving to New York? Critics, historians, collectors, dealers, and others once-removed from art-making must decide if Ed Ruscha is only just as good as Warhol or Oldenburg in his knife-edge banality, or if he's a lighthearted Hollywood gadfly, whose value lies in work that doesn't give a damn about expanding the boundaries of art, but does about expanding those of comfort and leisure. Is Tobey merely a less than heroic Abstract Expressionist or a more than formalist sage because Pacific Northwest tranquility let him regard painting as something other than a contact sport? Is assemblage (from Beatnik-era San Francisco/Los Angeles) a cutie-pie exploitation of esthetic license that Robert Rauschenberg, Jasper Johns, and then the post-Minimalists pursued with Duchampian rigor, or is it a vehicle of dark poetry available only to those who've given up the nonsense of art-historical leapfrog? Was the L.A. Look of the sixties merely the result of "dropout types in Venice making baubles for the rich"[1] (of resin, chrome, lacquer, and glass) or was it the dawn of a new perception, akin to both alpha waves and Buddhism, liberated from the dialectical harangues of New York? In order to decide anything about West Coast art, you must first take a look at the regions.

The Pacific Northwest is isolated from the three major cultural webs of the country: the East, meaning New York and its spillover; the Midwest, centered by Chicago; and the California coast, whose foci are San Francisco and Los Angeles. Its terrain is laced with mountains and wild rivers; its population is small (Seattle's and Portland's are under 600,000); and one of its principal crops is xenophobia: Pacific Northwesterners regard Californians with their bulbous automobiles and vulgar manners as a pestilence, even as tourists. But the area wallows in natural beauty—mountains, forests, jewels of fresh water, cool, rainy weather, and a rolling topography. This natural environment, the argument goes, resembles Honshu more than any American coastal region and is therefore the inspiration for a pervasive orientalism (muted rather than bright colors; intimate and contemplative rather than large-scale public art).[2] Tobey thought it an unfortunately unexpanded virtue: "I have often thought that if the West Coast had been as open to esthetic influence from Asia as the East Coast was to Europe, what a rich nation this would be."[3] Mild orientalism, however, dilutes the paintings of lesser artists like Louis Bunce, Carl Morris, and Kenneth Callahan into gentle odalisques of Abstract Expressionism. Morris Graves, Tobey's protégé, gets caught going the other way: storybook parables of blind birds, pine trees, and waves.

Regions usually coddle what indigenous ethnic art hasn't been bulldozed: In Oregon and Washington you see collections of Haida, Tlingit, Kwakiutl, and Nootka Indian art, and, more important, you feel it in the countryside. But a modern American artist cannot produce significant art out of a latter-day, sentimental appreciation of dolls, beads, and ceremonial masks. When a primitive art is synthesized, it must be within a vigorous modern movement (e.g., Black African art in Cubism) or within the talent of a great anomaly (e.g., Gauguin).

The best artists to develop within this milieu (besides Tobey, a separate matter) could be typified by Clayton S. Price, the Oregon "cowboy" painter. An illustrator, his initiation to fine art was the 1915 San Francisco World's Fair, whose exhibited art turned him to painting. There is in Price's landscapes an intense, awkward directness reminiscent of Ryder or Dove that is a bit hard to take. Price remained relatively poor, although he had an esthetic/ethical influence on a generation of Oregon painters and was given a retrospective as early as 1942.

1. Clayton S. Price, *Cityscape*, 1939. Oil on board, 16 x 20 inches. Collection of the Portland Art Association, Portland, Oregon.

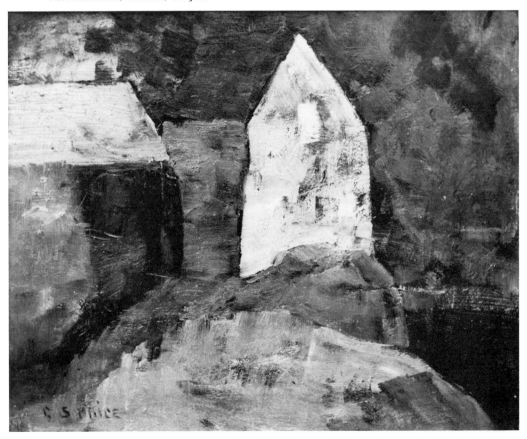

When the Mexican flag was hauled down on June 14, 1846, establishing the California Republic, William B. Idea invited "all peaceable and good citizens of California to repair to my camp at Sonoma, without delay, to assist us in establishing and perpetuating a Republican government, which shall secure to all civil and religious liberty, which shall leave unshackled by fetters, agriculture, commerce and manufactures."[4] All California, except for the sparsely inhabited mountains and deserts, is unfettered by weather. San Francisco has the same wet-dry cycle as Los Angeles (slightly wetter). Perhaps it was the kindly climate as well as the gold and the 2,000-mile moat between it and civilization that fostered the outlaw-vigilante politics of California's first fifty or sixty years. Except for Eadweard Muybridge (whose proto-cinematic studies of a running horse settled Leland Stanford's bet, and whose Yosemite photographs presaged the work of an ongoing school of California photographers), San Francisco's first real artists were writers, who rose from journalism in the trenches: Ambrose Bierce's sarcastic, Swiftian exposé/overstatements, Frank Norris's novels of social evil like *The Octopus*, Bret Harte's *Luck of Roaring Camp*, which got into print (in pieces, as a kind of assemblage) while Harte worked as a watchman in the U.S. Mint, the action stories of Jack London, a back-bay waterfront drunk when he wrote them. The intellectual roughhousing continued through William Saroyan's maudlin valley dwellers, John Steinbeck's *Tortilla Flat* and *Cannery Row*, Jack Kerouac's road novels, and Beat poetry. Unfortunately, painting and sculpture didn't share literature's muscle (with the French exception, nineteenth-century visual arts labored under an aura of politeness) and, despite some ensuing pyrotechnics, San Francisco has a historic under interest in contemporary art, due to a combination of wondrous natural scenery (the most beautiful setting of any city in the world) and a taste for adjunct gingerbread architecture, antiques, salon paintings, and bric-a-brac. Albert Bierstadt came out and painted "his" Yosemite. Thomas Hill established a derivative California school of romantic mountain landscape painting. William Keith painted his famous *Burning City* after the 1906 earthquake, and that was about it, except for the founding of the spine of Bay Area modern art—the San Francisco Art Association.

Twenty-three local artists, dissatisfied with flogging about separately for commissions, founded the SFAA in 1871 and opened a loft gallery over a butcher shop. Three years later they started a school and moved it to a Nob Hill castle (a conglomerate of architectural and decorative styles—assemblages abound!) in 1893. Under the patronage of Mark Hopkins (briefly as the Mark Hopkins Institute of Art), the enterprise shifted to Russian Hill in 1926 (where the final offspring, the San

Francisco Art Institute still is), the early traditional grounds of the artistic/literary set. People like Arnold Blanch, Maurice Sterne, and André Lhote taught Cézanne-ism, which, by the thirties, was manifested in San Franicsco through Social Realism, and in the back bay (Berkeley, Oakland) as late, late Cubism with overlays of Byzantine (gold-leaf) decorations.

Modernism, laboring far from Paris or New York under a Gully Jimson/ Jack Bilbo/*Savage Messiah* complex without benefit of a real movement of its own or a structural comprehension of Cubism, Surrealism, or Suprematism, produces phenomena like Beniamino Bufano and Anton Refregier. Bufano, a pint-sized, pugnacious stone carver, spent his years on a giant figure of St. Francis (realized) hacked from a thirty-ton block, which moldered, neglected, for twenty-eight years in a Paris warehouse before it was finally stationed at St. Francis's Cathedral in San Francisco, and a monumental US/USSR aviator atop a hundred-foot shaft (unrealized). Refregier painted the social-utilitarian Rincon Post Office mural in a common, chisel-figured, elongated, romantic-surface semi-Cubist style with such perniciously leftist nuggets as a Russian flag in the bouquet aimed at Fascism in the *War and Peace* panel. As have brethren before and after, both artists squandered half their time battling bifocaled fossils from the VFW and petty bureaucrats charged with approving/storing government-sponsored art, but San Francisco, eventually the first union-shop city in America and a hotbed of liberalism, failed to match in vehemence and silliness (the movie purges and art squabbles, 1947–52) that ofttimes Berchtesgaden of the United States, Southern California, and its capital city, Los Angeles.

The original *Pueblo de Los Angeles* was established in 1781, out of a network of early missionary settlements. For a hundred years the town was a riotous, raw, hooligan-patrolled arena of swindles (by gringos against the Mexicans holding the early land grants), brutal subjugation (of the Indians by the Catholic missionaries), racial persecution (of the Chinese), and land-boom intrigues. Southern California, except for tropical fruits, is not a benign agricultural environment; it doesn't possess a natural harbor and did not accommodate the kind of European cultural baggage so easily floated through the Golden Gate to the Bay Area. To San Francisco (for the first fifty years of the twentieth century the cultural capital of the state, with its opera, ballet, theater, and poetry), Los Angeles has always been "that flat city down south" populated by rude barbarians, suffused in a mindless hedonism (an opinion exacerbated lately by surpluses of freeways, smog, horizontal stucco architecture, and hot roads).

Los Angeles was settled by Midwesterners and Dust Bowlers, whose

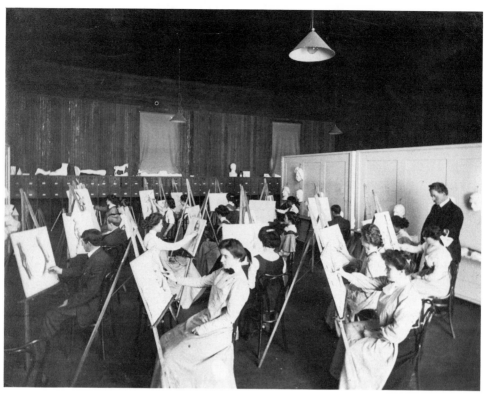

2. Drawing class at the San Francisco Art Association, early 1900s.

3. Sculpture class at the San Francisco Art Association, early 1900s.

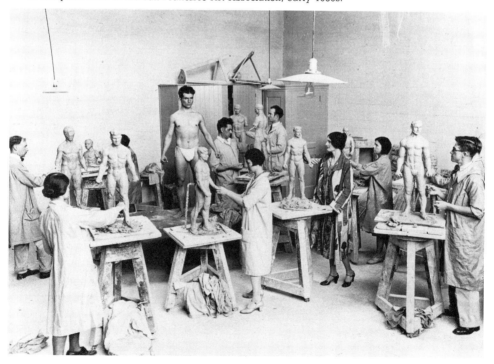

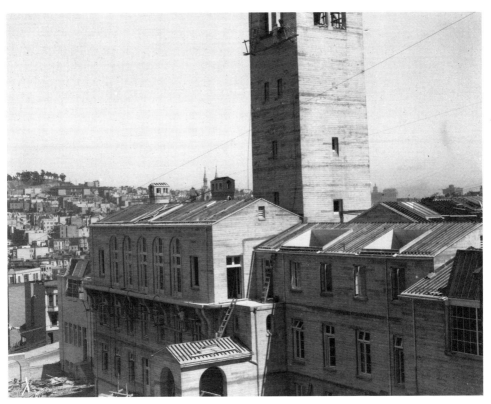

4. California School of Fine Arts under construction, in San Francisco, ca. 1925–26.

prosaic pragmatism resisted the frills of culture. But after World War I, the embryonic movie moguls of the East, hounded by bad weather and patent attorneys, made haste to Southern California. When sound obtained during the years 1927–30, the writers followed, providing dialogue for the shining gray faces on the silver screen. The likes of William Faulkner, Ben Hecht, and F. Scott Fitzgerald turned themselves into (highly) salaried employees, punching clocks, drinking, and tailoring their words to esthetic gorillas like Harry Cohn, Louis B. Mayer, and the brothers Warner. As the inhuman Irish school system produced William Butler Yeats, Sean O'Casey, and James Joyce, the psychic brutality of the dialogue mill produced Los Angeles's great books— Nathanael West's *Day of the Locust* and Fitzgerald's *The Last Tycoon*. When you compare those phenomena with the esthetic hostility and human indifference that kindled Abstract Expressionism in New York in the forties, and with a hundred other examples of great art born like pearls as irritants in the social oyster, you confront the unanswered question: Are the artists who Did-It-When-It-Was-Tough the only legitimate great artists? Are artists like Frank Stella and Larry Bell,

without the (perhaps) required catharses, playing out the pat, passionless hands dealt them by a benevolent art establishment—sympathetic schoolmasters and dealers who turn a nice profit on the whole business? Formalist critics hold that art derives from art, not fist-fighting, and that the (cold?) fact of the visual object is all there is to be considered.

Los Angeles didn't taste its first real modern art show until Stanton Macdonald-Wright, veteran of Paris of the Impressionists and Fauves, and originator, with Morgan Russell, of an abstract Cubist spinoff called Synchromism, put together an exhibition of the stables of the Daniel and Stieglitz galleries in New York at the Los Angeles County Museum in 1922, six years after he came to Los Angeles. (The show included paintings by Thomas Hart Benton, Andrew Dasburg, Charles Demuth, Arthur Dove, John Marin, Alfred Maurer, Marsden Hartley, Man Ray, Morgan Russell, Charles Sheeler, Joseph Stella, and a sculpture by William Zorach.) Previously, academic Eastern artists traveling west had packed painting satchels loaded with "Inness, and Millet in landscape, and, in figures, Sargent, Hals, and the New York Art Students League."[5] The exceptions, besides Macdonald-Wright, were in large part European emigrés who came to Southern California in the twenties and, with the rise of the Fascist dictatorships, in the thirties. Boris Deutsch

5. Anton Refregier, detail of a mural in the post office at Rincon Station, San Francisco, 1947.

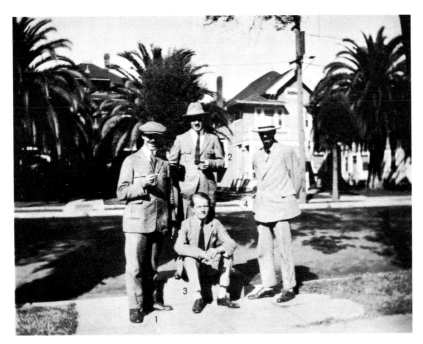

6. *Left to right:* Knud Merrild, Kai Gotessehe, Winchell Battern, and D. H. Lawrence, Los Angeles, 1923.

7. Knud Merrild, *Flux Bleu*, 1942. Oil on paper, 12 x 15½ inches. Private collection.

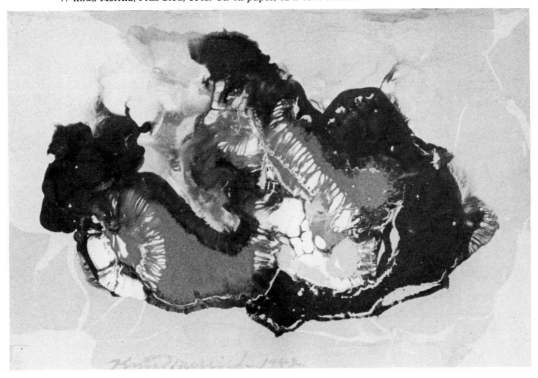

arrived from Lithuania in 1920, Knud Merrild—whose poured paintings coincided with Hans Hofmann's and predated Jackson Pollock's—from Denmark in 1923, and Oskar Fischinger—who turned Kandinskyesque abstraction into light paintings and remarkable films—from Nazi Germany in the middle thirties. And there were others: Archipenko, Ben Berlin, Ejnar Hansen, Fred Hocks, and Peter Krasnow. Man Ray came late, in 1940, and spent a dozen unproductive years. All of them mixed their European modernism with perceptions of color: as the architect R. Schindler put it in an unpublished essay," [the] subtle transparant shades created by the light on the grayish backgrounds [of rock and leaf]," compared to the "solid, opaque, positive colors of the northern and eastern green country."[6] Perhaps the most significant result of immigration, setting an example for "clean" modern art for years to come, was the evangelically progressive architecture of Schindler, Gregory Ain, Harwell Hamilton Harris, and Richard Neutra, built between 1935 and 1942.

Because the imperative to apply money to cultural acquisition for respectability's sake is weak, patronage is a perennial quandary for Southern California artists, even more than for their New York counterparts. (Three important Los Angeles modern collections— Walter Arensberg's Postimpressionist, Cubist, and Dada works which, in a great snafu, ultimately fled to Philadelphia; Galka Scheyer's pictures by the Blue Four—Klee, Kandinsky, Jawlensky, and Feininger; and Ruth Maitland's Mirós—did not involve local art.) Alexander Cowie, with a 1923 inventory of the "cowboy" painters Charles Russell and Frederic Remington, was the first serious local dealer (hardly avant-garde, but bona fide), and Dalzell Hatfield followed shortly with French Impressionism. The Stanley Rose Bookshop sufficed as a hangout in the thirties and even survived to show the likes of Lorser Feitelson and Helen Lundeberg (Los Angeles' best woman painter) on Hollywood Boulevard in the forties. But the climate in Los Angeles remained indifferent enough so that it was still second-page news when, in 1947, Sam Kootz flew out to Earl Stendahl, an early dealer, with a supply of eight Picasso paintings.

It's an unfortunate fact that serious modern art in America is a social luxury, propped up by rich people (directly, via purchases and commissions, or, indirectly, through contributions to museums, and corporate support). The history of its rises and falls in large part reflects the ebb and flow of personal fortunes, with artists like corks on currents of vanity, the stock market, and family feuds. On the West Coast, unlike New York, artists are sequestered from the rich. They don't hobnob with them at black-tie institutional compressions, and the rich don't often

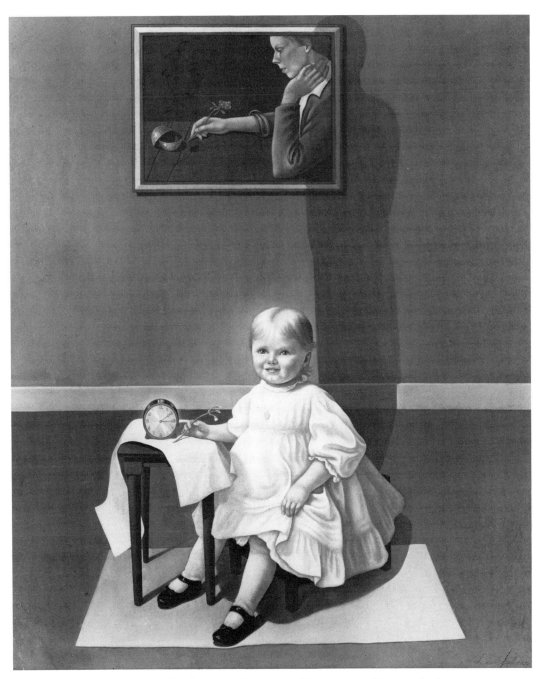

8. Helen Lundeberg, *Double Portrait in Time*, 1935. Oil on canvas. Private collection.

come down off the hills and out of the canyons to find out from the artists what the hell is going on. There are tiny paranoias on both sides: Artists (visual) on the West Coast don't really regard themselves as intellectuals with a stake in cultural history as a whole (few of them write); they're increasingly content with roles as inside-smart decorator-entertainers, making moves on top of moves in a game whose purpose rarely transcends strategy to become poetry. The rich suppose their part is simply buying the stuff, without having to confront the whole of a modernist culture which, by nature, questions their right to live off coupon-clipping and the gravy of savings-and-loans. Surely the dichotomy (poor democratic artists, rich oligarchic patrons) simmers elsewhere, but Europeans wash it down with several centuries of heavy-lidded worldliness, and New Yorkers put it constantly, albeit futilely, on the line. Up in Oregon and Washington they avoid it by returning to nature. In San Francisco it's cherished as urbanity. But in Los Angeles nobody's ever heard of the problem, and it's a renewable surprise when a good museum director is sacrificed (Richard Brown, 1965), buildings become albatrosses (Los Angeles County Museum of Art, 1965; Pasadena Art Museum, 1969), schools evaporate (Chouinard, 1971), publications pull up stakes (*Artforum*, 1967), and galleries fold by the handful.

Perhaps the model is misguided. The assumptions that patrons and artists should intermingle freely—argue and laugh at each other's jokes —and that artists should consciously assume roles of intellectuals and cultural custodians are integral to the art-society philosophy that defines a healthy art scene as a crowded, competitive, busy ambience: lots of shows, lectures, arguments in bars, taking somebody's art idea one step further, king dethroning, and, of course, gossip by the megaword. Two "flowerings," San Francisco Abstract Expressionism (1946–50+) and the "L.A. Look" (1962–68), were, to a large degree, deliberately (and benevolently) plotted by curators, writers, and scholastics eminently familiar with the mainstream model (Paris, early in the century, and New York, in the middle of it). Douglas MacAgy, Walter Hopps, Philip Leider, John Coplans, Jules Langsner, and other writers, teachers, and curators tried (oh, how they tried) to plant the seeds and water the plants. But the bushes died (or cyclically defoliated), and the West Coast art world has lamented ever since a never-was forest of great oaks and wondered aloud when one would grow. But Washington, Oregon, and California are not the eastern seaboard—geographically, socially, or economically —and it's *not* likely we'll ever fully join the dialectical mainstream. Perhaps (to continue the strained metaphor) ours will always be a seasonal garden of odd little plants, and perhaps now is the time to learn how to cultivate it.

2. Kultur, Kommies, Kars

Southern California was settled largely by Midwesterners, and later, in a "second wave" during the Depression and World War II, by rural Southerners; in the face of Great Plains utilitarianism, cultural institutions suffered a late start. The area's first, the Southwest Museum (1903) was appropriately dedicated to preserving indigenous Indian artifacts. The Los Angeles County Museum—a catch-all of science, art, history, and natural history, followed in 1913; the San Diego Fine Arts Gallery and the treasure-house Huntington Art Gallery in San Marino in 1928; and the post-Depression Santa Barbara and La Jolla museums in 1941. The brave career of the Pasadena Art Museum began in 1922, when a group of locals decided to keep "Carmelita," eventual site of the new museum (1969), "intact for cultural use." The Otis Art Institute of Los Angeles County was founded in 1918 on land donated by General Harrison Gray Otis, Los Angeles *Times* patriarch. One original Otis faculty member—Nelbert Chouinard—in turn originated her own school in the twenties, the Chouinard Art Institute, the region's most vital art school until its recent demise (it's now the feminist Woman's Building). Hans Hofmann taught there in 1931 after his first visit to Berkeley, and Jackson Pollock and Philip Guston were students at Chouinard.

The same utilitarianism, mixed with American xenophobia, has made political leftism a favorite scapegoat in Southern California. The Mexican muralist Siqueiros was brought to Los Angeles in the early thirties by Millard Sheets to paint, with the help of local artists Paul Sample and Phil Dike, a mural called *The Workers Meeting* on a wall at Chouinard; another, *Tropical America* (*Ill. 9*) was set up at the Plaza Art Center (a tourist attraction at the original *Pueblo de Los Angeles* site). The latter, "politically offensive," was painted out. Fifteen years later, conservative, fundamentalist, anti-union, Republican Los Angeles was the scene of the McCarthyesque HUAC hearings on "Communist influence" in the

movie business. The same issue at the same time almost destroyed the County Museum's *Annual Exhibition of Artists of Los Angeles and Vicinity*, which, from the late forties to the early sixties, provided the best ground for comparison of current work and the greatest encouragement of inter-artist communication within the region. The 1947 Sixth Annual, juried by Donald Bear of the Santa Barbara Art Museum, actor and conservative collector Vincent Price, and Erle Loran, author of the art school dependable, *Cézanne's Composition*, contained (for many) unpalatable pictures—"twilight of civilization abstraction" with twisting

9. David Alfaro Siqueiros, *Tropical America*, detail of a mural in the Plaza Art Center, Los Angeles, 1932. Paint on cement, 60 x 16 feet. Destroyed.

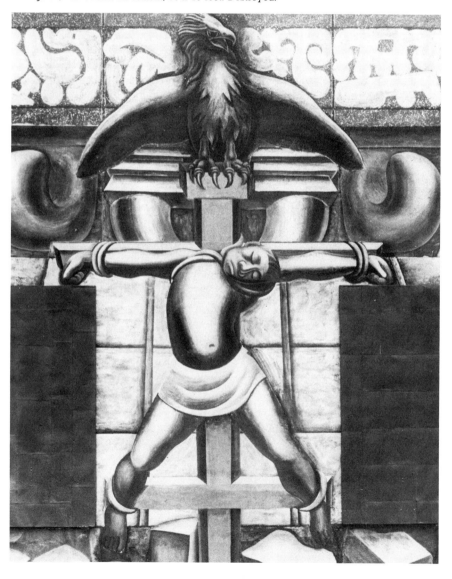

bodies, spiky shapes, Expressionist paint application, and a "meaningful," vaguely leftist theme. Rejected artists picketed, protesting "Red propaganda." The retiring President of the California Art Club denounced "degenerate, un-American subversives."[1] Price purchased a reject and gave it back to the museum in rebuttal, and a used-car dealer held a *salon des refusés* on his lot.

By 1951, the Los Angeles burgermeisters had enough of the "horror painters" like Jirayr Zorthian, "modernistic" prizewinners, "screwball art," and voted to have henceforth two sets of prizes—"traditional" and "modern." A group called Sanity in Art swore they detected maps of secret defense fortifications sequestered in abstract paintings, and one painter, Rex Brandt, was accused by an investigating committee for the City Council of incorporating propaganda in the form of a thinly disguised hammer-and-sickle within a seascape. Finally, the City Council resolved that the artists were "unconscious tools of Kremlin propaganda" and didn't rescind that opinion for eight years. The painting witch-hunt of 1947–52 was part of the prevailing fear. If screenwriters and college professors could be called on the patriotism carpet, why not artists? Although much painting *was* vaguely leftist (antiwar, one-worldist), most of the vitriol symptomized a frustration/suspicion complex concerning modern art: jumbled, illegible, devoid of traditional craft standards, therefore a plot to undermine, etc. When Sanity in Art changed its name to Society of Western Artists and held its own competitions of fumigated art, Huntington Hartford wrote in one of its catalogues, "The progressive artist avoids extremes."[2] But even Bernard Rosenthal's pleasant, inoffensive, semiabstract bronze *Family*, intended for the Police Building, was threatened with destruction in 1955, and Wallace Berman was convicted and fined for an assemblage at the Ferus gallery in 1957. In 1966, Edward Kienholz ran afoul of the county supervisors with an assemblage of sexual coupling (*Back Seat Dodge—'38*) and the resulting fracas nearly closed the new museum (retaliatory bumperstickers said "Dorn [a County Supervisor] is a Four-Letter Word"), and two years later Connor Everts was tried for obscenity in exhibiting a group of his semiabstract, vaginal Desperation series drawings.

The annual juried exhibition kept its importance through the middle fifties, but commercial galleries gained influence, if not market. In Beverly Hills, Frank Perls exhibited avant-garde painters Robert Motherwell, Morris Graves, Jackson Pollock, Mark Rothko, and Clyfford Still. Paul Kantor showed other New York Abstract Expressionists and early European modernists; and Felix Landau, the dealer who handled local art most authoritatively in the fifties (and with relative conservatism until his closing in 1971), opened a gallery. Private collectors, however,

10. Edward Kienholz, *Walter Hopps Hopps Hopps*, 1960. Mixed media. Private collection.

still preferred School of Paris blue chips, and, in 1955, the more adventurous artists in town patronized themselves with a salon show at the Santa Monica merry-go-round. All told, there was "no such thing as a 'school of Los Angeles,' "[3] although the current into the sixties was split into only two channels: Abstract Expressionism (heading into assemblage and back to a kind of Pop art), and Hard Edge (heading toward the technological ethereality of the L.A. Look). But for Los Angeles to become an important art center, a whole new group of collectors would have to be cultivated from the ground up.

The seminal gallery was Ferus, opened in 1957–58 by Edward Kienholz, who supplied the moxie from his experience with earlier enterprises

(Now and Exodus galleries, and Syndell Studios); Walter Hopps, a brilliant young Stanford art historian, who contributed the theoretical guidance and "eye"; and Irving Blum, a former Knoll salesman, who furnished the day-to-day management and front-office suave. Ferus's original stable included John Altoon, Craig Kauffman, Billy Al Bengston, Kenneth Price, Edward Moses, Paul Sarkisian, Richards Ruben, and Wallace Berman. It also showed Bay Area artists Jay de Feo, Sonia Gechtoff, Frank Lobdell, Hassel Smith, and James Kelly. Later, the gallery added Robert Irwin, Larry Bell, and Ed Ruscha. It augmented its serious exhibitions (often obscured behind a façade of comic-opera openings and artist antics) with a do-it-yourself art appreciation course for a new generation of Los Angeles collectors, to supplant the movie-mogul "safe" moderns constituting the bulk of the "serious" Los Angeles art market. Hopps, especially, conducted classes and lectured visitors.

Occasionally during this period, small exquisite exhibitions or a limited selection of works by rarified international talents helped to define the evolving taste of the gallery. [The Copley Gallery in Beverly Hills showed Magritte, Yves Tanguy, Max Ernst, and Man Ray.] Josef Albers, the great color purist, Giorgio Morandi, the amazing Italian intimist, Kurt Schwitters, the precocious master of collage, and Joseph Cornell, the father of the hand-held universe, were shown. No Picasso, no Matisse, no Chagall, no Henry Moore, no third-level works by established personalities. Hopps and Blum (at Ferus), in exhibition and installation, while attempting to achieve a specific philosophical overview, developed a work and thought center rather than a salesroom.

As a result of these specialized "Little Master" exhibitions, the work of the local artists changed. The big, loose paintings of Robert Irwin became very small. Rich "dollops" of color were contained in heavy frames which were finished on the back with silky wooden panels; each work complete in itself, independent of environment. Billy Al Bengston, reducing scale dramatically, produced his "heart" and "iris" series of perfect little hinged boxes with glass fronts. In these advanced examples of his, whimsical ceramic cups were placed along with collage material, which emphasized the personality of each vessel. Ed Moses developed a series of beautiful cut-paper drawings set in deep shadow boxes. Larry Bell, not yet with the gallery but under its influence, began his glass studies. Each of these has, in his own and collective ways, moved from this starting point to a position of prominence among mature artists.[4]

This scene was augmented by the middle sixties by a bumper crop of curators: Henry Hopkins and James Elliott, associated with the County Museum at staggered times, and James Demetrion at Pasadena, all of whom later graduated to directing their own museums. (The departure of

11. John Altoon, *Untitled* (Trip series), 1959. Oil on canvas, 53⅝ x 48 inches. Collection of the Pasadena Art Museum, Pasadena, California; gift of Robert A. Rowan.

12. Craig Kauffman, *Untitled*, 1958. Oil on canvas, 62 x 50 inches. Private collection.

26

commercial and public curatorial talent was, incidentally, a corollary factor in the leveling off of the Los Angeles esthetic momentum at the end of the sixties.)

During the sixties, a culture explosion—deriving from such disparate socioeconomic origins as youth emphasis, the election of JFK, newly available middle-class affluence and leisure, the bull market, and the fashionableness of colleges and universities as war babies filled them to overflowing—overtook the country. The visual-art portion of the phenomenon meant an increased audience and new quarters for public galleries and the burgeoning of the commercial ones. "Culture" meant "art," and "art" implied "new," and "new," as everybody was informed,

13. *Left to right:* Edward Kienholz, John Altoon, Billy Al Bengston, Craig Kauffman (upside down), Robert Irwin, Edward Moses (reclining), and Allen Lynch, *ca.* 1959–60.

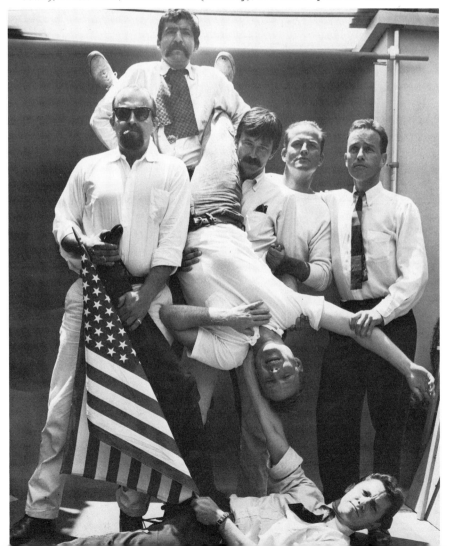

14. Larry Bell, *Untitled*, 1964. Mixed media, 36 x 36 inches.

meant California—particularly Los Angeles. "In the sixties, Los Angeles moved past Philadelphia in population into third behind New York and Chicago, held the Democratic convention, acquired a spate of major league teams, built several culture palaces and 1,000 miles of freeway, suffered an incredible racial upheaval, and generally enlarged/intensified itself into the malignant tumor of a Great American City."[5] But Los Angeles is not Manhattan. Its neighborhoods are far flung and precariously connected by automobile, rather than square blocks cohered by pedestrian travel or subway. When the society spreads itself out, the artists follow. Los Angeles has no Greenwich Village, Tenth Street, or North Beach—although Venice has become an "artists' quarter" of a sort in the past ten years. Artists' out-of-studio debates, dealing, informal teaching, and clique-forming do not take place with the intensity of activity at the Cedar Bar, the Club, or Subjects of the Artist, in New York.

At the height of the sixties art boom in 1965–66, however, twenty-five or thirty "serious" galleries operated, most on the short strip of La Cienega between Melrose and Santa Monica, and a few as far out as Westwood, near the UCLA campus. Dwan specialized in New York artists like Robert Rauschenberg and Jasper Johns. Comara exhibited "new

wave" younger California artists. Paul Rivas showed Feitelson's Hard Edge paintings. Bertha Lewinson handled Connor Everts's drawings. Frank Perls continued with classic moderns. Landau showed Los Angeles and San Francisco "establishment" artists. The L.A. Art Association supported neophytes; Primus-Stuart combined contemporary and pre-Columbian; Ceejé displayed offbeat native expressionism; and Ankrum, Feingarten, and, for brief periods, Feigen-Palmer and Rolf Nelson chipped in. The hallmark of the period was the weekly soirée called "art walk." Monday nights the galleries stayed open until ten o'clock, and browsers by the hundreds strolled in the semitropical night air. But as late as 1967, a critic could write, "L.A. galleries compete to attract the kind of customers who apparently buy paintings to match

15. Warhol show at the Ferus Gallery, Los Angeles, 1966.

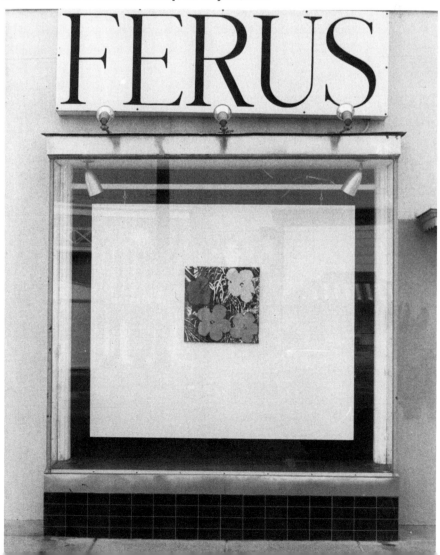

their carpeting or drapes."[6] By then he was missing the whole point of what had developed in Los Angeles since 1958: a new esthetic, divorced as much from New York art-historical dialectics (Abstract Expressionism, how/whether to carry it on), as from art for the decorator trade. The absence of a tradition in the middle ground of the forties and fifties, however, gave Los Angeles art an open field, without the obstacles of history or heroes.

> Early in the sixties, a young artist named Edward Ruscha—recent graduate of Chouinard and painter of "word paintings" like *Actual Size* and *Annie*—paid a call on the resident heavy of Los Angeles art, Billy Al Bengston. Ruscha rang the doorbell, and when Bengston opened the door, announced crisply, "Bengston? I'm Ruscha."
> Bengston examined the young man, said," Sorry, I'm not Bengston," and closed the door. Ruscha turned on his heel and descended the stairs. But he paused on the landing. He climbed the stairs, knocked again at the door, and, when the same man opened it, retorted, "Well, I'm not Ruscha, either."

That the fable isn't true does matter. Since the late fifties, considerable parody of art and the artist's role as well as exterior subject matter has permeated Southern California art. The artist's role in Los Angeles is schizophrenic because it's constantly measured, not against ingrained "fine art" tradition, but against the most salient facets of California culture: pop architecture and music, movies, and the garment industry. The Los Angeles artist of the sixties found it difficult to regard himself as a link in modernist camaraderie reaching back a hundred years (as could the Easterners—for example, Helen Frankenthaler to Jackson Pollock, to Thomas Hart Benton, to the Ash Can painters and Robert Henri, to Thomas Eakins). Concurrently, he found it difficult to take himself seriously as a prophetic rebel against the enemy of "culture" in California, for such an enemy was almost nonexistent. With the high-minded solemnity of artist-as-sage and artist-as-iconoclast denied, the California artist has been forced to see himself in a different light. The movie business makes a fetish of referring to actors and directors who have made money for the studios as "artists," and it's difficult to trade in disenchantment with "fine art" for *that* mess of pottage when the vehicle would likely be a mosaic mural for a sparkle-front bowling alley. Painters and sculptors are not appropriately armed by media to make the alienation from both "culture" and vulgar society the messagy subject of work, as were novelists like Evelyn Waugh (*The Loved One*). California artists for a long while were left the opportunity to admire the "art" in minor esthetic backwaters—the "Baroque sculpture" and kandy-apple paint jobs of car customizers like Big Daddy Roth.

3. First Flowering

Up north, the significant prewar event was Hans Hofmann's series of courses at the University of California, Berkeley, in 1930. Hofmann (born in 1880), witnessed firsthand the succession of European transformations —Impressionism, Expressionism, Fauvism, Cubism, Futurism, and Dada. Although unpracticed in English, Hofmann was ebullient, dedicated, and possessed of a prophetic understanding of Cubism's potential for fully intuitive abstract painting. In New York and Provincetown, where he ran his own schools, Hofmann's teaching had a singular influence. In California, although his tenure was brief, he willed to Berkeley a reverent coterie of converts, including Erle Loran. Forty years later, with the Hofmann wing of the new concrete *kunstbunker*, the University Art Museum, in situ, the spirit is incarnate.

In prewar San Francisco, little was apparent other than recycled regionalism and naïve abstraction funneled through designers' Cubism or illustrators' Surrealism. But lack of esthetic coherence did, apparently, invest the area with a "wild West independence."[1] The authentic beginnings of Bay Area contemporary art sprouted from 1946 to 1950 at the California School of Fine Arts (today the San Francisco Art Institute).[2] The chemistry was in a combination of ingredients: the physical atmosphere of the CSFA plant—with its old halls, cavernous, friendly studios conducive to expressive experiments, and an influx of older, G.I. Bill student-veterans and students with degrees in academic subjects from other universities—and a catalyst in the person of Director Douglas MacAgy, who covered up (but didn't destroy) the Diego Rivera mural, streamlined the school into a noncredit, non-degree-granting institution, "a little cell in the middle of a city which was concerned with other things; in other words . . . a vaudeville town."[3]

One stroke by MacAgy contributed immeasurably: the invitations to teach at the school for short periods that he extended to Clyfford Still

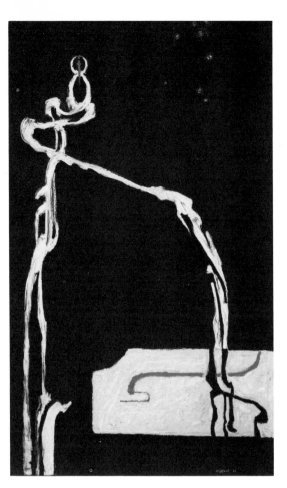

16. Clyfford Still, *Self Portrait*, 1945. Oil on canvas, 71 x 42 inches. Collection of the San Francisco Museum of Art.

17. Mark Rothko, *Slow Swirl by the Edge of the Sea*, 1944. Oil on canvas, 75 x 84 inches. Collection of The Museum of Modern Art, New York.

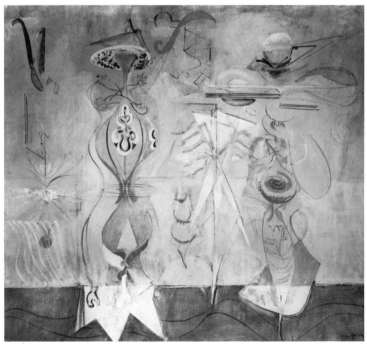

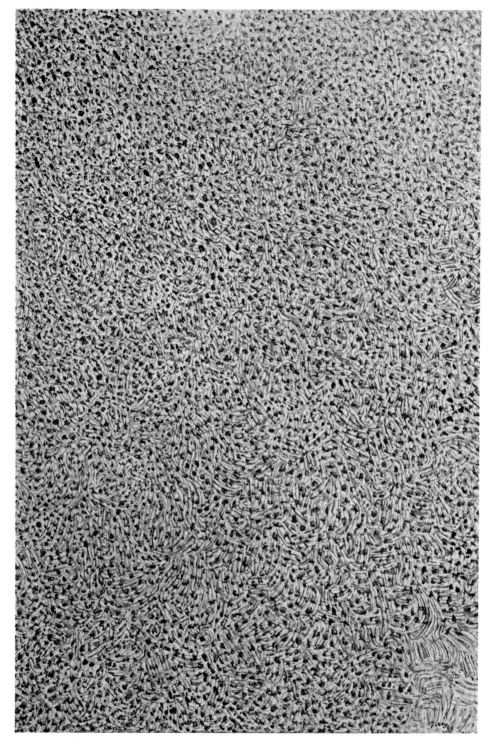

Colorplate 1. Mark Tobey, *By Its Own Rule*, 1969.
Tempera, 39 x 26 ¹⁄₂ inches.

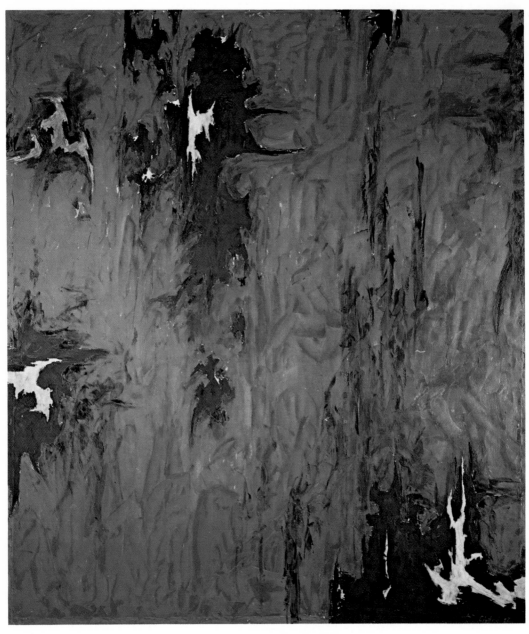

Colorplate 2. Clyfford Still, *Untitled (1947-R-No. 2)*, 1947.
Oil on canvas, 105 x 92 inches. Private collection.

(1946–50), Mark Rothko (summers, 1947 and 1949), and Ad Reinhardt (summer, 1950). Rothko and Still were (eventually) to represent (with Barnett Newman) the more abstract and less expressionist wing of AE. Their teaching echoed their work, which was, as opposed to de Kooning's, Pollock's, and Kline's) more open, less emotional, and more given to "refinement and extension."[4] Such instruction prevented CSFA "from being just another in a multitude of art schools selling commercial and popular versions of realism, Bauhaus esthetics, and muscular daubings."[5]

Still was at the time more advanced and headed toward a less sublime but more dramatic outsized kind of painting full of stark color contrasts, scruffy, anxious paint application, and almost mural-like proportions. Having lived in the Dakotas and taken his schooling in the state of Washington, Still developed a raw Surrealism early on that was reminiscent of clouds and wisps of smoke hovering above the prairie. He studiously avoided Cubism and its satellite styles, believing them to be, at bottom, adjuncts of the hated Renaissance (which, he thought, had "hog-tied" Western art), and in his philosophy fashioned a blend of outrageous conceit and solitary profundity which made him an incredible teacher.

> The manifestos and gestures of the Cubists, the Fauves, the Dada-ists, Surrealists, Futurists, or Expressionists were only evidence that the Black Mass was but a pathetic homage to that which it pretended to mock. And the Bauhaus herded them briskly into a cool, universal Buchenwald. All the devices were at hand, and all the devices had failed to emancipate.
> I had not overlooked the organic lesson; ontogeny suggested that the way through the maze of sterility required recapitulation of my phylogenic inheritance. Neither verbalizings nor esthetic accretion would suffice. I had to accomplish my purpose, my emancipation and the exalting responsibility which I trusted would follow, totally and directly through my own life and hands. . . . Through the years of the 1930s the work of clarifying, excising, extending and review-ing was presented during all the time and with all the energy I could order. Until those symbols of obeisance to—or illustration of —vested social structures, from antiquity through Cubism and Sur-realism to my then immediate contemporaries, were impaled and their sycophancy exposed on the blade of my identity.[6]

The paintings by Still shown in 1943 at the San Francisco Museum of Art and in 1947 at the Legion of Honor were still suggestive of the human presence (if not the human figure), but by the summer of 1950, in an exhibition at the Metart Gallery, Still fully realized the overpowering Jungian "feel," anxiously joyful paint application, impossible scale (even in moderate-sized Stills, due to the complete subversion of Cubist

figure-ground relationships), and brooding presence that captured a whole generation of Bay Area painters. Still, however, may have contributed simultaneously to the rise and fall of San Francisco AE. *He* could do without Cubism's infrastructure and rely on a sixth sense of independence and exhilaration, but his followers—no matter how strongly he cautioned them—could not, and San Francisco AE quickly became mannerism manifest. And Still raised the hackles of the mystic painters caught in the fringes of the Northwest fog, who thought his insistence on radical independence and the concreteness of paint made him a "hater" in the cosmos.

Rothko, by contrast, was an American-scene figure painter with eclectic traces of early moderns (Pascin, Weber, Hartley, and Avery) who had worked on the WPA. In the middle forties, he associated with Newman and Adolph Gottlieb in wishing to approach painting again, as Paul Klee had, like a child. In this case, however, the innocence was channeled through a collective subconscious, and the paintings of all three were simple pictographs after the manner of prehistoric cave paintings. From there, Rothko evolved toward a thinly painted, heavily brushed semistain of side-by-side, rectangular color clouds. He came to CSFA in the summer of 1948, bringing slides of the paintings of Pollock, Robert Motherwell, Adolph Gottlieb, Willem de Kooning, and others. In spite of his early background in Oregon, Rothko was a New Yorker— talkative, sophisticated, and more personable than Still. Although his sojourn was brief and his presence the "lesser" of the two, Rothko's gentler influence was an important element in the chemistry of San Francisco's fertile five years. Because of it, the students were able to see there was *something* (e.g., painting, art) out there beckoning them, and not just the seductive parables of a single messiah.

As artists, Still and Rothko (and Newman) were puzzles even to their peers because they seemed to dispense with the need to *represent* space in the interests of directly *manifesting* it. "Instead of using outlines, instead of making shapes or setting off spaces, my drawings declare the space. Instead of working with the remnants of space, I work with the whole space," Newman wrote.[7] Although most art students in the fifties imitated the gestural aspects of AE in Still's and Rothko's work, these two colorists of an abstract sublime were to influence sixties painters like Frank Stella, Kenneth Noland, and Jules Olitski more directly (than were, for example, de Kooning with his facile take on Cubism or Pollock with his vertiginous skeins of paint). Whatever the eventual disadvantages (imitation spawned by hero worship, and others), Still and Rothko saved the Bay Area painters from the calisthenics of Cubism rehashed. Frank Lobdell, John Hultberg, and Richard Diebenkorn, who

briefly constituted a Sausalito group of Abstract Expressionists, exemplified the advantages. Despite derivations from the landscape, such paintings as Diebenkorn's Berkeley series abstractions (*Ill. 18*) deal freely with the placement of frontal shapes and paint surfaces in relation to each other and to the edges of the canvas. Bay Area painters who remained in California reflected the immediate look at Still and Rothko less than those who, like Edward Dugmore and Ernest Briggs, eventually left for New York, and whose pictures, although finely composed, utilized Still's "torn wallpaper" motif in only slightly varied form.

A PARTIAL ROSTER OF ARTISTS AT CSFA, 1945–50

Instructors

Clyfford Still	Mark Rothko	Ad Reinhardt
Edward Corbett	William Gaw	Clay Spohn
Elmer Bischoff	David Park	Jean Varda
Dorr Bothwell	Robert McChesney	Charles Howard
James McCray	Hassel Smith	Ansel Adams

Students

James Budd Dixon	Ernest Briggs	John Hultberg
Jeremy Anderson	William Morehouse	Jack Jefferson
Edward Dugmore	Jorge Goya	Jon Schueler
James Kelly	John Saccaro	Lawrence Calcagno
John Grillo	Peter Shoemaker	Frank Lobdell
Walter Kuhlman	Madeline Diamond	Deborah Remington
Richard Diebenkorn	Philip Roeber	James Weeks
Joan Brown		

At least two highly individual painters—representative in their concern for painting as an introspective, moral enterprise, but atypical in actual morphology—emerged. Hassel Smith changed from his late thirties Social Realism (card players, drunks in bars, Indians, etc.) to AE under the CSFA momentum (and possibly in response to Arshile Gorky, who had a retrospective at the San Francisco Museum of Art in 1941). "There's no secret about it," he said, "I just got sick and tired of what I was doing and I liked what these other guys were doing."[8] From then on, Smith's crisply composed, calligraphic paintings were characterized by a spontaneous hooking line; Smith sustained this style for nearly a decade, then, in the early sixties, suffered an esthetic collapse, turning to cute little girly figures in shows at the Dilexi (San Francisco, 1964) and David Stuart (Los Angeles, 1965) galleries. For all their action, Smith's AE pictures are executed with restrained sensitivity;

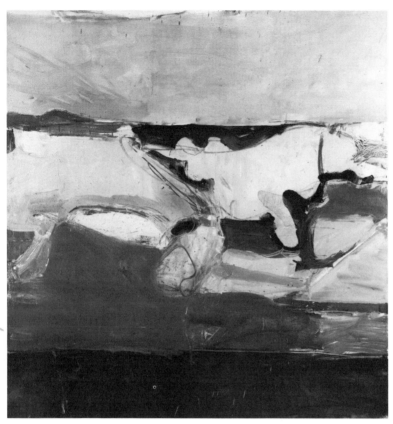

18. Richard Diebenkorn, *Berkeley, No. 48*,
1955. Oil on canvas, 62 x 59 inches.

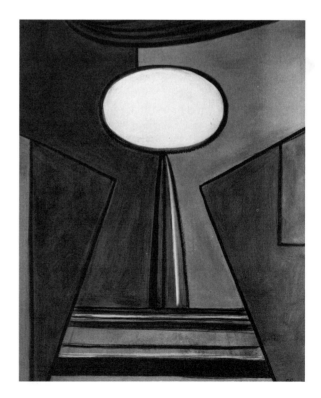

19. Clay Spohn, *The Aborigine*, 1946. Oil on
canvas, 49 x 39½ inches. Collection of
the San Francisco Art Institute.

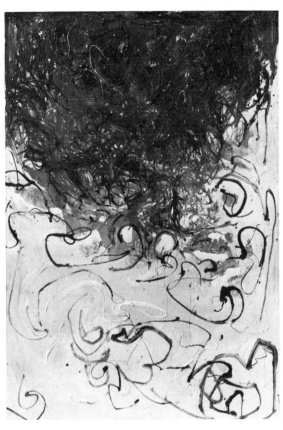

20. Hassel Smith, *Untitled*, 1953. Oil on canvas, 72 x 50 inches.

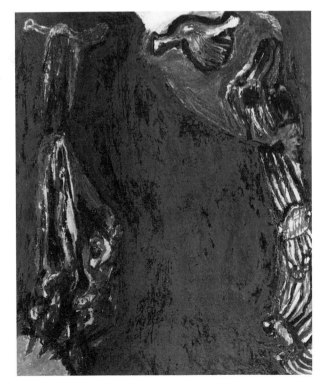

21. Frank Lobdell, *February*, 1959. Oil on canvas, 70 x 59 inches. Collection of the Los Angeles County Museum of Art.

his color is subdued, and the viscous surface displays its history in the underbrushing. In quality and chronology, Smith is a West Coast Philip Guston (who also traversed a path from Social Realism to AE, and then, on a bad impulse, returned to the figure). In the late fifties, Smith relocated to an apple ranch near Sebastapol, and in 1966 moved across the country and out of it to the peace of Bristol on the English coast. It may have been that Smith, like other West Coast artists, suffered from a lack of sustaining contact with cultural ambience—writers, critics, historians—and a consequent sense of historical/cultural mattering.

Frank Lobdell studied with Cameron Booth in Minnesota before coming to San Francisco. He also studied with Still, and of all the CSFA artists is the most obviously emulative of him, as can be seen in his over-all impastos and jarring, sometimes terrifying contrasts of bright and dark colors, enormous and incidental areas. But Lobdell's work is not so easily synopsized. It incorporates such sources as Picasso and has an intense, brooding quality, as if compositional choices were ethical imperatives.

> His art is deeply introspective, evokes questions of human dilemma and is far from an art of preconceived formal order, *ideatic* postulate, or hedonistic engagement. Confrontation with Lobdell's art immediately reveals his commitment to an evolving, intuitive, painterly process. Each painting, for the most part heavily worked and re-worked, obviously involves a prolonged process of formation.[9]

Patronage was thin, and there were only occasional museum shows. Private galleries like Mme. Lucien Labaudt's were scarce and, through the early fifties, the San Francisco Art Association (progenitor of CSFA), frequently in conjunction with the San Francisco Museum of Art, was the only public institution specializing in solo shows by Bay Area artists. (Fortunately, the museum was directed by Dr. Grace McCann Morely, who for twenty years gave support to abstract art and later to the neo-figurative style of David Park, Richard Diebenkorn, and Elmer Bischoff.) Lobdell, for instance, called 1952–53, when he had a studio in the Mission district, "the dark years." Many of the CSFA artists departed for New York. Lobdell went on a "no-exhibition kick," working intensely in the mid-fifties in his studio, surfacing in the U.S. exhibition of the 1955 São Paulo biennial (organized by Dr. Morely), and *Toward a New Landscape* at the Ferus.

Was there a San Francisco school of Abstract Expressionism? Bay Area AE, while five years behind New York (1948 for Lobdell and Diebenkorn, 1943–44 for Gorky and Pollock), did amount to more than a reconstituted formula spread by museum catalogues and postage-stamp magazine reproductions. New York AE dealt directly, consciously, with

Cubism, translating the multiple views and refracted planes into "legitimate" deep pictorial space via spontaneous paint application—in an effort to ward off the stigma of "decoration." San Francisco was not exposed to Europe as directly as New York (via emigrés like Mondrian and Ernst, and settlers like Gorky) and therefore was not as conscious of history and the need for "good-looking" painting. Early San Francisco AE seems on the whole more vegetable, colorful, personal—albeit less profound—and less dry and intellectual than New York painting. What differences there were, however, existed only five years or so; after 1950, cultural homogeneity obliterated them. Moreover, reaction and saturation set in. The termination of the G.I. Bill choked off the influx of mature students, and the artists themselves headed for New York in numbers. The city itself grew increasingly used to an academy of radicalism (by 1949, the museum's annual exhibition was almost entirely abstract).

By the middle fifties, however, the Bay Area was an attraction for a second wave of New York Abstract Expressionists, who visited and kept the pot simmering: Milton Resnick, an early "over-all" painter, George McNeil, a Hofmann alumnus and strident colorist, and Kyle Morris, an imitator of Franz Kline and de Kooning, among them. But the second echelon of Bay Area abstract painters produced less of consequence: conservative work (ranging from Rico Lebrunesque tonal constructions to Miró-esque Surrealism) by Alexander Nepote, Walter Kuhlman, Jordan Belson, and Ralph du Casse; straight Abstract Expressionism by Madeline Diamond, James Weeks, Julius Wasserstein, Jack Jefferson, Morris Yarowsky, Wesley Chamberlain, and Art Holman; and mystical work (primitive/ritualistic imagery and experiments with paint textures with cosmic overtones) by Dorr Bothwell, Fred Martin, James Budd Dixon, William·Morehouse, and occasionally the Tobey/Graves disciple Kenneth Callahan, down from the Pacific Northwest. By the middle fifties, AE in the Bay Area seemed to tread water, floating over the ground gained since 1945 (which is to say, the conglomerate style of Still, Rothko, Lobdell, and Smith). Painters were frustrated by endless encounters with "nothingness" and spontaneity. At the end of the decade, a critic summed up the fare as "minor-keyed and tensionless"and saw a split developing between painting as the "gentle art of the galleries" and the less formalistic work of underground artists operating within the context of the Beatnik subculture of North Beach (which had begun to produce ultimately the most interesting Bay Area art—assemblage).[10]

There was no "crisis" in Bay Area abstract painting, but several tangential factors encouraged a figure painting revival. First, the living conditions in San Franicsco and the East Bay were naturally "permissive" compared to those of New York—the climate, proximity of open space,

relative abundance of teaching jobs, and the availability of cheap working space. Consequently, California abstraction never possessed (or was possessed by) the tragic, melancholy, noble, and hopeless gestures against the monster city that pervaded much of the painting of Kline, James Brooks, Pollock, and even Rothko and Still. Bay Area abstraction showed little real defiance, and once the artists' tastes were left unsatisfied by the release of "action painting," they soon sought other outlets. Then, too,

> On the West Coast out came Clyfford Still and Mark Rothko who were dead set against French painting. They were utterly opposed to the French traditions in painting. So they yakked, yakked, yakked against it and the students picked up this opposition to something . . . but it wasn't French painting. . . . The New York School formed an opposition . . . but the San Francsco School didn't because they didn't know that much about it. . . . All kinds of strange childhood haunts and fantasies got into the painting out there.[11]

22. Ernest Briggs, *Untitled*, 1951. Oil on canvas, 70 x 68 inches. Private collection.

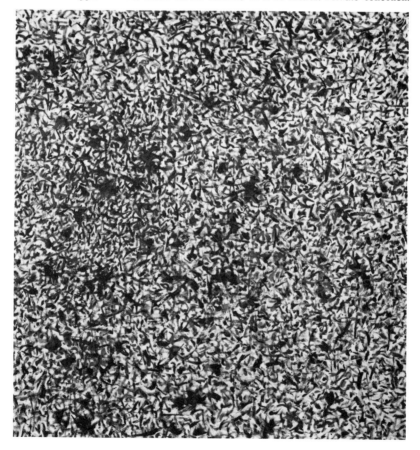

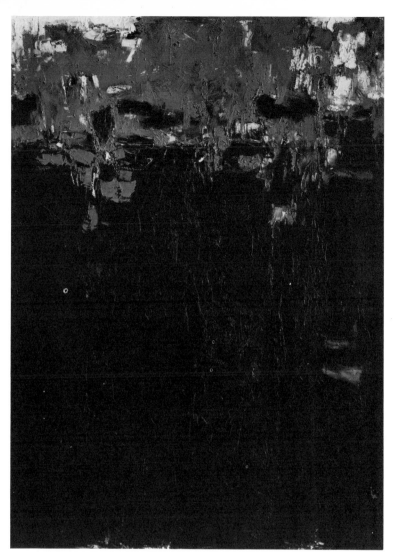

23. Edward Dugmore, *Untitled (No. 131)*, 1955. Oil on canvas, 84 x 60 inches. Collection of the Walker Art Center, Minneapolis.

When second-generation New York AE painters like Alfred Leslie converted to the figure, acknowledging the futility of following de Kooning, the effect was jarring. But the gradual inclusion of figures-in-landscape blended smoothly with Bay Area abstraction.

Whatever abstractionists' rigor or esprit de corps there might have been was seriously debilitated by a continuing exodus of artists for New York: Still and Rothko took their moral leadership with them, and good painters like Ernest Briggs, Edward Dugmore, and John Grillo

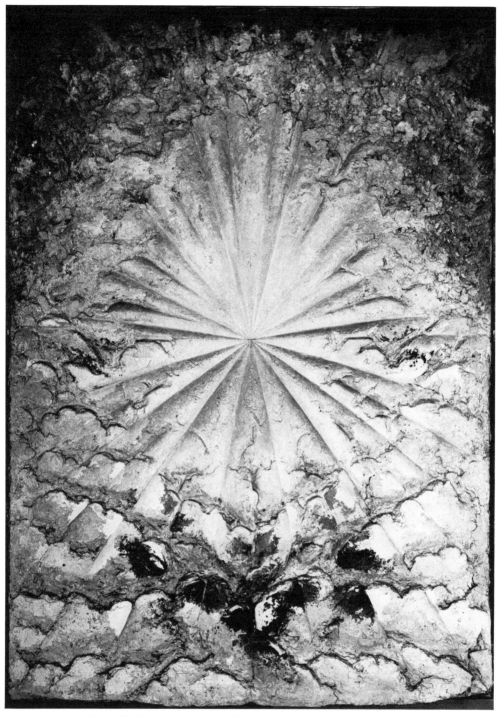

24. Jay de Feo, *The Rose*, begun 1958. Mixed media. Collection of the San Francisco Art Institute.

departed, too. Commercial and museum support remained nonexistent in any economically viable way. The galleries, like King Ubu (which showed Bischoff's abstract paintings), its successor the Six (with Wally Hedrick as director), and the Batman, were de facto art-for-art's sake ventures. Exhibitions were experiments; in one, several hundred tiny paintings and drawings were hung, and the selling prices ranged from half a dollar downward. (In Los Angeles, where Kienholz ran his Now gallery, Syndell Studios, and Exodus gallery in San Pedro, the beginnings were similarly modest.) The Dilexi gallery, opened in 1957 by Jim Newman, carried on a temporary revival, and showed the best of the later abstract artists, like James Kelly and Sonia Gechtoff.

Perhaps the career of Jay de Feo, one of the youngest, is representative of Bay Area abstract painting in microcosm. She's a minor legend in the Bay Area, having lived in San Francisco all her life, been at one time married to Wally Hedrick, been shown at Dilexi in 1958, and been included in *Sixteen Americans* at the Museum of Modern Art in New York (an exhibition that "introduced" Robert Rauschenberg, Frank Stella, and Jasper Johns). But she gradually dropped out. A painting in *Sixteen Americans*, *The Rose* (its original title was *The Death Rose*), is the core (*Ill. 24*). Begun in 1958, *The Rose* was literally built with layer upon layer of paint and assorted grog, radiating from the center in eerie relentlessness. *The Rose* weighs several hundred pounds; when the Pasadena Museum requested it for a show (the painting was always "in progress") a whole wall had to be cut out of de Feo's apartment for the moving men to get at it. Today, the painting is mounted in semiobscurity at the San Francisco Art Institute, its surface horribly, fundamentally cracked, and its below-eye-level "belly" bulging like an endlessly, futilely pregnant woman.

> If you wanted the characteristics of Bay Area art, it is that people who are not in any sense technically equipped to be artists, or talented in the historical sense to make art, live on the West Coast or in the Bay Area. We know numerous examples of people who are total clubfoots, who make marvelous works of art.[12]

4. Orient and Artifice

A few critics fancied an *Ecole du Pacifique*, a California equivalent of the New York School, composed of Smith, Lobdell, Diebenkorn, Bischoff, Sam Francis, perhaps Robert McChesney (an erratic, mystical painter of exotic pourings), Felix Ruvolo, Fred Reichman, Richard Bowman (who did "atomic" paintings), Edward Corbett, and Lawrence Calcagno —but there was "not enough formal or emotional significance common to all."[1] Diebenkorn and Bischoff soon defected to impastoed figure painting, Lobdell continued his wan, dark pursuits, Smith vacillated and faded, and Francis became an international star. If, before 1950, the main impetus in abstract painting came from the Orient, via Mark Tobey and Morris Graves, after that it began to waft in on the prevailing winds of New York, to which Still and Rothko had returned, via the pages of magazines like *Art News* that reached the hinterlands. But up to the *Ecole du Pacifique*, the Pacific Northwest's contribution—indeed the West Coast's—to modern art consists by and large of the work of Tobey and his spinoff, Graves.

Sam Hunter wrote in 1958 that the West Coast had produced only two painters worth mentioning, Sam Francis and Mark Tobey, "a minor episode in the history of abstraction."[2] (In the nonsensical business of claim-staking, the issue of calligraphic dripping is argued vis-à-vis Pollock, Hofmann, and Tobey—ignoring Knud Merrild, the Danish emigrant to Los Angeles, who poured his first Flux paintings in the thirties.) Tobey and Graves are an anomaly because they are the only important American painters to operate artistically within a definable belief system. Since all artists function with at least a faith in their own art, the operative word here is "definable"; in the case of Tobey and Graves, the system centers around a quasi-religious, pantheistic attitude toward nature that implies "oneness" and tranquility—which is

considerably different from, for instance, the secular *angst* of Abstract Expressionism.

Born in 1890, Tobey worked as a fashion illustrator in New York upon leaving the Art Institute of Chicago. Following his first exhibition (at Knoedler's in New York, in 1917), Tobey returned to Seattle to teach at the Cornish School from 1922 to 1925; upon his separation from that institution, he traveled to Europe and the Near East for a year. In 1930, he left Seattle again, for seven years, to teach painting at Darlington Hall in England; during that period Tobey sojourned again in Europe, and also visited China, Japan, and Mexico. During a respite in Seattle, he met Ten Kuei, a Chinese student at the University of Washington, and this friendship kindled Tobey's interest in Far Eastern art. In 1934, Tobey boarded with Ten Kuei's family in Shanghai while he studied calligraphy, the art that would have the most direct influence on his work. In 1935, Tobey was given an exhibition at the Seattle Art Museum, and in 1940 he won the grand prize in the museum's annual exhibition. But in 1945, after a decade of "white writing" (a quick, complex web of energetic but delicate painted white or off-white defining the drawn space and establishing the color tone of the painting), Tobey was thought to be "associated with extreme trends,"[3] and in 1949, before the full flowering of Abstract Expressionism had enlightened America, the "white writing" was cast off as "leading up a dead end."[4] But Tobey's fluctuations (from the early proletarian paintings, to the first white writings, such as *Broadway Norm* (1935), and then back to paintings of shipyard workers during World War II, for instance) were both infrequent and limited enough to prevent him from becoming a total enigma. Tobey's figurative paintings are energized by the white writing used as a representative drawing tool.

Tobey, who converted to the encyclopedic benevolence of the Baha'i faith in 1918, is an unreserved artistic proselytizer of his philosophical system. His tenets have confined him to a smaller, more private, quieter, less polemic art than that of the New York Expressionists—qualities that have rendered him less of a booming historical entity than his painter brethren in New York; but it was also his interest in religious explanations of the universe that propelled Tobey away from the particulars of illustration toward a more complete painterly abstraction earlier than many other American painters. "Tobey has not tackled a totality which is beyond his pictorial means, but has rightly concentrated the means available to him into the kind of visual statement they can bear."[5]

Tobey's paintings are characteristically modest, rarely more than a meter on a side, and his pictorial space is founded on a more mystical interpretation of Cubism, which he compared to the path of a fly buzzing

25. Mark Tobey, *The Void Devouring the Gadget Era*, 1942. Tempera on cardboard, 21⅞ x 30 inches. Collection of The Museum of Modern Art, New York; gift of the artist.

about the cubical space of a room, as opposed to the traditional multiple viewpoints and fracturing of planes and volumes. This is reflected in the white writing, which integrates line and plane, foreground and background, framing edge and interior as surely as Pollock's threads of paint. Tobey's white writing lies upon the picture surface much more obviously than Pollock's skeins, and any element, such as full chroma, that called additional attention to the on-top-of quality of the calligraphic strokes would peel the painting apart. Tobey's color is also characteristically quiet—tertiary colors, grays, occasional ochers, and, when they occur, small, separated swatches or cuts of red and light blue.

This art, with its ahistorical groundings, isn't given to "periods" and "advancements"; pictures painted thirty years apart look equally new (although there has been a general progression from open and linear to denser, more dotlike paintings, but even these are punctuated with "minimal" open compositions with surprisingly few brush marks). The

essence of Tobey's art is not public and physical, but private and psychic, which is the reason the work incurs underrating, and feckless apings by secondary artists.

Graves exceeds even Tobey as a wanderer; he left high school for the sea, but then returned to Seattle to study art. In 1934, he packed up his camping gear and set off with Guy Anderson, a sculptor and friend of Tobey's, for Los Angeles, where he made drawings of the birds in the L.A. zoo; of the several concurrent themes in Graves's art, birds remain, at least in the public eye, his trademark. During the Depression he worked on the WPA and studied with Tobey, whom he had met in 1934 (in 1939, after seeing a painting called *Doodle Doily* in Tobey's studio, Graves "adopted" the white writing). Thereafter, he began to work in subject series—Messages, Moon, Chalices. After inclusion in the *Americans, 1942* exhibition at the Museum of Modern Art, Graves removed himself to "The Rock," an isolated home he built on San Juan Island in Puget Sound; he re-emerged with an exhibition at the Tate Gallery, in London, in 1946, but went into isolation again, and seldom showed until 1953. Three years later, he forsook the United States (and

26. Mark Tobey, *Worker*, 1943. Tempera, 43 x 25 inches. Private collection.

27. Mark Tobey, *Tropicalism*, 1948. Tempera, 26½ x 19¾ inches.

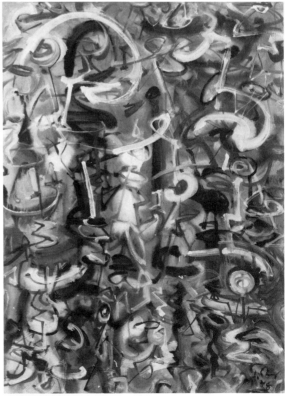

the art world, which he regarded as cannibalistic) for County Cork, Ireland, though he lives intermittently in the Pacific Northwest and travels in the Orient.

Graves is generally regarded as a lesser artist, heavily influenced by Tobey. While Tobey is the master, there are differences. Graves is more romantically pantheistic and less conceptual. His mental set has been influenced by the Ch'an school and Taoism, and edges closer to traditional nature worship than does Tobey—whose cosmology is dry and abstracted to the point of resembling Mondrian's universe of Dynamic Symmetry. Thus, Graves's work tends back toward illustration of the vitality of all things—the Chalices and Moons of 1942, the *Joyous Young Pine* of 1943 (*Ill. 28*), *Black Wave* of 1944, and the omnipresent birds, blind or newborn, as outright symbols of the fragility, innocence, and tragic beauty of life. Graves treads a finer line than Tobey, and consequently his paintings turn slightly sour (or sweet) on the reading of a single group of strokes. Are the deft ocher strokes around the border remnants of intensely felt white writing or are they related to the commercial artist's background shorthand? Are the centered images hovering with mystic energy, or does Graves's compositional sense not extend beyond concepts of representation-*cum*-filler? And are the drawing style and titles of the bird paintings indicative of a master's touch and poetic sensibility, or are they "fine-arts" equivalents of cartoonists' devices and maudlin anthropomorphism? When you consider Graves the man—tormented, fugitive, gentle, and principled— the issue is easily resolved in favor of the profound; but from the "look" of the work itself, it's easy to see that Tobey is the master and Graves the tyro.

Tobey and Graves have possessed Pacific Northwest art to the point of suffocation—a strange result, for the two artists have lived outside the region as much as within it. The causes are several. Tobey and Graves were there first; their discoveries—concerning the viability of "another way" of approaching art—were bound to influence later artists. Also, the characteristics of the region as an art center—geographically remote, overly conscious of regional identity, and desiring not to be another commonsense Midwest or an appendage of New York or California culture—predisposed local artists to domination by the first individual personalities to manifest both independence and exoticism. And the superficial graphics of both Tobey and Graves are easily imitatable within the bounds of ready-made taste. "All you had to do," one later painter recalled, "was to put together three shades of brown and a deep blue and you had it."[6] Louis Bunce once facetiously suggested "tubing up fog."[7]

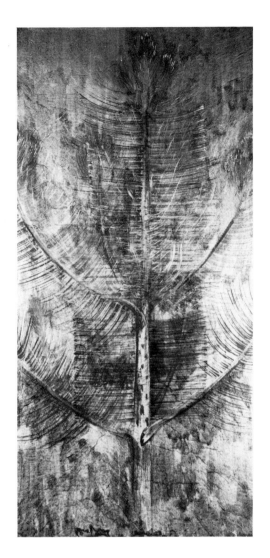

28. Morris Graves, *Joyous Young Pine*, 1943. Watercolor on paper, 52¾ x 27 inches. Collection of the Santa Barbara Museum of Art, Santa Barbara, California; gift of Wright Ludington.

29. Morris Graves, *Moor Swan*, 1933. Oil on canvas. Collection of the Seattle Art Museum; West Seattle Art Club, Katherine B. Baker Memorial Purchase Prize, 1933.

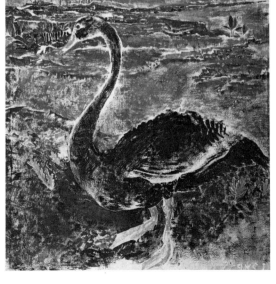

51 · Orient and Artifice

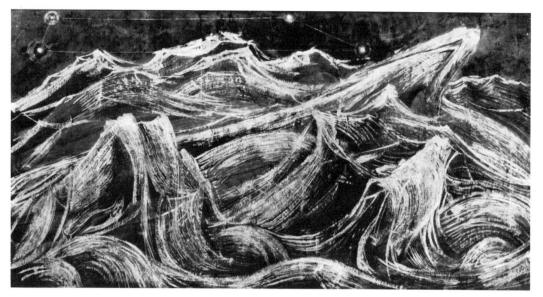

30. Morris Graves, *Sea, Fish, and Constellation,*
1943. Tempera on paper, 19 x 53½ inches.
Collection of the Seattle Art Museum; gift of
Mrs. Thomas D. Stimson.

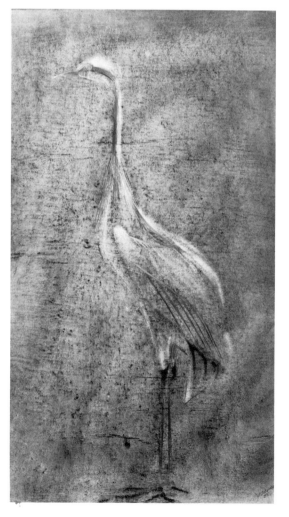

31. Morris Graves, *Consciousness Achieving the
Form of a Crane,* 1945. Gouache on paper,
42¾ x 24⅝ inches. Collection of the Seattle
Art Museum; Eugene Fuller Memorial Col-
lection.

32. Louis Bunce, *Beach, Low Tide, No. 3*, 1954. Oil on paper, 22⅝ x 28¾ inches. Collection of the Portland Art Museum, Portland, Oregon.

33. Carl Morris, *Written in Stone*, 1955. Oil on canvas, 48 x 40¼ inches. Collection of the Portland Art Museum, Portland, Oregon.

34. Kenneth Callahan, *River of Legend*, 1954. Tempera on paper, 12 x 22 inches. Collection of the San Francisco Museum of Art; Emily Winthrop Miles Bequest.

35. Gordon Onslow-Ford, *The Great Haunts*, 1950. Casein on Masonite, 48 x 96 inches. Private collection.

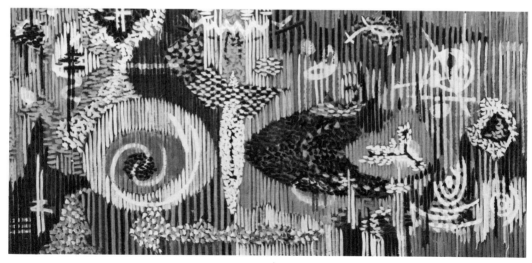

Bunce combined the Pacific Northwest sensibility in abstract painting with considerable manual facility and sense of landscape (sand, water, and rocks). His paintings are decidedly eclectic, but, largely because of his enthusiasm for surviving as an artist in a provincial environment, Bunce was a positive influence on scores of younger painters.

A painting by Carl Morris has been described as a "post-Mondrian Sung landscape emerging from a Tobey."[8] (Morris, a friend of Tobey's, underwent many of the requisite rituals—residing on a houseboat and working at Boeing during World War II). Abstracted from cliff walls, rocks, etc., Morris's work falls down on the same slippery ground as Bunce's: it's competent AE with discrete figurative implications, well engineered but unexciting, mired in the tonal supra-style of the Pacific Northwest (which tends to make paintings "work" easily and thus robs them of the daring that risks offensiveness and gains poetry).

Kenneth Callahan lived in Seattle and studied at the University of Washington. Regarded for a time as one of Seattle's Big Three (or Big Four when Guy Anderson is included), Callahan is a minor painter, with an oeuvre ranging from Tobeyesque figures constructed as if from wire, AE swirls, and "philosophical" subject matter ranging from William Blake, to Christianity, to classical Greece.

Gordon Onslow-Ford began as a mainstream Surrealist, collaborating with Matta in the late thirties, associating with Surrealist groups in London, Paris, and New York (lecturing on Surrealism at the New School during 1940–41), and finally forming part of the Dynaton group with Lee Mullican and Wolfgang Paalen in 1950–51. Onslow-Ford is a ubiquitous Bay Area abstract painter, often shown in the context of the lyrical side of the area's Abstract Expressionism. (In the late sixties he authored an extensive, treacly book, *Painting in the Instant*, a "poetic" free-verse summation of the "Zen" art of subconscious and chance.)

In the end, the Tobey-Graves esthetic, for all its sincerity (in the original) and accessibility (in the facsimile), proved spiritually untransferrable, and it remained for tougher and wryer attitudes to inspire successive generations of West Coast artists to rival the quality of New York art and the wonder of their own settings.

5. Return to Returns to the Figure

Painters often detour into more comfortable modes after bouts with the avant-garde. Postimpressionists forsook the "field" implied in Monet's serial paintings; Picasso in the thirties indulged himself in a reactionary, sentimental return to classical figure drawing; and now there's a Photorealist counterrevolution against later abstract painting. In this context, the Bay Area Abstract Expressionist painters who rejected the Still-Rothko styles in the mid-fifties were making a routine change, save for the quality of their painting. David Park, Elmer Bischoff (both of whom never *really* dug Still's painting), and Richard Diebenkorn produced the most welcome relief from forced-scale "post-painterly" abstraction and the camping of Pop; so, to a lesser degree, did Nathan Oliviera and Joan Brown.

One argument says that the stream was bound to hiss out of Bay Area AE once the evangelical, hell-fire personality of Clyfford Still had gone, that movements/styles require geniuses, and that San Francisco had none to sustain this one. On the other hand, dialectics are required to regenerate art modes; a philosophically competitive pressure cooker of constant argumentation (more through art than art criticism) together with a sense of cultural (not just municipal) history says that everything *matters*. New York, of course, is the model. In the crowds, cliques, and competition, the dedicated overthrowers of the last demi-decade's art radicals inspire defenders-of-the-faith who are not pettifogging hidebounders but equally dedicated and radical artists who see the task not as prolonging, but as setting the parameters of and redefining within their tradition. This requires an artists' community large enough to function as an audience to the rebuttal and counterrebuttal, to split into factions, to throw weight behind one or the other; if the audience consists only of a relatively few artists and the general public, the art becomes more deeply mired in acceptance. The Bay Area, like Los Angeles and

36. David Park, *Cousin Emily and Pet*, 1952. Oil on canvas, 46 x 33½ inches. Private collection.

37. David Park, *Couple*, 1959. Oil on canvas, 26 x 48 inches. Private collection.

38. David Park, *Berkeley Scroll* (detail), 1960. Felt pen on paper, 13 x 368¼ inches. Collection of the University Art Museum, Berkeley, California; gift of Mrs. Benjamin H. Lehman, Saratoga, California.

Seattle, lacks the numbers, concentration, and intensity for combative rejuvenation. As noted, many artists left for New York, but the ones who remained were free from historical imperative.

David Park stayed (Park had his first museum show in San Francisco in 1935, and from 1943 he taught in the Bay area, first at the California School of Fine Arts and for the last five years of his life at Berkeley). He progressed, under Still's influence, from primitive, illusionary Surrealism to a hard-wrought, painterly abstraction—in which he never quite "believed." In 1950, Park began to work with figures again. He was the most painty of the Bay Area figurative artists, using direct, thick, viscous, impasto swatches to build simple standing and seated figures. In facial configuration and body build, Park's figures are radically generalized—a few short, rough, curling, dark strokes forming the eye cavities, a thick, dark, shallow V like an inverted moustache, defining the shadow beneath the nose (the bridge comprising the tonal/color differentiation between the adjacent planes of yellow, pink, or flesh color), and a similar, shallow U for the shadow under the chin. To ensure that the figure doesn't entirely govern the picture—the lesson of AE— Park employed wide, interrupted outlines of dark, dragged paint (Prussian blue or burgundy) to separate the figure from its setting. Park's images, however, are less expressive in architectonic paint application than in color—mélanges of sour ochers, reds, greens, browns, and blues. His Kilroyesque cartoon drawing, especially of facial features in later paintings, distances us. As awkwardly forceful in figure painting as Lobdell is in AE, Park is not easy to like, and critical appreciation of his work (the best of which may be the Magic Marker drawings from his deathbed) seems more historical than esthetic.

Elmer Bischoff, a teacher at CSFA from 1946 to 1962, began his transition to figuration three years after Park, in 1953. An abstract painter of lesser stature than either Diebenkorn or Park, Bischoff is more at home with the figure, although he is far from being a narrative artist: "Ideally, one would wish to do away with all the tangible facts of things seen— of people, houses, paint on canvas, the rectangle of the canvas—and deal directly with the matter of feeling."[1] Bischoff's figures, like Park's, appear puffed, and kindly. His is the most pleasantly rococo brushwork in the Bay Area. Likewise, Bischoff's color is the prettiest (although he shares a predilection for slightly acid, chalky, landscapish hues), with deft traces of pink, glowing green, and orange mingled on the creamy surface.

Across the Bay in Oakland, the California College of Arts and Crafts had, by the fifties, earned a reputation as the Figurative school. One of its graduates, Nathan Oliviera, obliterated an illustrator-sharp drawing

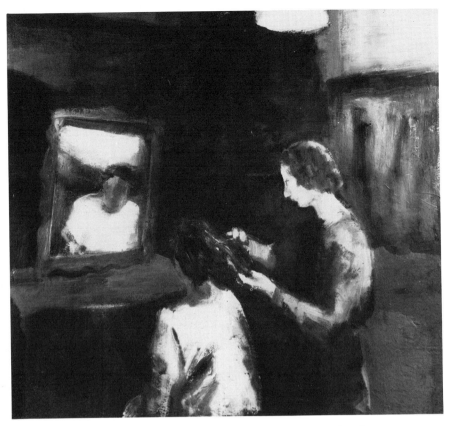

39. Elmer Bischoff, *Girl Getting Haircut*, 1962. Oil on canvas, 63 x 70 inches.

with brutalizing areas of vigorously applied paint, leaving fragments of profile, lettering, stars, and such exposed, hinting at meaning within; this narrative bent also distinguishes a Goyaesque body of Oliviera lithographs. Among the lesser painters who flocked to the conversion to the figure, which offered a fortuitous combination of academicism and license, were Charles Gill, Paul Wonner, who specialized in white garden furniture against brilliant green lawns, Walter Snelgrove, Roland Petersen, Robert Harvey, Robert Hartman, Boyd Allen, Al Barela, and, in Los Angeles, Roger Kuntz. But like any other critics' category, the Bay Area figurative school grows fuzzy at the edges; there's a question, for instance, whether semi-Pop painters like Wayne Thiebaud and pure Pop artists like Mel Ramos belong, *in extenso*, as do Photorealists like Robert Bechtle, a car-and-residence specialist, and Richard McLean, who went from Olivieraesques to prizewinning horses. Of the major practitioners, only Bischoff remains convincing within the style.

40. Nathan Oliviera, *Seated Figure with Pink Background*, 1960. Oil on canvas, 82 x 62 inches. Private collection.

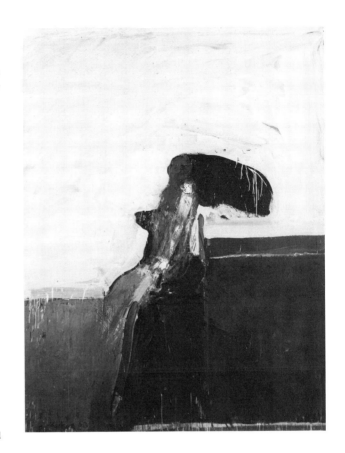

41. Paul Wonner, *On the River*, 1959. Oil on canvas. Private collection.

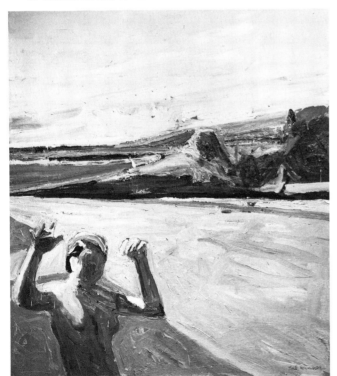

The most galvanic, animated interpreter of the figurative mode was the small, doe-eyed Neapolitan Rico Lebrun, the most persuasive teacher in Los Angeles during the late forties and early fifties, who carried, via his own romantic humanism, the influence of Surrealist painter and set designer Eugene Berman, who had visited before the war. Lebrun had come to the United States in 1924 and fashioned a career as a commercial artist in New York. In the thirties, his temperament drew him to the Art Students League and his material needs to the WPA; during this period, his drawings, based on linear contour, portrayed beggars resurrected from the streets of Naples. In 1938, Lebrun settled in Southern California. His drawing style changed abruptly, to somber, heavily shaded, tortured depictions of human forms (while he supported himself as a background artist for *Bambi* in the Disney studios). From 1947 to 1950 he painted crucifixions collectively reminiscent of Goya's *Disasters of War*, Rembrandt's bistre ink sketches, and Picasso's *Guernica*; the result was a Crucifixion exhibition at the County Museum, and a large panel donated to Syracuse University (*Ill. 42*). At the same time, he became a faculty member, and later director, of the Jepson Art Institute. The stylistic influence of Lebrun's drawings (his paintings, tonal though they are, remain outsized figure drawings), and his passionate, lyrical teaching is still active today in drawing faculties and in printmaking circles: the concern for human suffering, the overlays of wash and the bullwhip line, and persistent metaphors of peeling flesh, hollowed chest cavities, and skulls—all rendered with a clear eye for positive-negative crispness and velvety harmony of shapes. But Lebrun, for all his pretentiousness, was an artist on the grand scale. The *Genesis* murals at Pomona, though slick and eclectic, are powerful, and the illustrations for Dante's *Inferno*, if smacking of Beaux-Arts to tastes jaded by Pop, are nevertheless among the best traditional drawings executed in the later twentieth century.

Lebrun's style is unfortunately appropriable and seductive—"modern" in its veneer of Cubism and "traditional" in its virtuosity and patina of tragedy. The artists who studied Lebrun practiced a variety of figuration that formed the wide waistline of Los Angeles art through the fifties and early sixties. Howard Warshaw is the most faithful acolyte, using the standard *Guernica*-Lebrun formula of skulls, twisted animal shapes, chiaroscuro, and deft, academic line. John Paul Jones eschews the Baroque draftsmanship; his paintings are abstract, in that almost all of the surface is usually given over to a graduated, heavily worked, tonal field. But the central image is a ghostlike human apparition—such as a tall, long-gowned woman in profile—rife with allusion and mood. Joyce Treiman began in a Ben Shahn manner but gravitated toward less expressionistic figure painting, gaining steadily in verisimilitude,

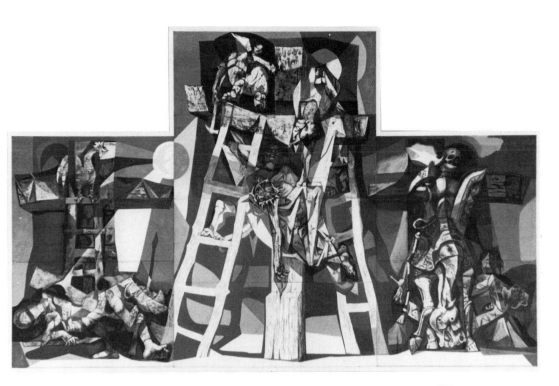

42. Rico Lebrun, *Crucifixion Triptych*, 1950. Oil
on board, 20 x 26 feet. Collection of Syra-
cuse University, Syracuse, New York.

43. Rico Lebrun, *The Accordian Player*, 1940.
Ink, 25 x 18 inches. Collection of the Los
Angeles County Museum of Art; gift of
Miss Bella Mabury.

44. Howard Warshaw, *Red Man*, 1967. Acrylic on paper, 60 x 36 inches. Private collection.

45. John Paul Jones, *Encounter*, 1964. Oil on canvas, 35 x 35 inches. Private collection.

46. Joyce Treiman, *Dear Friends*, 1972. Oil on canvas, 70 x 70 inches. Private collection.

anecdote, and subtlety. Charles White's drawings abide as strictly academic, with decorative touches of Cubism (refracted plane edges), and portray the heroism of the blacks. The Lebrun disciples—some closely tied, others loosely bound—are still legion: Joe Mugnani, Ernest Freed, Leonard Edmonson, Arnold Mesches, Morris Broderson, Keith Finch, and even, in a way, Connor Everts. Sculpture, too, was tied to conceptions of figurative humanism; Jack Zajac, for instance, a Prix de Rome winner as an abstract painter, converted to sculpture (e.g., the Easter Goat series—a roughly modeled, elongated, gracefully tormented sacrificial animal bronzed on a pole) when his appetite for expressive imagery went unsatisfied in paint.

Whereas Lebrun and his emulators in Los Angeles painted as though Abstract Expressionism was a six-month fad that would surely give way to their neo-Baroque and narratively humanist dressings-up, the Bay Area figure painters tried to domesticate it, to train it to support representation. For all their quality, however, Park and Bischoff produced merely extremely brushy figure paintings, without much hint of the structural virtues of AE; but one other painter did make the transition whole, and by doing so preempted a good deal of West Coast painting history in the fifties and sixties.

"To speak of West Coast painting is for many people, especially in New York, to speak primarily of Richard Diebenkorn."[2] Diebenkorn's preeminence is difficult to explain, at least formalistically: Is there a common denominator of conception or style beneath his apparent metamorphoses (from Bay Area AE to figuration, then back to a calmer, more elegant abstraction) that is deeper or profounder than his peers', or is his breadth (and maintenance of quality) itself the reason? He's never been a radical painter—advanced enough, however, to be "original." He's simply good; superb draftsmanship (loose, economical, and accurate) shores up the almost academic fineness of oil laid over a charcoal skeleton. His ideas are neither as scary as Still's nor as pugnacious as Park's—they are solid, workable armatures—and his scale, unlike Still's or Sam Francis's, is always moderate. At a time (mid-fifties) and place (West Coast) when radicalism was suspect, Diebenkorn was played up in the popular as well as the art press because he appeared to demonstrate that AE *could* be made reasonable —architectonic, figurative, and regional. Uncharacteristically, the popular judgment was right: Beneath his talent and scope, his brushwork and drawing, Diebenkorn is a *sensible* painter.

Educated at Stanford, Diebenkorn was stationed in Washington, D.C., during World War II, where he came into contact with the Phillips Collection, and Wolfgang Paalen's magazine, *Dyn*, which contained small

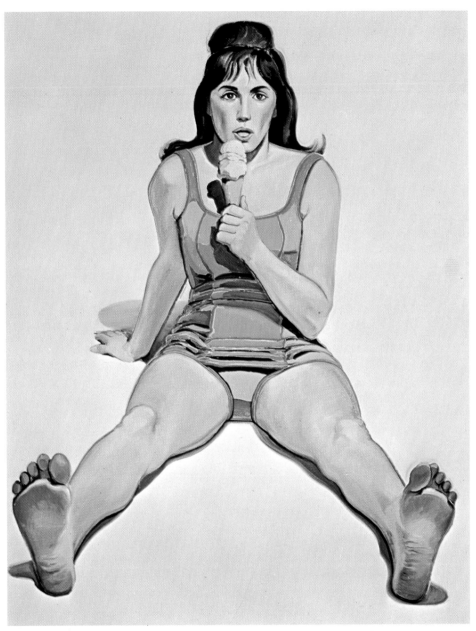

Colorplate 3. Wayne Thiebaud, *Girl with an Ice Cream Cone*, 1963.
Oil on canvas, 48 x 37 inches. Private collection.

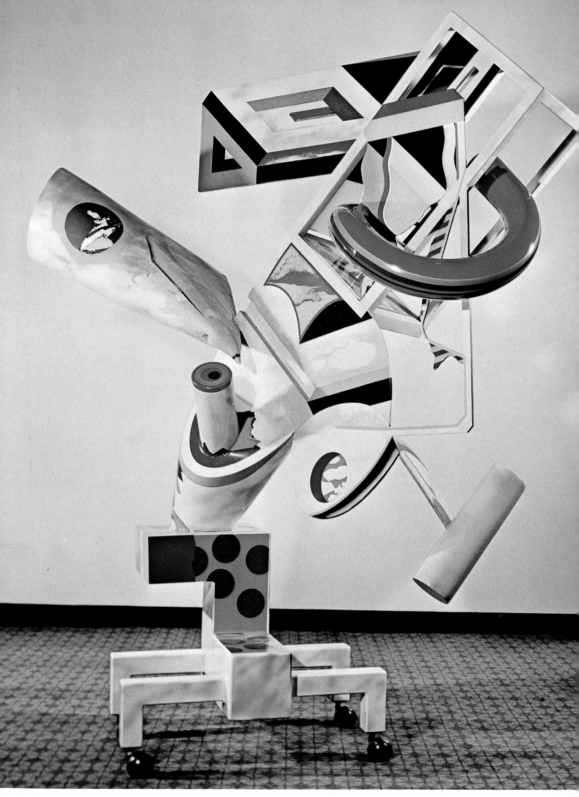

Colorplate 4. Robert Hudson, *Space Window*, 1966.
Steel, 69 x 60 x 57 inches. Private collection.

reproductions of early New York AE. On returning to San Francisco, he enrolled at CSFA and taught there the next year, one of the youngest faculty members and decidedly uneasy alongside his seniors. In 1951–52, Diebenkorn lived in New Mexico because a fellowship at the university enabled him to paint full time; after that, a year teaching in Illinois was an experience Diebenkorn found stultifying enough to force him to return to San Francisco. Diebenkorn's abstractions, e.g., the Berkeley series (*Ill. 18*), contain a heavy landscape implication—you look down from the hills at the gridded land and the bay. Diebenkorn's typical shapes—restful, near-rectangles, with "gutters" or roughly painted tapering stripes—lent themselves to the insertion of the figure. And, for all his paint-working, Diebenkorn was never a colorist like Hofmann, Rothko, or even Still (of whom he was only tangentially aware); his colors are essentially tonal, rooted in the California landscape.

In 1955, becalmed in AE at the height of its acceptance, Diebenkorn began to experiment, at the suggestion of his friend David Park, with figurative painting; his first effort was a casual, small, "messy" still life. Within the next two years, Diebenkorn developed his trademark style and the best synthesis of AE paint handling and figurative illusion of any of the Bay Area painters. Diebenkorn demands little outright precision from his figure drawing; though more articulated and "shapey" than Bischoff or Park, Diebenkorn's figures are still a little like paper cutouts, their shadow patterns cutting into their anatomies. In plain drawings, however, Diebenkorn is a master, making clear with minimal means the subtleties of construction and gesture. In the paintings, he preserves the combination of gesture and mood in which quality (in figure painting) resides—when the "relationship of figure and setting seem psychologically right."[3] The same ambivalence that eased his passage from AE to figure painting lives on in his work, and Diebenkorn pretends subject matter is still basically unessential (just as, on the other hand, he regards it as entirely permissible): "To abstract means to 'extract from,' or 'separate.' From this point of view, every artist is abstract, since he must create his own works, starting from his visual impression. That the approach is realist or subjective does not matter. It is the result that counts."[4] In the late sixties, Diebenkorn moved to Los Angeles and a studio in the Ocean Park section of Santa Monica, and embarked on a series of large, simple, lovingly painted abstractions (translucent surfaces on charcoal frameworks) derived from the landscape across the boulevard, toward the ocean. They comprise Diebenkorn's most mature work—his fullest and best, because psychological "rightness" arises directly from arrangement and color, from the sense of the neighborhood, without the intrusion of the specificness of the human figure—painted, significantly, after he

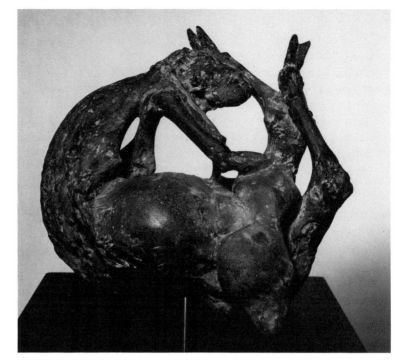

47. Jack Zajac, *Bound Goat*, 1957. Bronze, 28 inches long. Private collection.

48. Richard Diebenkorn, *Interior with View of the Ocean*, 1957. Oil on canvas, 49⅝ x 57¾ inches. The Phillips Collection, Washington, D.C.

discarded the Bay Area style for which he initially became famous.

Park, Bischoff, and Diebenkorn were still, in McLuhan terminology, "hot" painters—directly involved with the sincerity, directness, and improvisation of their art. It was perhaps inevitable that a "cooler" style (more distant and with less passionate handiwork and an almost anti-art subject matter) would evolve, the thick coat of paint the only tangible sign of an Abstract Expressionist heritage.

Wayne Thiebaud was included in several Pop exhibitions (*The New Realism* at the Janis Gallery in 1962, *Six More* at the L.A. County Museum in 1963, and *Pop Art U.S.A.* in Oakland the same year), and much of his

49. Richard Diebenkorn, *Ocean Park, No. 49*, 1969. Oil on canvas, 93 x 80 inches. Collection of the Los Angeles County Museum of Art; acquired from gifts provided by Paul Rosenberg and Co., Mrs. Lita H. Hazen, and the Estate of David E. Bright.

esthetic derives from commercial art. He drew one-line gag cartoons for the Air Force newspaper and worked as an illustrator in the late forties. But Thiebaud's fifties painting is close to Bay Area mainstream: an almost AE performance, domesticated into compartments by subject matter, the thick, vigorous paint application seeming slightly gratuitous, almost a filler for ordinary compositional ideas. Diebenkorn and Bischoff, facing the same problem, either backed off from subject matter or attempted awkward or illegible arrangements in order to keep the process difficult, spontaneous, and capable of causing the small figure-ground ambiguities crucial to painterly painting. Thiebaud looked for his solution in another direction: clarification. He sought out, un-camped, the "neglected" subject: "I try to find things to paint which I feel have

50. Mel Ramos, *Camilla, Queen of the Jungle*, 1963. Oil on canvas, 30 x 26 inches.

been overlooked. Maybe a lollipop tree has not seemed like a thing worth painting because of its banal references."[5]

Thiebaud's sixties paintings of pies, majorettes, hot dogs, gumball machines, and middle-class figures on creamy white backgrounds with a patented sandwich outline (one band of color overlaid with its complement) are focused, but residually painterly, pictures.

> Reinforcing . . . a configuration of color interfaces, in an effort to establish energy sources, the artist uses the technique of locating an object in a monochromatic ground removed of "things." The severe austerity of the ground plane, on a very simplistic level, concentrates attention and assists in clearly identifying the object, in a manner common to the general advertising media and some Pop art. However, in this particular case, the ground's function has been enriched. It serves as a "force-field" that is activated by continuous horizontal brushstrokes and eventually by an arbitrary reinsertion of "things."[6]

In the Thiebaud mold, Mel Ramos, originally a sign painter, is slicker, prettier, and Pop-oriented. Ramos began in 1962–63 with comic strip characters, moved on to combination stripper/jungle-queens, and finally satisfied himself with cheesecake.

> Ramos . . . connects the Renaissance with the art director, combining the labor of an honest craft (realistic figure painting), an accessible image (young, creamy, naked women of the sixties—long, straight hair, big boobs, pale nipples, no genitalia) and an audience expectation (for paintings which function at once as hip Pop, fine art, decoration, and polite eroticism). Ramos has got his Thiebaud-cum-Vargas thing down to a science; the solitary image, the outline-halation, the "imbedding" of the scumbled flesh into a raised background, and the arbitrary, illogical shadows anchoring the simple compositions.[7]

The West Coast is, in the seventies, once again, deprived of dialectics; the figurative stance soon lost its feistiness in a languid, unthreatened atmosphere. With the possible exceptions of Pop artists like Ed Ruscha, who made a time bomb of *trompe-l'oeil* (which the Photorealists then took dead seriously), and the straight painters who trundled along undeterred by short-run art history, the vitality of a contemporary figuration of either the left (Park, Diebenkorn, Bischoff) or the right (Lebrun, Warshaw), was short-lived.

6. Assemblage Line

Assemblage is the first home-grown California modern art. Its materials are the cast-off, broken, charred, weathered, water-damaged, lost, forgotten, fragmentary remains of everyday life: old furniture, snapshots, newspaper headlines, dolls, dishes, glassware, beads, clothing, books, tin cans, license plates, feathers, tar, electric cord, bellows, cameras, lace, playing cards, knobs, nails, and string—adhering not shiny and whole, but piecemeal and tarnished, as melancholic memorabilia, or Draculalike social comment. The taste for assemblage, however, predated the style:

> Repose and restraint, as a rule, are lacking in much of our older American sculpture, as some of our Market Street statuary testifies. It seems that our unsettled conditions find an echo in our art. It is much to be hoped that a certain craving for temporary excitement will be replaced by a wholesome appreciation of those more enduring qualities of taste and repose.[1]

Bernard Maybeck, the architect of the Palace of the Fine Arts for that 1915 fair in San Francisco, believed in mixed styles and polychrome stucco. William Randolph Hearst, one of Maybeck's clients, had San Simeon Castle built overlooking Morro Bay on the central California coast (*Ill. 52*), and if the architecture itself, a mélange of classical styles, is not assemblage, then the contents are (*objets-d'art* as thick as barnacles, with only the common denominators of preciousness and bombast to unite them). Of all the unconscious proto-assemblages, however, the towers at Watts, a black suburb of Los Angeles, are preeminent.

Beginning in 1921, an immigrant tilesetter named Simon Rodia, who had contracted patriotism during World War I and wanted to do

"something big" for his adopted country, persevered for thirty years—
after hours—with scrounged materials (broken pop bottles, teacup
handles, wire, tile fragments, and cement). He constructed a lacy
complex reaching up a hundred feet from a mosaic-walled, triangular
sliver of land near the railroad tracks (*Ill. 53*). In 1954, Rodia calmly
handed the deed to the property over to a neighbor and disappeared.
Three years later, the Department of Building and Safety condemned his
hommage, but a stress test with steel cable and winch (!) failed to budge
anything. Only a fierce preservation campaign, led by critic Jules
Langsner, saved the masterpiece of unschooled, native Art Nouveau.

The natural home of assemblage—its spirit more than physical form—
must be San Francisco, a wedding-cake fantasyland of tighty packed,
conglomerate esthetics: ocean, hills, mansions, row houses, neoclassic
granite, trolley tracks, folkisms, ethnic communities, and imported
"culture." Its randomness is the inspiration and its gentility the target.

Veterans of C.O. camps like the one in Waldport, Oregon, drifted
south after World War II and, tasting the elixir of the city, spinoffs of the
art ambience around the California School of Fine Arts, and jazz
musicians and poets, formed the kernel of what became popularized as
the Beat Generation (a term deriving from manifold implications: tired,
as in "beaten down," jazz rhythm, and, according to Jack Kerouac,
blessed, as in "beatific" and "beatitude"). The result was, in the eyes of
the beholders, by no means less than the previous triumph of New York
over Paris, of brawny, Whitmanesque Americana over gilded European
culture.

> There is no question but that the San Francisco Renaissance is radi-
> cally different from what is going on elsewhere. There are hand
> presses, poetry readings, young writers elsewhere—but nowhere
> else is there a whole younger generation culture pattern character-
> ized by total rejection of the official high-brow culture—where
> critics like John Crowe Ransom or Lionel Trilling, magazines like the
> *Kenyon, Hudson,* and *Partisan* reviews, are looked on as "The En-
> emy"—the other side of the barricades. There is only one trouble
> about the Renaissance in San Francisco. It is too far away from the
> literary market place. That, of course, is the reason why the Bohe-
> mian remnant, the avant-garde have migrated here.[2]

An equivalent feeling—although less concisely expressible—held sway
in the plastic arts. Abstract Expressionism had, by the fifties, become the
Hudson Review of the art world—progressive but respectable. The New
York Tenth Street painters had their eyes on uptown, on the blue-chip
wall spaces occupied by now expensive early moderns. In San
Francisco, the Still-Rothko esthetic at CSFA was, for all its integrity and

51. Goslinsky House, San Francisco, 1909. Bernard May-
beck, architect.

52. Bernard Maybeck, San Simeon (interior), 1919–51.
Julia Morgan, architectural supervisor.

53. Simon Rodia, Watts Towers, Los Angeles, 1921–54. Mixed media, approximately 100 feet high. Although Hearst's mansion and Rodia's towers seem almost to be esthetic antonyms—one, the central California pleasure palace of one of America's penultimate magnates, the other a humble patriotic gift of an immigrant manual laborer—there are striking similarities. Both were labors of obsessive love; both took about thirty years to reach their final stages; both were incomplete and/or uncompletable; both were the works of self-taught artists (although Hearst was properly untaught and had professional advice); and both were architectural assemblages on the grand scale.

purpose, intently concerned with the purity of (capital A) Art. The Beats wanted art which mixed with, if not street life itself, at least with a free flow of other arts, philosophies, and politics. Kenneth Rexroth, Kenneth Patchen, and Lawrence Ferlinghetti mixed with Allen Ginsberg, Kerouac, and Gary Snyder. Coffee shops, where poet-performers read aloud, painted on walls, discussed Jung, Zen, the *I Ching*, Kafka, the pleasures of pot and red wine, and a ramshackle Marxism caught between Old and New Lefts, eked out meager existences in North Beach, along with art galleries with names like The Monkey Building, Porpoise Book Shop, Black Cat Café, City Lights Book Shop, Miss Smith's Tea Room, and The Place (where a seminal show, *Common Art Accumulations*, was held in 1951). The culture heroes were blacks (then Negroes), jazz musicians, and the Spanish Civil War poets; for once in California there was an integration of art with avant-garde literature and music, through the rich social life of the streets, cafés, and lofts.

> One time the Rat Bastards and Dave Hazelwood and the poets decided to organize a parade through North Beach with banners and standards. It was totally unannounced, and all of a sudden there were about two hundred people walking down Grant Avenue and across Broadway. There was a poetry duel between Phillip Lamantia and some bullshit poet who had moved in from New York for about two months to take advantage of the publicity there was about North Beach. Phillip Lamantia came in and it was like a pseudo-ritualistic proclamation. His opposing poet was sitting in this coffee shop and there was a two-foot stack of all the stuff he was going to read. Phillip came in with one piece of paper and read his poem and then announced he had written it when he was fourteen years old. Then he turned and walked out. That was the end of the duel. The opposing poet, who had challenged him, was totally deflated. The shows were just Happenings, too. We'd put things in the street just to see what would happen to them.[3]

Kerouac gives a fictionalized account, in *The Dharma Bums*, of a main event, Ginsberg reading *Howl* at the Six Gallery in 1955—everybody loaded, Ginsberg cheered on like a fighter, the excoriation in the *Chronicle*, and Ginsberg's tender letter of rebuttal. A visceral contrast to the academicism of most "little magazine" material, the resuscitation of the "oral" tradition of poetry succeeded only partially, and the combination of poetry with painting or with jazz failed to coalesce as anything but an experiment. The plastic arts of the Beats amounted to very little—Keith Sazenbach, a painter of mandalas, their only decent formal artist.

The diametrically different Still-Rothko esthetic at CSFA floundered, in part because Still's followers were understandably given to imitating the superficial appearance of his art, mostly his paint application. Clay Spohn

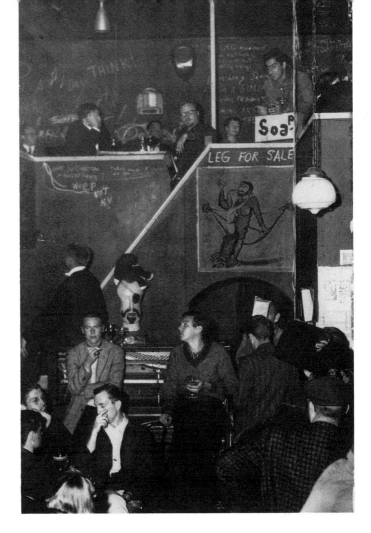

54. Beat poetry reading at "The Place" bar, San Francisco, ca. 1958.

was an alternative, bringing a kind of Dada to the scene (with the sometime collaboration of Hassel Smith), with his display *Museum of Unknown and Little-Known Objects* (*Ill. 55*).

Two of the first assemblagists proper are exceptions proving the rule: Wallace Berman, who, while laboring in a "period" furniture factory in the late forties, made naïve, Surrealist-overtoned drawings of pop culture heroes, and Wally Hedrick, an Otis Art Institute student who migrated north in 1952. At CSFA Hedrick reacted against the residual abstract painting with its "high art" look, and began to paint thick, garish pictures like *Peace Flag* (1958), which emulated the juvenilely fancy lettering of Hedrick's idol, Von Dutch Holland, a Los Angeles hot-rod "striper." The early, aggressive, anti-art quality of Hedrick's work brings to mind Andy Warhol's later, indifferently stretched/stapled "bad" silkscreen paintings; and Hedrick's *Anger* is probably the earliest protest

55. Clay Spohn, *Museum of Unknown and Little-Known Objects,* 1949. Installation photo, California School of Fine Arts, San Francisco.

56. Wallace Berman, *Panel,* 1949–57. Mixed media, 66 x 24 inches. Destroyed.

against intervention in Vietnam (*Ill. 57*). Always an off-and-on artist, Hedrick never regained the clunky fervor of his early work: "No one ever likes the painting that I'm working on. I like this because this means that the things I'm thinking about in my head are still mine (i.e., no one has ever thought of them before)."[4]

Bruce Conner came to California in 1957, a member of the Wichita Group, which included playwright Michael McClure ("The Beard") and publisher of the Rat Bastard poets, Dave Hazelwood. Encouraged by Jay de Feo, Conner experimented with conglomerations he called "funk" and went on to the death-wish collages—hideously embalmed combinations of old lace, black surface, cobwebby nylon, and doll fragments—which reflect the "semipornographic, aberrated sexuality of society."[5] In 1960, by which time his assemblages had become prettified by a printmaker's taste, his house of horrors perfumed, Conner turned to a logical extension of assemblage, film. *A Movie*, with splices of peepshow footage, *Cosmic Ray*, and *Report*, with its haunting repeated images of film leader and the Oswald assassination rifle hoisted high over a crowd of reporters, are among the most important underground films of the sixties (*Ill. 59*). Berman's major inventions, too, were refinements of assemblage: the Verifax collages of 1965–66, made on an old machine bequeathed by a friend.

The preemptive, grand-scale assemblagist is Edward Kienholz, major domo of the late fifties Los Angeles art scene. Raised on a ranch on the Washington-Idaho border, where he picked up basic skills in carpentry, plumbing, electricity, etc., Kienholz at various times worked in a hospital, managed a dance band, ran a bootleg club, sold vacuums, opened a restaurant (The Black Boris), presided over a foreign-car agency, and put up liquor store window displays. He arrived in Los Angeles in 1953, opened the Now Gallery and Syndell Studios in 1956, and cofounded the Ferus Gallery in 1957. Before 1960, Kienholz's work progressed from paintings poured from incompatible chemical bases and proto-assemblages (when he couldn't afford thick paint surfaces, he slapped on boards and painted *them*) of 1954–55, to *The Little Rock Incident* (1958), the first painting with a full, attached object (a deer's head), and *John Doe* and *Jane Doe*, his first freestanding objects (*Ills. 61, 62*). In the early sixties, Kienholz constructed his major tableaux— semienvironmental sculptures of room-size proportions, exhuming social evils (backstreet abortions, brutalization of mental patients, materialist Christmases, and the hypocrisy of a Nevada brothel) with the surgical incision and moral outrage of a true muckraker. It is, in fact, this moral passion which sets Kienholz apart from other assemblagists: "His mind can't think for him past the present moment, he is committed there for the

57. Wally Hedrick, *Anger*, 1957. Oil on canvas, 64 x 66 inches. Private collection.

58. Bruce Conner, *Couch*, 1963, and *Tick-Tock-Jelly-Clock Cosmotron*, 1961. Mixed media, 32 x 70¾ x 27 inches and 57½ x 53 inches. Collection of the Pasadena Art Museum, Pasadena, California; purchase.

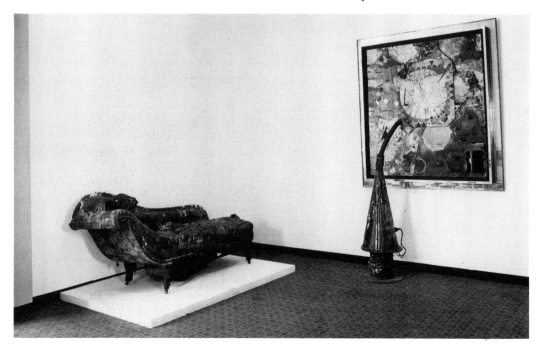

59. Bruce Conner, stills from *A Movie* and *Cosmic Ray*, 1964.

60. Wallace Berman, *Untitled*, 1966. Verifax collage. Private collection.

rest of his life."[6] To Kienholz, each item in the extended assemblage is a totality. "Each piece is related to all the others . . . parts from one will show up in another; a total thing like a toy or piece of furniture will be taken apart and then those various parts will be used here and there, and they are all related. . . . I am interested in an environment."[7] *Roxy's Tableau* is a "complete" reconstruction of a World War II Las Vegas whorehouse. The madam, a cowskull-headed, leering monstrosity, presides over resident doxies (mangled mannequins with withered legs and innards of peanuts), amidst a cheap color reproduction of General MacArthur, faded rugs, and a round-top radio console (*Ill. 63*).

Barney's Beanery (1965), an overpublicized kettle of assemblage, Pop, and *art brut*, is another "complete," theatrical rendition of a (then) L.A. artists' hangout. Since then, Kienholz has drifted toward the Conceptual; in 1967 he conducted the notorious "trade" show, in which nearly identical watercolors (differing only in the stenciled nomination of barter) were traded for one buck, up to a washing machine, up to a Cadillac. Lately, all he has produced are specifications (on paper or plaques) for tableaux yet to be realized.

Kienholz's case is at once curious and illustrative. His almost naïve moralism, his patchwork, untheoretical method, and the outright, complex junkiness of his "look" are anathema to a New York mainstream; in Europe he's long been *the* Western American artist, but he's had only one New York show (Iolas Gallery, 1963). And that fact bears an argument for the existence of a regionalist art that is fully capable of international acceptance, that is fully capable of operating outside the lineal leapfrog of Europe-to-New-York styles, and yet of adding to them.

61. Edward Kienholz, *John Doe*, 1958–59. Mixed media. Private collection.

62. Edward Kienholz, *Jane Doe*, 1958–59. Mixed media. Private collection.

63. Edward Kienholz, *The Madam*, section of *Roxy's Tableau*, 1963. Mixed media. Private collection.

Kienholz was a "hot" artist in cool times, a hound of subject matter in reasoned abstraction's time, and a preacher in professors' times. Assemblage, at least Kienholz's, necessarily fails to acknowledge New York.

In 1957, George Herms created an "assemblage-environment" in Hermosa Beach (a small seaside town outside Los Angeles, noted for jazz clubs and coffee houses—a kind of North Beach South). A year later Herms moved to a canal shack in Larkspur, then back to Topanga Canyon (Greenwich Village in a ravine), and then to isolation near Malibu in a "totally permissive environment" called Tap City Circus. Herms is the first *real* hippy artist; where Conner's work is a fluoroscope of bestiality and futility, Herms's assemblages offer hope—expressed in his ubiquitous motto, "Art is Love is God"—affected but sincere Cornellian expressions of cosmic influence and astrological kindness, as in the *Zodiac* boxes. Herms's esthetic is like the more gentle, prevalent

assemblage of artists like John Bernhardt, Ben Talbert, and, later, Shirley Pettibone, Fred Mason, and even Dennis Hopper.

Assemblage, in the end, is non-Duchampian anti-art; that is, it does not deal intellectually with what is or is not art, or with deliberate subversion of the bourgeoise production-distribution system of salable art objects. Created with whatever means the artist has at hand in an urban world of consumer goods, trash, violence and poetry, assemblage statements range from Herms's pantheistic meditations, through the cool, neutral horror of Bruce Conner, to the anguish of Kienholz's *State Hospital* (*Ill. 65*). Its only direct offspring was sculpture loosely gathered under the label "Funk" in a 1967 show at the University Art Museum in Berkeley, but Funk there meant the eclectic, raucous painted metal sculpture of Robert Hudson (and others)—a prettier, more highly crafted object, without the soulful cries of the original. Assemblage, nevertheless, is the

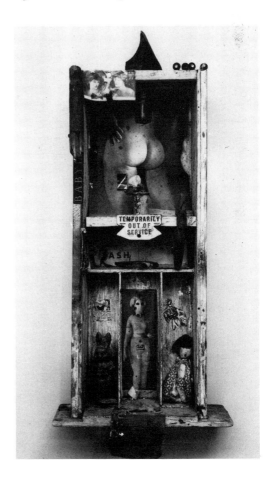

64. George Herms, *Babylon Box*, 1961. Mixed media, 33 x 13½ x 6¼ inches. Private collection.

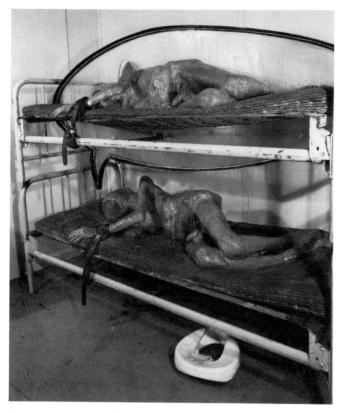

65. Edward Kienholz, *The State Hospital*, 1966.
Mixed media, 8 x 12 x 10 feet. Collection of
the Moderna Museet, Stockholm.

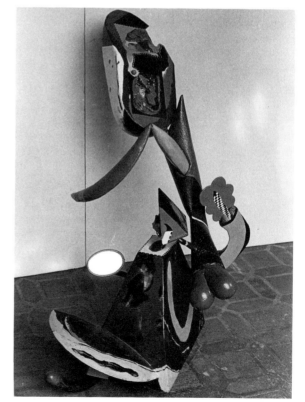

66. Robert Hudson, *Untitled*, 1963. Mixed media.
Private collection.

most intense manifestation of the former of two currents of West Coast art extant today—the "dirties" and the "cleans."

Funk, in 1967, was historically late, having appeared in jazz circles ("bagless funk") after World War II, and the term implies an improvisation, looseness, and difference antithetical to Hudson's fussy, albeit complex, sculpture, which was really the result of Hudson's having outstripped, as a student, the standard technical virtuosities. The most strictly Funk are the ceramicists around Robert Arneson, who delight in the squeeze of frozen, deadpan clay renderings of simple, surreal, and often jokey ideas: James Melchert (who had worked with Peter Voulkos), William Geis, Clayton Bailey, and David Gilhooly. Arneson has shown toilets, self-portraits in *trompe-l'oeil*, brick, glazed dirty dinner dishes, and dirty jokes like *Call Me Lover* (1963), a ceramic telephone whose receiver is a penis-and-testicles and whose dial surrounds a vagina. Funk like Hudson's and Arneson's is fed also a bit on New York anti-estheticism—the "bad" brightness of Lichtenstein and Warhol—as well as on a Northern California predilection for frivolous puns, sexual allusions, and nose-thumbing. Joan Brown's almost premature success within the Bay Area figurative style finally transformed her painting into a primitive Funk. It's at this point, however, that Bay Area art becomes eclectically cosmopolitan once more.

The bridge between the generation and Adaline Kent, one of San Francisco's first modern sculptors, and assemblage/Funk was Jeremy Anderson, a G.I. Bill student at CSFA during the halcyon days of 1946–50. Anderson, too, was weaned from Still's seriousness by Clay Spohn, Hassel Smith, and the medieval armor in local museums. Anderson's late forties work reveals the presence of the surrealism common to Still and Park, and, as he evolves toward bulbous and linear forms, industrial materials, and polychrome—i.e., Funk—Anderson is the touchstone for Bay Area sculpture. Harold Paris's work, on the other hand, is a mechanically ambitious oscillation between environments— ceramic walls, black rooms with "souls," long rubber pathways with "profound" inscriptions—and the attentive preciousness of small objects, "souls," encapsulated in lighted boxes. Relentlessly literary, Paris is more indicative of travel and Beaux-Arts than a Funk's gritty liveliness. Manuel Neri is the most problematic of the Bay Area sculptors because of his attachment to figure painting. Neri studied with Bischoff and Park at CSFA in 1956 and practiced ceramics with Peter Voulkos. During 1959–60, he constructed a group of rectangular wall-hangings related to the human torso, which "were only slightly related to the figure, and were in effect nonobjective paintings in which one questioned the shape to arrive, with difficulty, at the source. This approach acted as a brake on

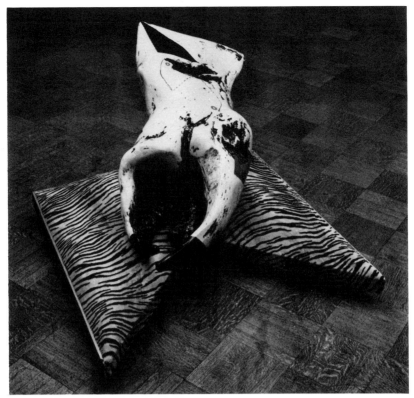

67. William Geis, *Tensor II*, 1966. Mixed media, 5 x 4 x 3½ feet. Private collection.

68. Robert Arneson, *Dirty Dishes*, 1971. Ceramic, 6 x 20 x 9 inches.

69. Joan Brown, *Reindeer Painting*, 1966. Oil on canvas, 42 x 84 inches. Private collection.

70. Jeremy Anderson, *Gunboat 28*, 1961. Wood, 19 x 34 x 7⅞ inches. Private collection.

71. Jeremy Anderson, *Riverrun*, 1965. Wood and enamel, 55 x 79½ x 17½ inches. Collection of the University Art Museum, Berkeley, California.

72. Manuel Neri, *Loops, No. 2*, 1961. Ceramic, 21 x 18½ inches. Private collection.

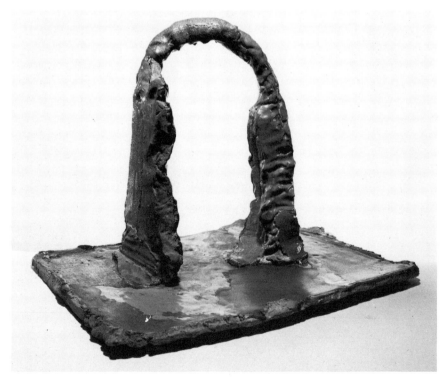

73. Jess Collins, *Tricky Cad*, 1953–59.
Newspaper collage, 19 x 7 inches.
Collection of the Los Angeles
County Museum of Art; gift of Mr.
and Mrs. Bruce Conner.

the painting in plaster itself, and these fragments remained just that, and less interesting than the complete figures."[8]

With little metamorphosis, Pop can turn to Funk, and vice versa; thus, in some Bay Area art vulgar subjects, even fragments of advertising art, are grafted together without the acceptance/worship of banality characteristic of New York and Los Angeles Pop. (The Bay Area, after all, is less suited to an indigenous Pop art than Southern California, which has the perhaps considerable, perhaps dubious, advantage of Hollywood.) Jess Collins, primarily a poet, made seven comicstrip collages entitled *Tricky Cad*, between 1953 and 1959 (*Ill. 73*). Derived from *Dick Tracy*, they combined panel fragments and disjointed and misplaced dialogue balloons in intricate semicoherence: "One surprisingly curmudgeony Fraternity Sunday in 1953 Tricky Cad scrambled out of Chester Gould's *Dick Tracy*, afterwards to concentrate (undertaking eight cases) in demon-stration of the hermetic critique lockt up in Art, here Popular. Also here was a bad case of sincerest-form-of-flattery; later, not amusing to the originator."[9]

The late sixties saw an ongoing psychic disengagement with notions of intellectual art, science, and industrial progress. A hipshot Pop surrealism developed, its roots in the drug culture and protest movements, where residual intimations of Beatnik subculture were still felt. The acid rock esthetic of Haight-Ashbury brought with it a "psychedelic" revival of Art Nouveau in rock concert posters, and the folklore of the counterculture (drugs, narks, busts, ripoffs, and the seamier, poorer urban life) created a comicbook movement with such artists as Victor Moscoso, S. Clay Wilson, Robert Crumb ("Keep on Truckin' "), and Texas emigré Gilbert Shelton, creator of *Wonder Wart-Hog* and the *Freak Brothers*. San Francisco, in a sense, acquired a sister city, Chicago, which had its own non-mainstream, the "monster" school of Ivan Albright-to-Leon Golub. Jim Nutt and Gladys Nilsson (The Hairy Who) and Peter Saul, a painter of super-grotesque Day-Glo editorial cartoons, practiced in both places. San Francisco, or so San Franciscans think, is like New York in its compactness and sophistication; Los Angeles, of course, is supposed to have neither. But Los Angeles art, as we shall see, at least acknowledges New York art issues, while the Bay Area goes its own way. Ultimately, assemblage is the product of a Bay Area bric-a-brac sensibility, although its single major manifestations—historical (the Watts Towers) and current (Kienholz)—are in the south. If the spirit of assemblage lives, it's indirectly, in the catharsis of Process and performance art. Meanwhile the "cleans"—those formalists forever trying to hone art down to a few, refined, elegant essentials—have held the day.

7. Plain Ol' Painting

During the fifties, between Rico Lebrun and the Ferus cohesion, abstract painting in Los Angeles—other than Hard Edge—was practiced by a number of disparate artists. Hans Burkhardt, a Swiss who had associated with Arshile Gorky in New York before coming to Los Angeles in 1937, painted in a thickly coated, expressionist, Cubist-derived style. Lee Mullican was involved, with Wolfgang Paalen and Gordon Onslow-Ford, in a late forties esthetic of cosmological abstraction (energy in the air, etc.) called Dynaton; his own work was characterized by thousands of inch-long vertical impasto paint lines stitched into Indian-like zigzag patterns. Emerson Woelffer, who painted his first abstract picture, *Day is Orange,* in 1950 after a year in the Yucatan, was educated at the Art Institute of Chicago and by an interest in "Chicago style" jazz. A characteristic half-apple shape marked his painting until the early sixties. James Jarvaise was included in the Museum of Modern Art's *Sixteen Americans* show (1959), with Johns, Rauschenberg, and Stella, when he painted the shapey, facile Hudson River series.

But the most important event—for L.A. painting, ultimately—was Peter Voulkos's arrival in 1954 and establishment of a ceramics workshop at Otis Art Institute. In four years, Voulkos and his students managed the redoubtable feat of removing the craft of ceramics to the province of sculpture by overcoming a dependence on the potter's wheel, by slab-building, denting, cracking, and only partially glazing—in short, by creating a Southern California Abstract Expressionist ceramics. The cups and vases, in turn, founded a more lighthearted, deft, and clean AE esthetic that carried over into painting through artists like Billy Al Bengston, who began at the Otis kiln and later returned to painting. Voulkos, a painter with experience as an apprentice molder, experimented with the use of hollow, thrown cylinders as armatures for more complex ceramic sculpture. Voulkos's pupils from 1954 to 1958

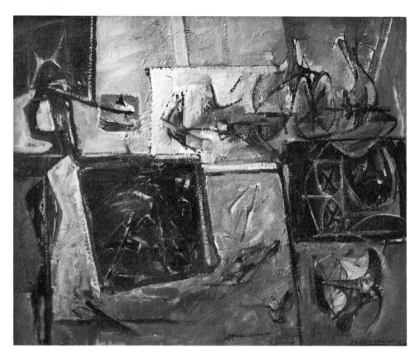

74. Hans Burkhardt, *Composition,* 1953. Oil on canvas, 38 x 50. Private collection.

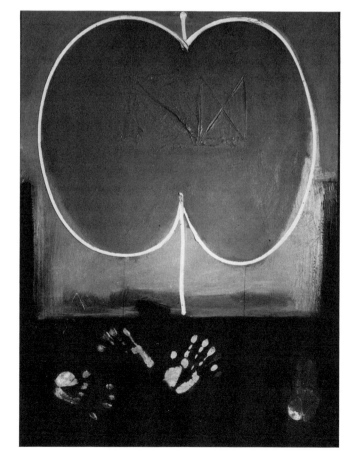

75. Emerson Woelffer, *Artist's Hands and Blue Mirror,* 1962. Oil on canvas, 54 x 38 inches. Private collection.

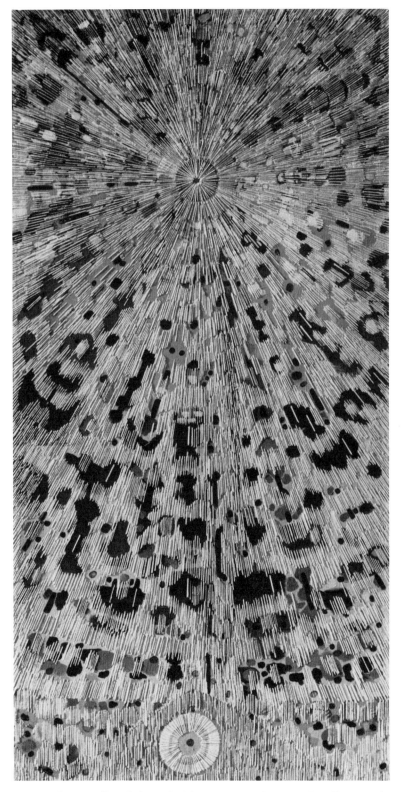

76. Lee Mullican, *Ninnekah*, 1951. Oil on canvas, 50 x 24 inches. Private collection.

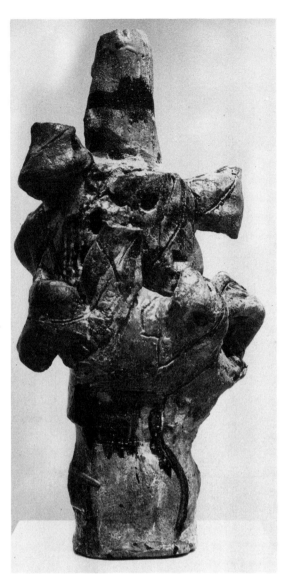

77. Peter Voulkos, *Pot*, 1959. Ceramic, 26 inches high. Private collection.

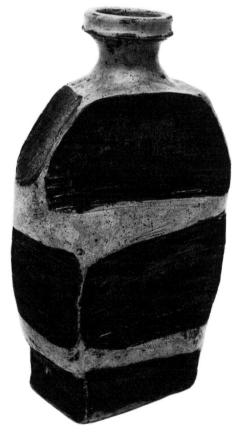

78. Malcolm McLain, *Pot*, 1957. Ceramic, 15 inches high. Private collection.

included Malcolm McLain, Michael Frimkess, Ron Nagle, Bengston, and Kenneth Price (the latter two were to derive their tastes for small, elegantly crafted *objets-d'art*—an important element of the L.A. Look of the sixties—to Voulkos's virtuosity as a "straight" potter). Voulkos encouraged squeezing, scoring, collapsing, and the use of glazes that bubbled and cracked, in two directions: craft into sculpture, and expressionism into craft. With the departure of Price (to sculpture), Bengston (to painting), and Voulkos himself to more ambitious sculpture, the project expired in 1957–58.

In 1959 Voulkos left for Berkeley to work in metal, founding the Garbanzo Iron Works, the "most cooperative, confused, most productive, most slapstick do-it-yourself foundry on record."[1] Eventually, the foundry included forty people, including Robert Hudson and Manuel Neri, as often as not in each other's way, pouring, cracking molds, finishing, and assembling. Voulkos's own best work resulted from a transfer from clay to bronze as a finish material. The ragged, expressionist volumes and edges of works like *Honk* (*Ill. 80*) and *Remington* gave way to the "clean" bronzes of 1964–65—combinations of table slabs, supporting columns, solid tubing, and nodules of burnished metal—acrobatic defiances of weight and adhesion. But Voulkos's reputation as the West Coast's major sculptor is at least equaled in importance by his influence as a teacher at both Otis and Berkeley.

Of the Voulkos associates, John Mason—although he was not an "out of the cylinder" orthodox potter like Voulkos—stayed with ceramic sculpture. Out of the anticraft craft of the early AE cups and bowls, Mason developed a spectacular ceramic technology, moving into architectural commissions (whole ceramic doors), and edging toward Minimalism with massive cruciform and rectangular sculptures. Mason's totemic, weighty sculpture, spatially inert but utilizing an active (glazed) surface of color and reflection, is the purest expressions of the 1954–58 thrust at the Otis kiln.

It was Ferus, however, that sustained important Abstract Expressionist painting in Los Angeles. The central artist was John Altoon, who returned to Los Angeles in 1955 after four years as a commercial artist in New York. A gestural painter in the firm grip of an imported sensibility, he developed, in 1958–59, an art of biomorphic shapes against a less heavy-handed background. With a drawing talent no less than magical and a palette as pastel as de Kooning's, Altoon created the best body of painterly painting to come out of Los Angeles. His friend, Bengston, said:

> It has always been my contention that John Altoon is one of the most underrated living artists and that [this] painting in [the] exhibition [*Late Fifties at the Ferus*, Los Angeles County Museum, 1968],

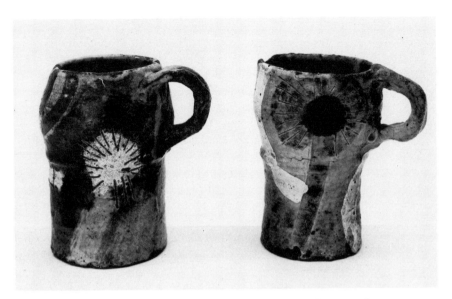

79. Billy Al Bengston, *Cups,* 1957. Ceramic, 4 inches high. Private collection.

80. Peter Voulkos, *Honk,* 1962. Bronze, 96 x 48 x 36 inches. Private collection.

Colorplate 5. Sam Francis, *Untitled*, 1973.
Acrylic, 10 x 8 feet.

Colorplate 6. Ron Davis, Zodiac, 1969.
Resin on fiberglass, 60 ½ x 136 inches.
Private collection.

81. John Mason, *Vase*, 1957. Ceramic, 12
inches high. Private collection.

82. John Mason, *Cross Form*, 1966. Ceramic,
64 x 54 x 25 inches. Collection of The
Oakland Museum, Oakland, California.

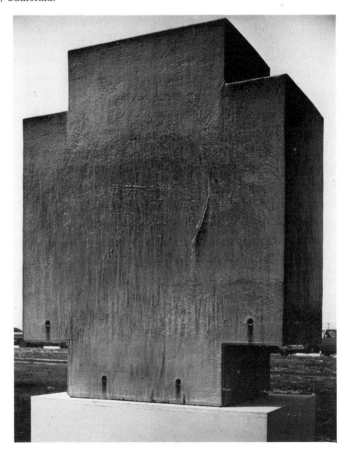

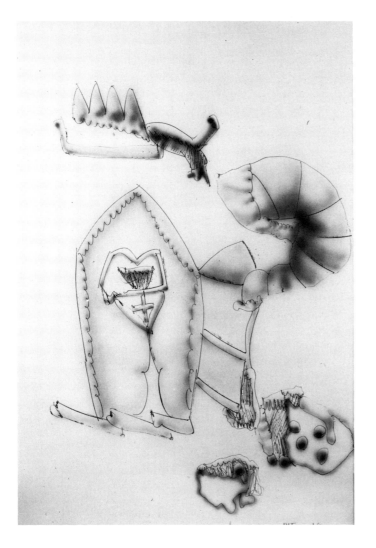

83. John Altoon, *Untitled*, 1966.
Mixed media, 60 x 40 inches.
Private collection.

84. John Altoon, *Untitled*, 1968.
Mixed media, 30 x 40 inches.
Private collection.

which could be any one of hundreds he painted at the time, stands as a monument to the idea that one man's unique personal vision is greater than the importance of fashions in art or mainstream type philosophy.[2]

Craig Kauffman's Ferus-period pictures are Abstract Expressionist but contain the first evidence of a Los Angeles sensibility: *Tell Tale Heart* (1958) is structured superficially along the lines of a second-generation New York painting, but it reveals the original stem-and-bulb shapes Kauffman was to later translate into plexiglass. The "clean" Abstract Expressionist work of Craig Kauffman could be the point at which Los Angeles art decided to live on its own life-terms, instead of those handed down from Paris, New York, or even San Francisco.

> A blockbuster and still right on [*Tell Tale Heart*], Kauffman was the first Southern California artist ever to paint an original painting. His paintings of 1957–58 proved we had to wash our hands, throw away our dirty pants and become artists. Prior to these works every Southern California artist in the Ferus gallery was suffering from a bad case of Northern California sensibility—probably bred out of a misunderstanding of the paintings of de Kooning, Kline, and Gorky.[3]

Altoon's and Kauffman's paintings, although gestural (i.e., a kind of action painting), are moderately sized, even intimate; the first California painter to approximate the sweep and scale of Still and Robert Motherwell was Sam Francis. But Francis is an anomaly: an American artist whose work and public acceptance were—at least in the beginning—as much Parisian as American; a Northern California painter whose "feel" is—if local at all—Southern Californian (airy, oceanic, pretty). He is also considered the third member of a West Coast postwar triumvirate of "major" arists, with Tobey and Diebenkorn.

Francis served in the Air Force during World War II and, while supinely recuperating in a military hospital, took up painting watercolors as occupational therapy; he recalls the clouds above his stretcher as a germinal influence. Francis studied with David Park after the war, making his first abstract painting in 1947. Three years later he obtained a master's degree from Berkeley and headed for Paris (Lobdell met him there in 1951—a particle of explanation for the elegance of Lobdell's later paintings), the city of Stanley Hayter's Atelier 17, the etching workshop of artfully soaring boomerang shapes and cosmic, ropy lines. A continuously prolific painter (he did over 500 paintings and drawings between 1960 and 1965), Francis's work has traversed discernible periods. His use of thicker oils in high-key, grayish color in sausagy strokes played against edge elements in pre–1953 paintings gave way to

the "classic" pictures—runny stains of primary and secondary colors in delicately balanced conglomerates on large white grounds—of 1954–57 (after his return to California). From 1958 to 1960, refined red-white-and-blue prevailed, and the inside shapes were gracefully tapered and grouped together in poetic "continents." The later pictures in the latter period flirt heavily with the edges, attenuating California AE into virtual emptiness. These paintings of carefully calibrated whites barely contain the flying combos within the picture plane. For his health, Francis moved to Santa Monica in 1962, and in 1966 made a further leap to the edge: Almost totally white paintings are fenced by skinny slivers of liquid primaries. Most recently, however, Francis has recycled, bringing colored bands back across the girth of his canvases.

Francis resembles Jackson Pollock, but his crisp, lyrical *tâchisme* is closer to the work of such other Abstract Expressionists as James Brooks and Bradley Walker Tomlin, or even the super-chic of the French painter Georges Mathieu. His style, however, is very much his own; Francis is a decorative painter like Matisse, and a draftsman with the facility of a Tiepolo.

Of the three major West Coast esthetics—those of Tobey-Graves, Bay Area abstract and neo-figurative painting, and the L.A. Look,[4] Bay Area painting has been the most sensitive to styles elsewhere (particularly, New York Abstract Expressionism). The middle sixties, however, saw New York painting caught on a pair of horns: the Greenbergian tendency to involve itself with only those qualities peculiar to itself (e.g., flatness, color, the shape relations of the content and the contour of the ground), and a growing suspicion that, relative to sculpture, painting had played itself out, that almost everything possible had been done with liquid pigments on a flat surface, and, more important, any future inventions would be strictly hermetic and anticlimactic. In Southern California, the finely finished glamor of L.A. Look objects made it difficult for new painting to compete in terms of "presence" or visual impact; in the north, painting suffered from the feeling that, because of Bay Area artists' returns and rereturns (e.g., Diebenkorn's *traversement* from AE to figure painting and back to abstraction), painting was in a cyclical rut. For many, the ready solution was "color" painting.

Since about 1963, he [David Simpson] has been aware of others working along similar lines but feels their direction leads to different conclusions. He does, however, align himself with the predominant attitude of the sixties, particularly in the sense that color is a distinct contribution to form and that in this sense the whole range of color and form possibilities are necessarily to be used. Here, optical over-image and after-image, color, harmonics, tonal gradations,

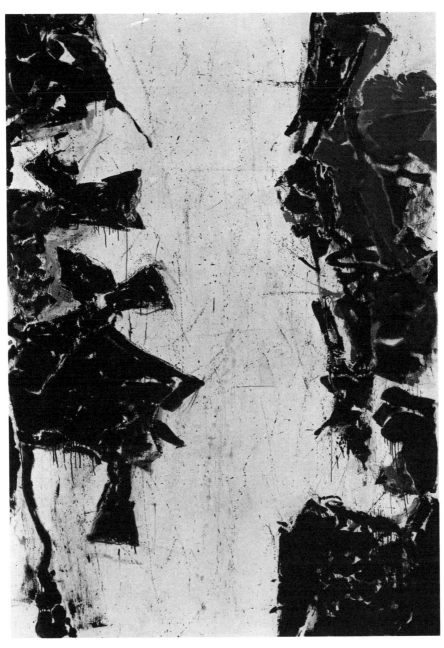

85. Sam Francis, *Untitled*, 1958. Oil on canvas, 108 x 75¼ inches. Collection of the Pasadena Art Museum, Pasadena, California.

86. David Simpson, *Rainbow Bounce*, 1965–66. Copolymer, 54 x 54 inches. Private collection.

spatial illusions, symmetry and asymmetry are all vital to the processes of painting and are part of the subject. He feels that drawing now is just as important as it ever was though the particulars of intention may have altered. Like so many of those working today he feels that the painting is its own content and all that leads into associative meanings outside the painting must be removed to display the concrete substance of the work itself. He claims no more for a painting than that all of its parts add up to an ordered, specifically controlled sensory whole, matching an inner need for expression in a universal language, a personal totality for which one can use the much feared word, beauty.[5]

Such statements reflect a desire to refine painting further, to tame through studious formalism, and the artists who pursue it are legion, north and south. Characteristic are Jack Carrigg's uniform vertical

stripes, Keith Boyle's simple fields, accented by sharp shapes and brushy edges, Sam Tchakalian's conversion of AE into thick fields, Paul Brach's closely low-chroma color combinations, Miriam Schapiro's perspectival illusions of geometric solids, Neil Williams's pale stripes on shaped grounds, and, among recent works, Joel Bass's "overlapping" rectangles, Guy Williams's thousandfold stenciled color bars, and James de France's canvases with cut rectangular holes (the backs are painted with bright color so that mysterious glows appear in the vacancies).

Ron Davis, however, managed to take the precepts of formalism and wring from them a kind of painting that, almost alone in the mid-sixties, had the electricity of early action painting, without being its rehash. That Davis studied engineering is apparent in his early works as a "vibe painter" (West Coast for "Op"—that is, for "optical" for visual trickery), and his 1965 monochromatic, semisculptural shaped canvases; but these paintings were way-stations in the development of Davis's eventual thesis: that full-chroma color could be integrated into a fully expressionist abstract painting. Only Hans Hofmann, in New York, had painted AE

87. Keith Boyle, *Flyin' Home,* 1964. Acrylic resin on canvas, 71 x 74½ inches.

88. Miriam Schapiro, *Keyhole*, 1970–71. Acrylic on canvas, 72 x 108 inches.

89. Joel Bass, *000128*, 1971. Synthetic lacquer on canvas, 56 x 87 inches. Private collection.

90. Ron Davis, *Two and Fro*, 1964. Acrylic on canvas, 72 x 72 inches. Private collection.

pictures whose Cubist-derived compositions were optically locked by color. Davis worked as a researcher on the issue of whether color and arrangement in abstract painting could be fused by any means other than the Hofmann solution. His pictures were at first more mechanically inventive than pictorially original: shaped formats contoured as illusions of geometric solids seen in emphatic perspective, painted like a shop-window decoration on the back of layers of clear resin on a reinforced Fiberglas plane. This device enabled Davis to control expressionist splatters by working within the illusion of a geometric solid—the physical shape of the whole painting. Also, he could stabilize any color in any area, providing the work with breathtaking resonance.

91. Edward Moses, *Untitled*, 1958. Oil on canvas.

92. Edward Moses, *Culver Tract A, Sec. 2*, 1973–74. Mixed media, 84 x 72 inches.

Ed Moses provided another opening for formalism: extending the idea
or feeling of painting to *au naturel* canvases, unstretched and coated
on the back with resin, hung softly on the wall. Whereas Davis
intensified the inherent geometry and convention of the rigid wall object,
Moses emphasized painting's relative nonphysicality, its looseness,
casualness, and subtlety. One of the first Ferus exhibitors, Moses
remarked, "I didn't make it in L.A. right off because I didn't 'fit.' When
everybody else was doing these fetish objects, and the L.A. thing was
starting to boom, here I was doing those goddamned valentines."[6] (The

93. Tom Holland, *Dead Lizard,* 1962. Oil on canvas, 80 x 65 inches. Collection of the San Francisco Art Institute.

94. Tom Holland, *Selvey,* 1973. Epoxy on fiberglass, 7 x 11 feet.

"valentines" are small, cut-out, pop-up drawings and collages from the early sixties.) Moses first (in the late fifties) experimented with eccentric-line, off-hand, Kauffmanesque painted bulbs. Like his contemporaries Bengston, Altoon, and Kauffman, Moses wanted to mitigate the seriousness of the local AE style, but for Moses the step was not away from painterly handiwork (as it was for Kauffman, with his plastic pieces), or painterly ritual (as it was with Bengston).

The sixties was largely a period in Moses's work of unrelenting drawings of a highly private nature. The vocabulary was meticulously limited to contours and cut-outs of either a flower or one of several simple, but evocative, map-like shapes. Most entailed an essentially codified use of lines of various thickness or interruptions. The drawings seem to alternate, and sometimes combine, what appears to be a single-minded striving toward an idealized perfect product, and an equally determined concentration on a repetitious pencil mark, as first seen in the flower cut-outs of 1963. The ultimate form of the latter are the overall drawings comprised solely of equal, regulated short marks. The dominant element in these drawings is the visual evidence of the time/process of actually putting the marks on the paper. Since the central image is removed, it is the process that is seen to be of primary importance.[7]

95. Allan McCollum, *Enjambment*, 1971. Mixed media, 138 x 180 inches. Private collection.

Moses's intensity and integrity (at times he wondered about whether to paint at all) wasn't rewarded until there was a swing back from the coolness of the L.A. Look and New York Minimalism; in 1969, Moses developed the "soft" painting in which he employed his longtime repeated horizontal-line motif in snap-line, bleeding colors, and with an elegant tension between visual and visceral properties.

Tom Holland worked toward the same ends from another direction. Holland's early paintings were overwhelmed by the residue of a year in Chile on a Fulbright grant—surreally brown, thick, textured, with crude alligators and airplanes—and the aura of Bay Area Funk. In the late sixties, Holland began to paint more elegant pictures on an "ugly" premise—layered, grommeted abstractions on flat sheets of Fiberglas— at first with sculptural, looping bands on painted plastic, and later with more domesticated, refined, collage layers. Like Davis, his combination of object and painting is resolved in favor of painting as opposed to Process art, but without the illusory solids; his "drip" is not a compositional element, but homogeneous surface activation. Both Davis and Holland relate to mainstream modernist painting in their attempt, through conscious "violations" of the picture plane, to continue the Impressionism-Abstract Expressionism linkage.

Younger painters, more affected by Process and Concept art (and the corollary doubts about the viability of any art object), nevertheless operate with a painting tradition in mind: Carlos Villa's billowy spray paintings metamorphose into actual cloaks festooned with feathers and glass, and Allan McCollum, Tom Wudl, Patrick Hogan, and Jack Barth produce Moses-esque "soft" surfaces. The trouble with current West Coast painting is reflected in these hybrids: A solution to the problems of painting—its dependence, as with most "object art," on economically privileged connoisseurship, stultification through over-used forms, and persistently homemaker-level technology—lies all too readily in turning painting into non-painting, so easy to do, given New York's tradition of austere radicality, which, even today, acts as conscience to its younger artists.

8. The L.A. Look

Prewar Southern California produced little important art, and the main gain was the hard-won beginning of modern art's cultural acceptance; Lorser Feitelson was the prepossessing personality. The Georgian son of an art teacher, he arrived in Los Angeles in 1927, having seen the Armory Show first hand, and disseminated an appreciation of European moderns. Together with the student who became his wife, Helen Lundeberg, he precipitated a group of Postsurrealists (Surrealism plus geometric stylization), and later moved on to a purer geometric abstraction—the Magical Space Forms of the forties. But Feitelson's teaching, and his spokesmanship for Functionists West (an alignment of abstract painters) in the fifties, were as influential as his own work. Lundeberg continued within Surrealism and retained an intimation of the shadow arches, beckoning doorways, and melancholy landscapes in even the simplest of her later paintings.

Feitelson remained the senior statesman for all of modernism and his own seemingly isolated abstraction; it wasn't until the *Four Abstract Classicists* (Feitelson, John McLaughlin, Frederick Hammersley, and Karl Benjamin) show at the Los Angeles County Museum in 1959 that the beginning of a rich, albeit cool, vein of Los Angeles art—from geometric abstraction, to the meditative transparent/translucent surfaces of the L.A. Look, to post- Art-and-Technology environments—was formally unearthed. The show traveled to London, gave the area's best critic, Jules Langsner, a chance to originate the term "Hard Edge,"[1] and provided Los Angeles with its first claim to international success as a modern art center. Feitelson's Space Forms were by then designy, and the mainstay of the exhibition was John McLaughlin, an unobtrusively powerful painter of "bland, circumspect authority."[2] The quality in McLaughlin's work is difficult to specify, and it's tempting to attribute it to his seniority (he was born in 1898), his regimen (he paints seven

96. Lorser Feitelson, *Untitled*, 1967. Acrylic on canvas, 60 x 60 inches. Private collection.

hours a day, seven days a week), his knowledge and appreciation of
Oriental art, or his adherence to modest formats, austere configurations,
and a homely paint application hardly deserving the term of Hard Edge.
His work relies, in the end, on a subtle benevolence. "I could get into
the pictures [Oriental paintings] and they made me wonder who I was.
Western painters on the other hand, tried to tell me who they were."[3]

McLaughlin, who turned to painting full-time in 1946 after serving as a
military intelligence officer, was the least seductive and most intellectual
of the group, working from compositional notes and chancing only the
color. McLaughlin's paintings have always demanded visual acuity,
without which the viewer will fail to detect his processes of purging and
purification. Karl Benjamin's pictures are composed of small, jagged,
active pieces seemingly lifted from an endless pattern, and Hammersley,

a survivor of the very ungeometric Chouinard and Jepson schools, composed on "hunch," commencing his pictures as Abstract Expressionist and evolving them slowly to a frozen form.

Four Abstract Classicists reveals, in retrospect, not merely four senior moderns who reduced their painting to precise, flat profundities, but a current of sensibility in the esthetic climate of Los Angeles—just as the early assemblages pointed up a maniacal (or horrifying) California appetite for conglomerates. Hard Edge arose out of Los Angeles's desert air, youthful cleanliness, spatial expanse, architectural tradition (of *almost nothing* previous to Gill, Neutra, Schindler and Ellwood), and,

97. Karl Benjamin, *Black, Gray, Umber, Red,* 1958. Oil on canvas, 62 x 42 inches. Collection of the San Francisco Museum of Art.

most vaguely and most importantly, out of optimism, which (unlike the mood of the world around Malevitch, Mondrian, or Albers) said this, too, will suffice as art because the eye and mind require no other pleasure. If *Four Abstract Classicists* was not an earthshaking revelation (Hard Edge painting per se in Los Angeles has been acutely minor ever since), it illustrated, even symbolized, the quiet, spiritual refinement creeping up on the artists, especially some of the Ferus group.

Just as there was no New York School, however, there was no L.A. Look. The latter term refers generically to cool, semitechnological, industrially pretty art made in and around Los Angeles in the sixties by Larry Bell, Craig Kauffman, Ed Ruscha, Billy Al Bengston, Kenneth Price, John McCracken, Peter Alexander, DeWain Valentine, Robert Irwin, and Joe Goode, among others. The patented "look" was elegance and simplicity, and the mythical material was plastic, including polyester resin, which has several attractions: permanence (indoors), an aura of difficulty and technical expertise, and a preciousness (when polished) rivaling bronze or marble. It has, in short, the aroma of Los Angeles in the sixties—newness, postcard sunset color, and intimations of aerospace profundity. By 1968–69, the chemical smell of resin and a frozen drop

98. John McLaughlin, *No. 12*, 1961. Oil on canvas, 42 x 60 inches.

99. Craig Kauffman, *Violet-Yellow*, 1965. Acrylic on Plexiglas, 47¾ x 36 inches. Private collection.

at the nozzle of a 55–gallon drum were as familiar Beaux-Arts studio decor as splattered floors and turpentine.

In 1957, Craig Kauffman's painting slid toward Hard Edge, his "erotic thermometers" (buried in the AE paintings) outlining themselves in silhouette. Kaufmann's Plexiglas paintings developed from the "thermometers"—to rippled wall pieces with a painted electric-blue border line—to lozenge-shaped, bulging pieces sweetly spray-painted from the back in verily immoral color combinations (magenta/yellow, orange/blue)—to more sophisticated, almost smooth pearlescent

super-peanuts—to transparent, gradually tinted, hanging, hooked sheets of Plexiglas—to (in retrograde) linear wall pieces closely resembling "straight" painting in their use of directional, vacuum-formed lines and rear-painted painterliness. Plastic drastically changes the nature of pictorial space and relationships. Although visually deep, plastic objects are reflective, making it difficult to "place" color in a painterly depth. Reflective surfaces animate with the viewer's changing position. Moreover, its industrial anonymity raises the specter of artist-as-idea-man originated by mid-sixties Minimalists and carried to the fringes by Conceptual artists. Kauffman's plastic paintings—together with Larry Bell's boxes, Alexander's and Valentine's castings, Bengston's lacquered aluminum paintings, Price's colored "pod" ceramics—are an offshoot of the readily and unashamedly perfumy *objet-d'art*. Southern California sunsets, neon, flowers, ocean, desert landscapes, and wide boulevards sifted their ways into the subconsciousnesses (or consciousnesses) of Los Angeles artists. If it wasn't necessary to be a loft-rat to be an artist, then it certainly wasn't necessary to employ "tough" composition, "heroic" scale, or "off" color to make good modern art. And Los Angeles artists had already developed a liking for small, finely honed objects. "If the studio were on fire," Bengston said, "I'd grab my cups first."[4]

Peter Alexander started casting resin in 1964 in small volumes (the pieces are a little over a foot on a side), but with the added fillip of striations (from casting in separate layers) and residual landscape overtones (illustrative "clouds"—white puffs of impurities or air bubbles), derived from his architectural renderings—a not uncommon L.A. artist proto-skill. In 1969, Alexander's squat pyramids elongated into standing, straight-backed wedges; the change embodies the two phases of the L.A. Look. Elegant, solid objects become optical phenomena (seen frontally against a white wall, the wedges "disappear" near the top and gradually coalesce into "existence" toward the base). Alexander's sculpture has by now dematerialized into ethereal "painting" with thin plastic bars.

DeWain Valentine came to Los Angeles from Colorado in 1965, bringing an oeuvre in resin. Valentine, taken by Bengston's "tight surface" and the esthetics of California's car culture (kandy-apple paint jobs and "Baroque" sculpture of customized automobiles), made oddly coupled, erotic volumes of Fiberglas metallically sprayed in lush chromatic gradations. Returning to resin, Valentine, unlike Alexander, emphasized physical mass—in cast rings, truncated wedges, and large, convex, purplish discs (which established him as the technician *par excellence* in the material, casting two-ton jewels of weight and light).

But it was Larry Bell who stood, in the mid-sixties, as *the* embodiment

100. Peter Alexander, *Untitled*, 1969.
Resin, 96 x 8 x 8 inches. Private
collection.

123 · *The L.A. Look*

101. DeWain Valentine, *3-Silver*, 1966. Fiberglass-**reinforced** polyester, 54 **x 78 x** 54 inches. Private collection.

102. DeWain Valentine, *Circle*, 1970. Resin, 70 inches in diameter. Private collection.

of the L.A. Look, both in its initial phase and as it developed. He was the youngest and last of the Ferus stable (first show, 1962) who had made his debut in, succinctly enough, *War Babies* at the Huysman Gallery. From there, his work underwent several specific transformations symptomatic of the whole metamorphosis of Los Angeles art in the decade:

1) Simple, "shaped canvas" paintings, like *Little Orphan Annie*, 1962. Bell dices off the corners of the physical canvas, with resultant intimations of an isometric box, then fills the "inside" of the painting with flip-flopped, depicted images of the same shape. More important than their coinciding with, or predating other shaped can-recitation of the 2-D versus 3-D problem which has, in other ways, occupied for years artists like Ron Davis, Richard Smith [the English vases, is their early concern with a straight, powerful, contradictory painter], and Frank Stella.

2) Paintings with glass, like *Conrad Hawk*, 1963, in which the "distinct separation between the viewer and the objects begins to break down as the viewer's image is subtly reflected by the glass and becomes a visual element of the piece." [Barbara Haskell]

3) Cubes—mirrored, with thick chrome edges and almost heavy-handed graphic surface compositions, using the "illusions" of iso-metric cubes and ellipses, stripes and checkerboards, like *House, Part II*, 1963.

4) Cubes—"clear" (the glass rhodium-coated with electrons of faint, halating rainbow color, or more accurately, a chemical which bends the traversing light to such effects), thinner-edged and carefully deployed (atop a plexiglass pedestal low enough so that shape is retained and high enough to avoid the look of a decorative furniture accessory).... These cubes were begun in 1964 and continued to 1967–68; Bell's own vacuum machine enabled him to jump to a couple of feet on a side. More emphatically than the mirrored boxes, these cubes reach out and suck the surroundings in through an ambivalent space (enclosed because of the hard glass sides, open because of transparency), and return them (through reflections) to the viewer.

5) Cubes—direct, unadorned, glass-to-glass edges, darker, "uniform" coating, and slightly larger size, ca. 1968–69.

6) The walls—variable configurations of standing, perpendicular, "lifesize" sheets of thick, darkly coated glass, ranging gradually through degrees of reflectivity. Bell at once boasts and confesses that this total process (materials and basic juxtapositions) will, given a little handling, "work almost anywhere," in almost any configuration; but this ease is due as much to Bell's now valuing complete subjectivity and flux as it is to the inherent glamor of the demi-object.[5]

Formal Minimal sculpture was contagious in Southern California, whose taste for simple, regular, geometric solids in flat, straightforward

103. Larry Bell, *Untitled,* ca. 1966. Chrome, steel, and glass, 36-inch cube. Private collection.

104. Larry Bell, *Untitled,* 1971. Glass, 8 feet high. Installation photo, Walker Art Center, Minneapolis.

colors (or none at all) emanated not from the dialects of short-term art history (as in New York), but from a physical demography dating more or less from World War II. Los Angeles's urban landscape consists of functional (or dreary), economical (or cheap) stucco boxes, and big-building architectural ornament of stainless steel, neon, and plastic (instead of granite, marble, or bronze). New York Minimalism was openly polemic (e.g., inert, white plywood fabrications hostilely consuming most of the space usually granted to spectators, its un-art finish in aggressive testimony to the ultimately conceptual residence of its quality within the *plan* of the work). In Southern California, Minimal sculpture could be more innocent, but also less final; whatever fining down was done, was only a stopping point on the path toward ethereal phenomenology (Bell's glass walls), and not an irreducible definition of the art object as the unbreakable gestalt of a regular solid. Lloyd Hamrol, for instance, was influenced by both H. C. Westermann, the Chicago folk-Dada sculptor, and Hard Edge painting, his early work assuming the form of brightly colored, Hard Edge icons of concentric, progressively deepened wooden reliefs. In 1966, Hamrol showed a series of coated plywood blocks that could be variously dispersed, then folded and stored. John McCracken's work is even simpler (flat, hollow, plywood planks coated with resin and spray-painted with countless coats of high-gloss lacquer, leaned in dead-man stance against the wall). Tony De Lap's 1966 "modular" sculpture employed a macrostructure of related shapes (where Bell simply let the image of one box—serial Minimalism—insinuate itself on a successor, De Lap employed the "identical" pragmatically—endless combinations of the bent S module). DeLap, however, is better known for his layered icons featuring an eerie craftsmanship. Minimalism in California either dissolved itself in *further* reduction or attenuated itself, via serialization, into idea-as-art.

In 1967 the Los Angeles County Museum chose to mount a vast, premature survey of *American Sculpture of the Sixties*. The show was conceived at the height of the Minimal episode and the L.A. Look. Taken together, the two styles constituted a break with the "relational" aspect (of one volume or plane balanced against another), so that most previous sculpture seemed to allude to people or trees. The new sculpture, theory-fed by such books as George Kubler's *The Shape of Time* and Morse Peckham's *Man's Rage for Chaos*, advocated use of a wide range of twentieth-century materials and techniques, with a craftsmanlike finish—but with an austere physical integrity (truth to materials) to speed up the "visual scan" (the way one's eyes reveal the work to the brain) so that the work impresses itself, as indelibly as possible, on the viewer as a perceptual gestalt. Even discounting the natural function of museum extravaganzas to act as tombstones for the

105. Lloyd Hamrol, *Five by Nine*, 1966. Formica on wood, 6 x 30 x 30 inches. Private collection.

106. John McCracken, *Untitled*, 1968. *Mixed media*, 120 x 22 x 2½ inches. Private collection.

107. Tony DeLap, *Ka.*, 1965. Mixed media, 60 x 96 x 13 inches. Private collection.

very art they celebrate, the direct influence of *Sculpture of the Sixties* on local artists was temporary. Judy Chicago (the first of several women to adopt pseudo-geographical surnames as Feminist gestures), had shown her large canvas-covered plywood constructions, *Sunset Squares*, in 1965, and, by the time she participated in the County's conglomerate, was well on her way toward the super-unfinished look of Process (eventually returning to painting by 1970). Of the younger sculptors, only the Dill brothers (Laddie and Guy) managed to conserve a romantic Minimalism in object sculpture (segmented neon tubes and sheet glass inserted upright into mounds of sand by the former, and glass, sheet metal, cable, turnbuckles, straps, and rope by the latter).

Near the end of the decade, the L.A. Look began to realize its metaphysical (the great white light of Zen, the quiet peak of a good trip, or simple serenity) and scientific (sensory deprivation, inundation,

108. Judy Chicago, *Ten Part Cylinder*, 1966–67. Fiberglass, 8 x 20 x 20 feet. Private collection. Installation photo, Los Angeles County Museum of Art.

Ganz fields, and anechoic chambers) implications; what had started as a milieu of mass-production methods, plastic, sunshine, and affluence, attained the velocity of an esthetic philosophy. The seminal figure is Robert Irwin, originally an AE painter in the Ferus group, who participated, as it turned out, in all Los Angeles's postwar styles: He studied at the Lebrun-oriented Jepson Institute in 1948–50, and spent another year at relatively conservative Otis and two more in expressionism at Chouinard. Irwin bases his real progress from the 1961 monochrome line paintings (widely separated horizontal bars in masked-off impasto). The evolution—reflecting a drive against the

inherent paradoxes in paintings-as-objects (Irwin refused to allow the specificity of his work to be compromised by photographs and reproductions) via constant reduction and perceptual subtlety—continued in 1965–66 in rectangular but concave canvas panels of faintly colored dots, which, from eight feet away, halate optically. In 1968, Irwin's paintings took the form of white convex discs (tinted quasi-imperceptibly pink and green near the circumference), mounted on cylindrical sleeves and lighted from four corner lamps (two floor, two ceiling) casting petal-like shadows on the wall behind. These discs and a subsequent set on frosted Plexiglas with transparent stripes across the middle, represent a jump from the single object to environments (disc plus wall plus shadows). Irwin has since reduced his art to pure space and light in subtle, but convincing, interior architectural space arrangements altered by the placement of nylon "scrim," glass wall, and fluorescent light. Irwin's theorizing—incalculably influential on whole troupes of younger

109. Robert Irwin, *Untitled*, 1961–62. Oil on canvas, 60 x 60 inches. Private collection.

artists—expands art even beyond liberation from the object into simple, personal deeds, yea, attitudes (entering a "situation" like a college or museum or gallery, and "reacting," that is, doing anything from holding court with the audience to undertaking a collaborative building/research project). What separates Irwin from others entering that bailiwick from opposite directions (theater, dance, ephemeral sculpture) is his reverence for intellect, his guiding everything back toward thinking itself.

> A lot of times people have talked to me or made certain statements that I had something to do with "less is more" in a negative sense. Actually less is the sum total of more; you're really at some point eliminating those things that are arbitrary, no longer really worthwhile dealing with. So sometimes less is the means to more. And that is a matter that goes to our definition of a state of consciousness. If you define your reality with a particular system then it's constructed and it is housed by that system. The very ability to form and communicate thought must with a little perspective be seen as a system with definable strengths and weaknesses; but for that it is necessary to have a system capable of restructuring thoughts. It is precisely here that the question of change must begin."

A younger artist, Jim Turrell, made a similar quantum leap with "paintings" of near-rectangular formations of projected light, closest yet to the "floating color" Rothko and Jules Olitski had sought. After his exhibition (at Pasadena in 1967), Turrell "retired" into teaching and private work (in an entirely sealed chamber in his studio). He surfaced in the 1971 *Art and Technology* exhibition, freethinking about alpha-conditioning and the groundings of perception bordering on a scientistic metaphysics. (Turrell eventually resigned from the Los Angeles collaboration—with Irwin and a scientist, Edward Wortz—and produced no physical work, but he had indicated the redefinition of the artist's role in postindustrial society: a perceptual engineer differing from his scientific brethren only in his intuitive approach to studying/producing controlled phenomena.)

> All of this [Art and Technology research] is very Pavlovian. You're not really asking much of the person, or yourself. And all you can watch are the surface responses. People were often going through a dance with you. . . . Then [the Art and Technology project] began to change, and move into sensory interaction, where the senses influence one another. And then into alpha-conditioning, which is sort of taking a Pavlovian approach to spirituality. It has no end. . . .
> Our culture is going through a strange time—looking at Eastern thought—their work with meditation; their sense of the body and mind and soul. We're approaching it through psychology. We're very physical. When we want to go into the universe, we can't look at a rock, like the Japanese. We have to actually go to the moon.

We're so literal. We totally ignore the Eastern way. There are actually meditative sciences, or sciences of the soul. We have devices, sensors, alpha-conditioning machines. The machines are just manifested thought. Technology isn't anything outside us. . . . We just go about it very clumsily and very wastefully. Because we have to actually *make* all those devices, we have to go to the moon, we can't see the cosmos in a rock, and we can't meditate without having this thing (the alpha-wave-inducing equipment) strapped on us.[7]

Michael Asher, another of Turrell's generation and inclination, was a radically anti-object artist from the start, his work taking the form of blown-air chambers as graduate student stuff, and subsequently refining itself to calculated vacant interior architecture exuding a passive inaccessibility.

Asher's focal difficulty as an accessible artist is his insistence-by-default on Art; he has no repertoire of art-history dialectics, like the post-Minimalists, no RAND-y researcher's points to prove, like Irwin, no neo-Duchampian head fakes, like Nauman, and no super-decorative *tours de force*, like Bell. Asher's art is like a gentler, more expansive Ad Reinhardt's, without the withering, reinforcing dogma; but he shares the attitude of art-as-art and refuses to dress his pieces up with theory. The work is the work, alluding to nothing but itself. "What is it you're after?" is the question I inserted, in slight variations, during two lengthy conversations, hoping for a convenient quote from *Scientific American* on optic nerves, a discourse on Bell's failings with glass, or a scathing denunciation of the salable object. But the closest I came was his answer to a suggested affinity with "performance pieces": "I guess I'm just too serious for that." As Asher's work leaves off an inch short of didactics (the walls [of the L.A. County Museum's *Twenty-Four Young Artists show*] have no boobytrap dispersements; the Museum of Modern Art space was not cutely empty à la Yves Klein; and the "air works" were unnervingly low-key), his methods retain the ambivalence which has always maintained the artist's high ground between elevated decoration and dilettante science. Asher regards himself as somewhat cerebral, leaving little to chance in the final project, but his research consists of informal conversations with tradesmen rather than library time; he counts contiguity of surface and interior unobtrusiveness as esthetic necessities, but dislikes the labor his pieces force him to do. From an a-technological stance, he assumes, "Anything can be done."

What Asher attempts is an old-fashioned esthetic cohesiveness in a total situation, a real time (uninterrupted by events or things) through a deceptively simple "balance of lighting" and "uniformity of surface," while increasingly and hopefully expunging the last traces of "illusionism"—for Asher, present in any kind of inherently effect-getting colored surface or play of light. Pursuing these Augean

110. Jim Turrell, *Afrum*, 1967. Projected light. Installation photo, Pasadena Art Museum, Pasadena, California.

111. Michael Asher, *Untitled*, 1972. Mixed media, 7¾ x 32 x 13 feet. Private collection.

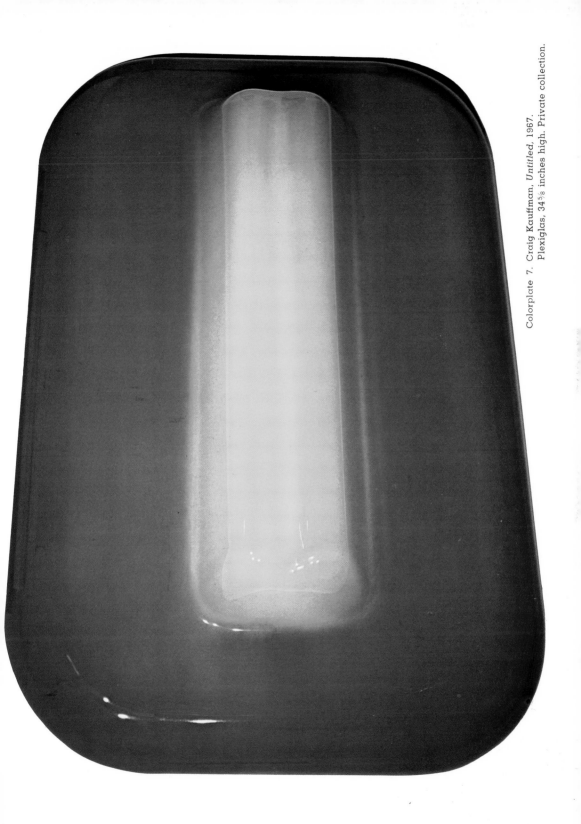

Colorplate 7. Craig Kauffman, *Untitled*, 1967. Plexiglas, 34⅝ inches high. Private collection.

112. Connie Zehr, *The Crossing*, 1971. Mixed media, 24 x 34 feet. Private collection.

goals, his work has utilized conspiculously nonvisual (tactile, auditory) sense combinations with the visual—trying to get an is-ness of space itself (what Robert Morris called "an art of being"), and now, for a proposed work (an empty room painted half black and half white), reverting to the visual alone.[8]

Unless art becomes a collaborative, nonattributable enterprise—as is indeed the implication of Irwin's thinking and of Jack Burnham's *The Structure of Art*, which maintains that the sudden, radical change in art's nature/function is premonition of a major change in the nature of humanity itself—positions like Asher's and Turrell's are preemptive, leaving little room for work in the same vein. They stand as barriers of absolute clarity before such makers of semiplastic objects as Ron Cooper (whose shimmering, shallow boxes deny physicality) and Doug Wheeler (who incorporated neon to dematerialize his), or the "environmentalists" —Tom Eatherton, who uses nylon scrim and cool back-lighting to alter interior space, Maria Nordman, whose devises pure, bare Ganz-like rooms, and Eric Orr, whose low-light environments require optical "decompression" before one enters the atmosphere of blue-white

Colorplate 8. Bruce Nauman, *Green Light Corridor*, 1971.
 Mixed media. Private collection.

graininess. And as this non-physicality grew from Los Angeles's geographical/architectural/cultural climate, it has created its own pervasiveness; Irwin, Asher, Turrell by no means practice a hermeticism, and the net effect of their work is a tingle of doubt surrounding practically every art object produced in Southern California—as if every piece had to justify its slimmest mass in terms of material economy and psychological effect. Work like David Deutsch's rotating plywood sheets, Mary Corse's white-on-white ground-glass paintings, Charles Arnoldi's fey twig configurations, and Connie Zehr's smoothly dispersed sand-egg dioramas are under the gun of ethereality. This final (perhaps) attenuation of the L.A. Look is, at the moment, the equivalent of New York "toughness"—the standard by which most serious new art is measured and it is, to date, the most important contribution of West Coast art.

9. Vox Pop

On the West Coast, and this is especially true for the fluid Southern California scene, Pop art has rightly been considered the active ingredient in a general housecleaning that during the past three or four years has all but exterminated the last traces of prestige for local and imitative versions of Abstract Expressionism, for second-generation Bay Area figurative, and for stillborn, Lebrun-Mexican-Expressionism; in other words, it has functioned most significantly as a transitional art, an opening wedge.[1]

The question, at least for Southern California, is not so much whether the area was/is ripe for Pop, but whether the whole ambience—from show business to aircraft industry to the Gobi of suburbia—is not preemptively Pop in itself. The inventory is practically endless: used-car lots, hamburger stands, tacky apartment houses, freeways, billboards, press-agentry, Hawaiian shirts and Bermuda shorts, supermarkets, parking lots, teenagers and so on. How then, could an artists' Pop art get going, and, what tone would it take? Just as there's nothing *too* French about a cathedral or meadow to keep a French painter from painting it, there was nothing *too* vulgar or banal about Los Angeles to prevent it from becoming a Pop subject. But sustaining Pop art in a region too grotesque to satirize is another matter, and California Pop differs from the New York/London brand in its ease, mildness, subtlety, and benevolence. Los Angeles has almost no cultural tradition—particularly no modernist tradition—to overthrow. In that city there's not much sense to paintings which, like Andy Warhol's or Roy Lichtenstein's early work, lampoon or simply ridicule the Beaux-Arts preciousness of action painting—or in sculptures that are blatant, unmodified blow-ups of ubiquitous commercial objects.

Not surprisingly, Pop art found its first proper American acceptance in Los Angeles. Warhol's first commercial solo show was at the Ferus in

1962. Walter Hopps's 1962 exhibition, *The New Painting of Common Objects* at Pasadena included Lichtenstein, Jim Dine, and Warhol; *My Country 'Tis of Thee* at the Dwan gallery in 1963 included work by Tom Wesselmann, Jasper Johns, Robert Indiana, Robert Rauschenberg, and Claes Oldenburg. When Lawrence Alloway's *Six Painters and the Object* arrived from New York's Guggenheim Museum, *Six More* was readily conceived as an addition to it (the six were Billy Al Bengston, Joe Goode, Ed Ruscha, Philip Hefferton, Wayne Thiebaud, and Mel Ramos), and John Coplans put together *Pop Art U.S.A.* for Oakland. All this in the same year (1963). Finally, the inspirational figure behind the debunking of art-as-art, Marcel Duchamp, was given a retrospective at Pasadena also in 1963. Assemblage, which continued well into the sixties, already contained a number of sub rosa Pop attitudes. Kienholz's frozen, corporeal morality plays contain castoff objects and Pop images (e.g., the Marines raising the flag on Mount Suribachi); Wally Hedrick's "bad" paintings denounced fine-art handiwork; and Wallace Berman's Verifax collages are, in their surface uniformity and blatant mechanism, at least halfway anti-art. Jess Collins's *Tricky Cad* (*Ill. 73*) is, though a literary cacophony, "untransformed" in the manner Lichtenstein offended Erle Loran in his enlargement of a diagram from *Cézanne's Composition.* There were, in fact, younger artists like Tony Berlant (laminated clothes, later Athens-New York Temples) and Llyn Foulkes (Postcard paintings), who worked in the cracks between assemblage and hard-core Pop. To top it off, California found itself the subject of Pop artists, particularly Englishmen such as Peter Blake and David Hockney.

Pop art in Los Angeles is, then, something more than art—it's lifestyle, showbiz, and, strangely, a kind of integrity—and something less than Pop—a complex social statement, not just the conundrum of it's-so-bad-it's-good. "When in the L.A. Basin, ask anyone about Billy Al Bengston," says an art magazine ad, which contains a photograph of a moustached, helmeted desperado in motorcycle leathers beside a B.S.A. racing machine. Bengston came to Los Angeles from Dodge City, Kansas, dropped out of Los Angeles City College, worked in a clothing store and as a beach lifeguard (where he made friends with Kenneth Price), painted automobiles, and spent a year at California College of Arts and Crafts in Oakland. He was close to Voulkos at the Otis kiln, and a charter member of the Ferus Gallery. An anti-archetype artist, Bengston smoothly ingratiated himself with the art public when the prevailing style was sweatshirts and snarls; when a buyer's market prevailed, Bengston ruined a Whitney Museum show by asking what the rental fee for his paintings would be. When hair was long, Bengston cut his short; when

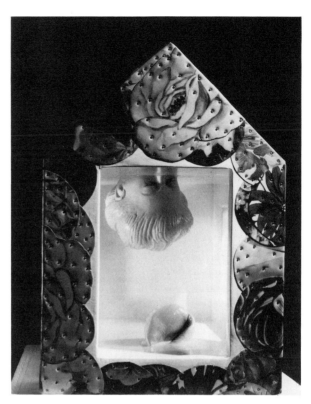

113. Tony Berlant, *Venus*, 1971. Mixed media, 14½ x 10 x 14 inches.

114. Llyn Foulkes, *Postcard*, 1964. Oil on canvas, 65½ x 65 inches. Private collection.

L.A. artists were acquiring vast working spaces, Bengston devoted most of his to showrooms called Artist Studio and painted in a garage corner, near the motorcycles. And, when Venice drove beat-up Volkswagen buses, Bengston acquired a Cadillac and kept it scrupulously polished.

Compared to his persona, Bengston's work is mild and not readily definable. A facile Abstract Expressionist painter in the Altoon-Kauffman mold, Bengston's first shows looked like bad illustrations—tongue-in-cheek hearts, irises, motorcycle emblems. Bengston is not properly a Pop artist; his use of chevrons, however, is a device to counter the accumulated tastes of the recent past: Abstract Expressionist painterliness, "dynamic symmetry" compositions, the fetish of artists materially "sacrificing" themselves to their art, and big scale (Bengston's scale in 1960 was determined by "available materials"). If Bengston made one major departure it is the *Dentos*, begun in 1965: sheets of aluminum dented *a priori* with a soft-headed mallet and painted with deft sprays. They derive, in their rumples, from his AE ceramics and, in their finish, from his hot-rod painting and an early (1957–60) set of cellophane collages. The centralization of image could have been prompted by New York painting (Jasper Johns's or Kenneth Noland's targets), but by now it's completely evocative of sixties L.A.

Ed Ruscha, on the other hand, is transcendent Pop (paintings, drawings, prints, films, book, and, anonymously, *Artforum's* layout). Ruscha and Joe Goode represent (with poetic justice) the "Okie" constituency in Los Angeles art (coming, like thousands in the thirties and forties, from the plains to the lure of palm fronds and Hollywood), and they manifest easygoing, nonmilitant Pop, as at home in Southern California as was Impressionism on the banks of the Seine. Ruscha began with hard, brittle word-paintings (*Annie, Actual Size* [1962]) while still a Chouinard student; the word-paintings pointed to more surreal plays-on-letters (e.g., letters being squeezed by a *trompe-l'oeil* clamp), which led in turn—in Ruscha's rambling, cross-media free-association—to whole environments for words (the Standard Station pictures of the early sixties). There followed a series of gunpowder drawings (1967) wherein words are spelled out in standing ribbon, and, later, word-paintings wherein ambiguities like "Ruby" or "City" are uncannily spilled on delicately graded grounds. The visual puns are manifold: paint as rendering of liquid, drops as words, words as image, "floating" spills suspended in mid-air, and "realistic" illusion against a plane of real paint. Another facet of Ruscha's painting is simple, spooky juxtaposition—birds next to yellow pencils—but without strained "meaning." When Ruscha's considerable wit creeps openly into his art, it's as though by accident, as when the bespectacled boy-genius drops

115. Billy Al Bengston, *Gas Tank and Tachometer 2*, 1961. Oil on canvas, 42 x 40 inches. Private collection.

116. Billy Al Bengston, *Holy Smoke*, 1966. Mixed media, 48 x 48 inches. Private collection.

117. Billy Al Bengston, *Bahia San Luis Gonzaga Dracula*, 1972. Acrylic on canvas, 114 x 114 inches. Private collection.

118. Ed Ruscha, *Large Trademark with Eight Spotlights*, 1962. Oil on canvas, 67 x 121 inches. Private collection.

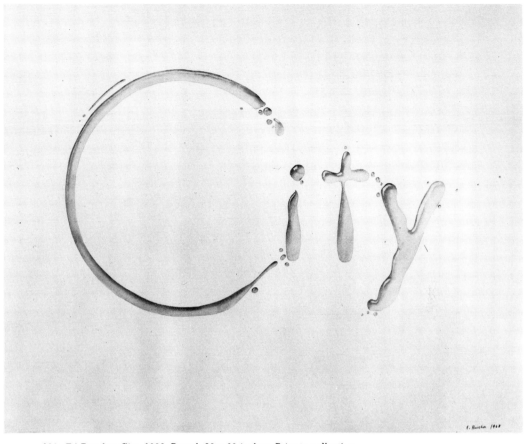

119. Ed Ruscha, *City*, 1968. Pastel, 23 x 29 inches. Private collection.

his secret fluid and it poofs into a genii: the pointed "dumbness," the pseudo-naïve *tours de force*, the mock worship of California's earthly paradise. Ruscha is a Los Angeles phenomenon, precariously indigenous to a garden of vulgarity (as Warhol is ultimately alien to his) with only his own insouciance and facility to ward off the smothering flora.

Joe Goode, Ruscha's classmate at Chouinard, seems to have a greater concern with classical Dada and its questioning of art per se. Goode's first public paintings (1962) are monochrome panels footnoted by painted milk bottles resting on the floor beneath them. Goode's interest in conceptualized illusion prompted more complex versions, with the bottles painted a color identical to the ground's, their "vacated" silhouettes in the panels. Influenced by his teacher Robert Irwin, Goode as a Pop artist is as much concerned with the perception of objects as with social context. After a weird "staircase" show at Nicholas Wilder in

120. Joe Goode, *Leroy*, 1962. Oil on canvas. Private collection.

1966 (a mock-up, leading into the gallery walls or paralleling them, seemed half buried in the wall), Goode returned to the theme of "sky," which occupied him in a 1965 series of "window" paintings. Goode consistently paints colored skies, clouds, and illusions of photographs of skies, themselves floating, like Ruscha's words, atop the ground—all in flat, pastel, and a strangely unpolished rendering. It's as though, down deep, Goode rejects all that Ruscha accepts—as though he were, in the end, more a philosopher than an entertainer, and more respectful than enigmatic.

In 1966, "no one else, on the East or West Coast [was] working like Ken Price."[2] Price, who joined Bengston and Voulkos at the Otis kiln, took a bachelor's degree in ceramics and was a "straight" potter until 1959, when he began to make mound-shaped pots with brightly colored glazes, and configurations resembling Gorky paintings come alive. By 1963, Price's work had shed its allusions to conventional pottery and assumed a typical closed "pod" form. Perched on wooden pedestals, these oddly narrative (what is it seeping from the bulb, and why?) small sculptures took another step away from "pottery" when Price substituted, as anticraftsmanship craftsmanship, multilayered automobile lacquer for

glazes. Price's sculpture similarly operates on several levels. First, the object in itself is appealing, like a jeweled watch or a piece of electronic equipment; second, it's a *genuine* synthesis of form and color (the sculpture inconceivable in its native drab clay, and the color dependent on a rounded surface); third, Price's small, personal scale and meticulous craft demand repeated visual scans. In 1964, Price reduced his object even further, to "specimens" (almost nondescript ceramic pancakes with exotic, semiglittering surfaces, exhibited under Plexiglas boxes), requiring as much from the viewer in the gradual perception of them as from Price in their meticulous execution. Later, he reverted to cups—vessels with thematic handles and bases (frogs, ballerinas, crabs, leaves)—with incredible facility, and increasingly bizarre gouaches depicting the cups. The product of a private, introvert esthetic, the cups are also an example of typical Los Angeles going-against-the-grain—

121. Kenneth Price, *B.T. Blue,* 1963. Ceramic, 10 inches high. Private collection.

122. Kenneth Price, *Lizard Cup*, study for a Gemini G.E.L. print, 1971. Acrylic on paper, 30 x 40 inches. Private collection.

123. Philip Hefferton, *The Marriage of George and the Cosmos*, 1964–65. Oil on canvas, 48 x 36 inches. Private collection.

exactly what, under the aegis of the formalist dialectic, the "next step" ought *not* to be.

> All the pictures involve cups, a subject used by Price in his apparent transition from a mainly sculptural artist to a pictorial one. It seems at least possible that Price, who has always been a delicately eccentric artist, concerned more with pleasure than with theory, has arrived at the station where any object, no matter how small, finely crafted, and colored, is insufficiently mystical to be involved with, and is now making pictures because pictures, being basically false (a physical thing alluding to non-physical things, and vice versa), are basically free.[3]

Ruscha and Goode have, in the breadth, slickness, and Pop-spiritual accuracy of their styles, eliminated a great many Pop "opportunities" for lesser Los Angeles artists—for Pop is largely a matter of staking out territories (romance comics, giant, soft everyday objects, low-grade photo-silkscreening, etc.). Two early Pop painters—Philip Hefferton, with crudely painted portraits of money, and Robert O'Dowd, with oversize

124. Vija Celmins, *Untitled*, 1969. Graphite on paper, 34 x 40 inches. Private collection.

125. Robert Graham, *Untitled*, 1968. Mixed media. Private collection.

126. Robert Graham, *Untitled*, 1968. Mixed media. Private collection.

postage stamps—were lost in the shuffle. Later artists like Jerry McMillan (who makes physical impossibilities—a feather piercing a brick), Don Lagerberg (who makes swimming-pool Rosenquists), and Richard Pettibone (who does miniature copies of well-known art) are inevitably minor by comparison. Those who manage to work within a generic Ruscha-Goode sensibility do it without the ironical Pop implications. Vija Celmins's graphite renditions of seas or lunar surfaces are examples, as are Robert Graham's erotic lilliputians with fetish marks like bikini tans and garter belts.

These days, the vestiges of Pop banality mingle in Photorealism. Its large, hand-copied blow-ups spring from, on the one hand, the desire—amid frantic self-questioning, parodying, and debunking of the art object by Process and Conceptual art—to return to satisfying, therapeutic handicraft, and, on the other, the trickle-downs of information theory, as, for instance, when pictures of Mars are transmitted back to Earth by electronic blips and guilelessly reconstructed into visuals. A third, overrated factor is the need to deal in narrative fashion with the ubiquitous visual phenomena of commercial American life. As homesteaded by individual Photorealists, these include: parked cars

127. Robert Bechtle, '67 *Chrysler*, 1973. Oil on canvas, 48 x 69 inches. Private collection.

128. Bruce Everett, *Thumb Tacks*, 1972. Oil on canvas, 68 x 68 inches. Private collection.

129. L.A. Fine Arts Squad, *Isle of California*, 1970–72. Enamel on stucco, 45 x 63 feet.

(Robert Bechtle and Don Eddy), tack boxes (Bruce Everett), movie stars' homes (Paul Staiger), horse breeders and trophies (Richard McLean), downtown signs (Robert Cottingham), and close-ups of seals or Indians in a bejeweled Photo-Impressionism (Joseph Raffaele). If there's any hope for painting in this newer, "radical" realism, it rests with enterprises like the L.A. Fine Arts Squad, a group of five semi-anonymous muralists who have turned the odd outdoor wall into Cineramic views of Venice under six inches of snow, or a cracked-off section of desert freeway above the Pacific waves (*Ill. 129*).

The California variety of "radical" realism aspires to have it both ways—the quasi-defiant banality of Pop and the painstaking, fine-art finish of academic painting. That so much painting has regressed to this throws the question of the viability of painting, indeed, of object art into further doubt. The West Coast hasn't had a sustained reverence for painting or a set of heroes to emulate, and it's all too understandable why West Coast painters settle for either a hesitant Process mode or the comfort of filling-in. Pop self-effacingness, sugared sarcasm, and ability (if modernist art still has a social quotient) to bore from within, are the best qualities of minor Pop spin offs, but Pop itself, seemingly at one with the flow of vulgarized California, is now just another thesis in the struggle of modernist art to stay alive in a society that has relegated it to an intellectual amusement.

10. Decline and Fallow

New York art has been dominant in America since the end of the
Depression, and its preeminence raises that crucial question: Is the best
regional art (including West Coast) that which matches (chronologically
and esthetically) New York art or that which differs most from it? The
examples of West Coast artists who have built international reputations
(Kienholz, who outflanked New York, Ruscha, who made a New York
style into a Los Angeles truism, Diebenkorn, painting the "issues" of
postwar art but with a regional topography, and Sam Francis, who took
aspects of AE and French decoration and made California painting of
them) provide only the loosest of answers. The truth is that, as the New
York art world 1955–70 became overpopulated, academicized, and
commercialized, the West Coast art world became more and more like it;
as the distribution systems grew more similar (in style, not size), the art
that fed them also patterned itself more and more after the same models.
Styles arrived everywhere with metronomic rapidity—Pop, Op, Post-
painterly, Minimalism, post-Minimalism, Process art, Concept art,
"body" art, and counterrevolutionary forays like Photorealism—and the
avant-garde became a predictable mechanism. "It seems a truism at this
point that the static, portable, indoor art object can do no more than
carry a decorative load that becomes increasingly uninteresting. One
waits for the next season's polished metal boxes, stretched tie-dyes, and
elegantly applied Liquitex references to Art Deco with about as much
anticipation as one reserves for the look of next year's Oldsmobile."[1] On
the West Coast, moreover, the psychedelic motif of an underground rock
poster appears on a buttermilk carton a month later; the dress of
Haight-Ashbury shows up in stylized form on celebrities in six months,
on middle-class schoolchildren within a year, and on their parents in
another year. Giant industries—rock music, "peacock" men's fashions,
and pornographic movies—spring from formerly esoteric, sub-group

130. Los Angeles County Museum of Art, 1965. William Pereira, architect.

consumer bases. Where the traditional yearbook brand of college politics
yielded to the Free Speech Movement (in Berkeley in 1964), where the
hierarchical family structure (daddy at the office with his desk and boss,·
mommy with Pillsbury in the kitchen, and the children out rolling hoops)
was all but annihilated by leisure time, methedrine and the Pill, it
became increasingly difficult for the modernist artist to function as any
sort of societal antenna.

The West Coast hit the late sixties with some optimism: Los Angeles
had established itself as the "second city" of American art and expected
to provide for the coming art-and-technology boom. But a funny thing
happened on the way to the pantheon: The West Coast art scene hit the
skids—not collapsing, but flattening out. The most noticeable leveling
took place in Los Angeles, where hopes were raised highest. In 1965 the
Los Angeles County Museum of Art opened in sumptuous, Hollywood-
Babylon quarters in west Los Angeles, with the most floor space of any
museum since the Metropolitan (*Ill. 130*). If the museum, with an imported
New York curator of modern art, did not at first fulfill all expectations, it
at least gave Los Angeles artists—historically under-attended—
subconscious hope of patronage and enshrinement. Six months after the
fanfare, however, Richard Brown was forced to resign as director over
the issue of trustee interference in the day-to-day management of the
museum. The trustees—the usual corporate Ottomans or their wives, who

give culture back to the public out of their profits—used the excuse of Dr. Brown's administrative "inadequacies" to tip the balance against his vision and scholarship, and the fact that relations had been bad ever since Brown refused to accept Millard Sheets in place of Mies van der Rohe (compromising only reluctantly on William Pereira's monumental kitsch) as the building's architect. According to Brown:

> Although any board of trustees has every right and duty to assume responsibility for policy, individual board members have forced decisions and taken unilateral action not consistent with good museum administration, which requires the full-time efforts of trained specialists, and which cannot be handled by part-time laymen regardless of their devotion or attainments is non-related fields. Recently, this tendency has disrupted normal day-to-day professional operation and has mitigated what could and should be an ideal program of acquisition, care, maintenance, exhibition, and interpretation of art for the public good. The Director, as legally constituted head of a County governmental department, has been circumvented consistently by individual trustees in dealing with County government. Under such circumstances, the Director is not permitted to operate the museum on the proper level of professional standards nor to maintain his personal integrity without conflicting with the individual board members concerned.[2]

A stratum of exceptional curators (Henry Hopkins, James Elliott, James Demetrion) soon departed, and with them went much of the

131. Pasadena Art Museum, Pasadena, California, 1969. Ladd & Kelsey, architects.

acumen surrounding the earlier L.A. Look. The Pasadena Art Museum, an "insider's" showplace in its old, dank, *faux-Chinois* barn, built a new building in 1969 (*Ill. 131*). Its basic premise—a glamorous, inflexible, overdecorated, expensive setting for large, clean art objects—was a burden from the start. The inlaid floor couldn't withstand bolted sculpture or moisture, the narrow corridors imprisoned paintings hung in them, the ceramic veneer wouldn't tolerate contraction/expansion, and the budget, purged by the building, couldn't sustain operating expenses. Eighteen months after opening its doors, the museum drastically reduced its schedule of exhibitions and, for a while, requested takeover by the County of Los Angeles.

Meanwhile, Gemini, a commercial spinoff of Tamarind, went a long way toward usurping the local market for younger, more inexpensive art. (June Wayne, a self-taught printmaker, discovered in the late fifties that she had to go to Paris to have lithographs executed properly, and so she secured a Ford Foundation grant to open Tamarind Lithography Workshop. From 1960, Tamarind buttressed the deteriorating American art of lithography through fellowships to establish New York and European artists, technical materials and assistance, and the training of "artisan-printers" to spread the gospel.)

> Firmly convinced that progress is the vital key to the [Gemini] work-shop's past and future success, [Kenneth] Tyler commissions only established American artists who are interested in utilizing modern technology in their work. . . .
> Financial stability is a vital factor in providing the equipment and research necessary to support the ever increasing demands of the artists who work at Gemini. Under the supervision of Sid Felsen and Stan Grinstein, the workshop has gained the active support of an international group of collector subscribers and subscribing dealers who work together for the foundation upon which it operates.[3]

All of this meant that Gemini's production would be the handiwork of New York sixties blue-chippers like Robert Rauschenberg, Roy Lichtenstein, Frank Stella, Jasper Johns, Claes Oldenburg, and Ellsworth Kelly, and that its clean, professionally multiplied merchandise would unavoidably draw off patronage usually reserved for local artists whose prices for "major" (one-of-a-kind) works were equivalent to Gemini's big-time multiples.

Finally, the brief California history of *Artforum*. The magazine first appeared in San Francisco in 1962 (edited and published by John Irwin, John Coplans, and Philip Leider) as a monthly devoted to West Coast art; in 1965, *Artforum* took up residence above the Ferus Gallery in Los Angeles. By then, it had developed a partisanship for "cool" art, a

132. California Institute of the Arts, Valencia, California, 1972. Ladd & Kelsey, architects.

penchant for a formalist and analytical (if somewhat obtuse) writing style, and a slick look—all of which rendered it the consensus successor to New York's *Art News* as the most important journal of current art. But in 1967 (because advertising New York galleries pressed for primary coverage of New York art, and because the editors wanted something more than a *regional* periodical), *Artforum* packed up for New York; West Coast artists were abandoned once again to the cursory snippets in *Art News* and *Arts*, and the parochial criticism of local newspapers.

By the late sixties, some 300,000 Master of Fine Arts degree-holders— streaming out of Yale, the University of California campuses, and Midwestern factories—were abroad in the land, many of them avant-garde painters, sculptors, and performers who returned as instructors to the schools that spawned them. In turn, *they* held classes, gave stylized assignments, and awarded grades—initiating the final steps in the academization of the avant-garde. These aspiring artists knew also that the artist's lot had evolved from simply the promise of little capital gain, save for occasional jackpot careers, to the necessity of operating with formidable overhead: large quantities of exotic materials or equipment, expensive rentals, and promotional travel and publicity. And they knew the stepping-stones of inclusion in strategic group shows, the middleweight-to-heavyweight galleries, and the necessity of art-magazine linage. As the rigors of the art world changed artists from

passionate naïfs or grizzled, resigned, old plodders into semi-showbiz sharpies, artists (by reputation or participation) fed back into and changed the system producing their own emulators, by staffing avant-garde academies. Chouinard Art Institute, for instance, was technically "Cal Arts" even before it left its old quarters near downtown Los Angeles. An excerpt from a recent admissions bulletin:

> A hundred years Wagner conceived of a perfect and all-embracing art, combining music, drama, painting, and the dance, but in his wildest imaginings he had no hint what infinite possibilities were to become commonplace through the invention of recordings, radio, cinema and television. There already have been geniuses in combining the arts in the mass-communications media, and they have already given us powerful new art forms. The future holds bright promise for those whose imaginations are trained to play on the vast orchestra of the artist-in-combination. Such supermen will appear most certainly in those environments which provide contact with all the arts, but even those who devote themselves to a single phase of art will benefit from broadened horizons.[1]

The concept of a total school of the arts—painting, drawings, sculpture, music, theater, and dance—is almost as old as the idea of a supreme, conglomerate art form itself. One of its pioneer stokers on the popular front was Walt Disney, whose prewar film *Fantasia*—episodes of

133. Walt Disney, still from *Bambi*, 1942.

classical music animated with animal fantasies (e.g., alligators on ice skates)—is a landmark of kitsch meta-art. As the Disney enterprise grew voraciously, Disney dreamed of an ultimate training ground for his animators, who would be draftsmen and painters versed not only in film, but possessed of a pan-esthetic background in music, dance, and theater, to create future *Fantasias*.

But animated cartoons became economically less feasible, and Disney branched into live-action films, television, and amusement parks. Disney himself still believed in a super-school, and he bankrolled a brand-new campus for Cal Arts in pastorally removed Valencia, forty northward miles from the Los Angeles grind. By the time Cal Arts emerged from a transitional year in a defunct Burbank Catholic high school in 1971, however, the social gestalt of the "ideal" art school had mutated considerably beyond the combination-by-addition of separate, accepted,

134. University Art Museum, Berkeley, California (interior), 1970. Mario J. Ciampi & Associates, in design partnership of Mario J. Ciampi, Richard L. Jorasch, and Ronald E. Wagner, design associates; John Voulkos, project architect.

academic disciplines that Disney envisioned. The lessons of the recent past predicated several basic "reforms" of the school's tenets: first, to prevent the stifling of visionary artists by conservative curricula, that the avant-garde be the standard; second, that art be *ipso facto* associated with radical-reform politics, as it had been in, for instance, the Courbet Paris commune; and, third, that "art" means the use of new media and technical procedures.

> The Institute is a laboratory and a performance center. Students and faculty perform as a collaborative.
> There are no grades. Progress is measured as it is in the arts themselves: by what's done as it's done, with evaluation an organic aspect of the process. Continuance in the programs depends on demonstrated ability. Whatever the work is, it will be rigorous. Interaction among the members of the schools is fundamental to the Institute, which is a complex of workshops, galleries, studios, and performing areas of extraordinary versatility. Faculty resources of all schools are available to all schools. . . .
> As a community of the arts, the Institute has no intention of being hermetic. Its immediate concerns extend to the environment of the new city in which it is being built and to the surrounding megalopolis. Research and performance move into the wider community and beyond it, for the most basic commitment of the Institute, in a radically changing time, is to the development of artists with singular gifts, willing to risk private vision in the urgencies of our common life. . . .
> A basic assumption of the School of Art is that from the day he enters, the student is an artist.[5]

The net effect of it all (in the Bay Area, too, which saw the San Francisco Art Institute develop into a locus of Conceptual art, performance, and film, the University Art Museum at Berkeley undergo controversies concerning management and exhibitions, and gallery closings comparable to L.A.'s) is pluralism. The combination of academic heat (i.e., the artist-producing system running full-blast with apparent limitless faith in the avant-garde's future) and commercial cool has dispersed the scene into separate, and practically equal, clots. An ever-present California languidness, plus the experience of the presence and dissipation of so many simultaneous esthetic options, has obviated the return of any single "court style" and any sense of utopia to which modern art has aspired for fifty years. In the interim, the art object's strength has wavered, while art that edges toward ephemerality, linguistics, and plain thought has prospered.

11. Art and Technocracy

During the sixties, the West Coast produced a contingent of kinetic and electronic sculptors who seemed to assume the artist's job would be to make playlike use of abundant advanced technology, and who still managed to function within the "object" convention: among them, Charles Mattox, a student of Gorky attracted by kinetic whimsies, Fletcher Benton, Charles Frazier, assemblagist turned hovercraft sculptor, Don Potts, designer of skeletally gorgeous, dysfunctional "cars," and Stephan von Huene, an electronic assemblagist. None of these, however, approached technology in the grandiose frame of mind of the County Museum's broker of artists, Maurice Tuchman, who had seen enough in other "technology" shows not to care that, by the late sixties, the subject was a little tired.

In 1966, when *Art and Technology* was first conceived, I had been living in Southern California for two years. A newcomer to this region is particularly sensitive to the futuristic character of Los Angeles, especially as it is manifested in its advanced technology. . . . I became intrigued by the thought of having artists brought into these industries to make works of art, moving about in them as they might in their own studios.

In reviewing modern art history, one is easily convinced of the gathering esthetic urge to realize such an enterprise as I was envisioning. A collective will to gain access to modern industry underlies the programs of the Italian Futurists, Russian Constructivists, and many of the German Bauhaus artists. . . . A need to reform commercial industrial products, to create public monuments for a new society, to express fresh artistic ideas with the materials that only industry could provide—such were the concerns of these schools of artists, and they were announced in words and works.

During late '66 and early '67, I began studying the nature and location of corporate resources in California. In November, 1967, I went to the Museum's Board of Trustees, members of which were significantly involved with over two dozen West Coast companies, to outline my proposal and to elicit advice and support.[1]

136. Charles Mattox, *Red Rotor and Eye*, 1964. Mixed media, 28 x 5 x 6 inches.

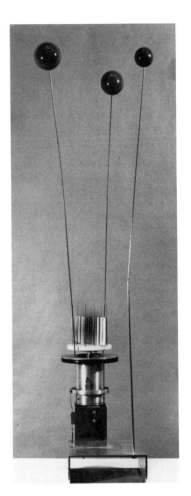

135. Fletcher Benton, *Synchronetic C-8800 series*, 1966. Mixed media, 83 x 70 x 11 inches.

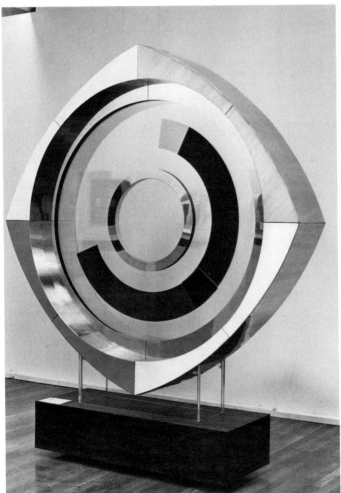

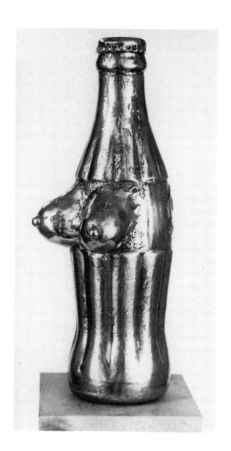

137. Charles Frazier, *American Nude No. 3*, 1963. Bronze, 7¾
inches high.

138. Stephan von Huene, *Pneumatic Music-Machine*, 1967.
Mixed media, 75 x 24 x 22 inches.

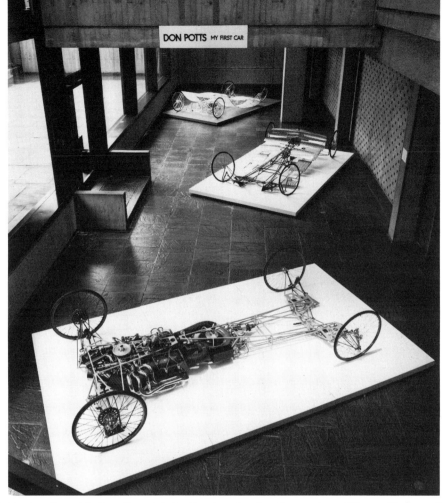

139. Don Potts, *My First Car*, 1969–72. Mixed media. Installation photo, Whitney Museum of American Art, New York.

A Report on the Art and Technology Program of the Los Angeles County Museum of Art, 1967–71, the exhibition's catalogue, is not so much the narrative of a completed project, but an interim report on a hoped-for ongoing metamorphosis of modern art, centered in Los Angeles. Its candid and lengthy description/documentation of every attempted collaboration between the museum-matched artists and corporation admits to every artist's arrogance, every corporate stubbornness, and the ubiquitous mutual vanity—as well as the easy alignment of artists with hard-core capitalism and war-related industries (while the war in Vietnam was at its height). The exhibition itself was the swan song of sixties art—European and New York superstars (Caro, Christo, Dubuffet, Fahlstrom, Judd, Kelly, Lichtenstein, Morris, Oldenburg, Rauschenberg, Rosenquist, Tony Smith, Vasarely, and Warhol), and the

140. Rockne Krebs, *Day Passage*, 1971. Lasers. Installation photo, Los Angeles County Museum of Art. Executed in collaboration with Hewlett-Packard.

underlying assumption of a technological future benevolent in its excesses, even to artists. It would constitute an esthetic plus, *A & T* seemed to say, if assemblage, environmental art, kinetic and light art, and the colors, size, mass and, indeed, prosperity available through the corporate structure were extended *ad absurdum*. *A & T*'s solution was, in the end, hardware, attempting to draw the artist abreast of the *real* powers—science, industry, the military, and commerce—by allocating similar materials to him, on a commensurate budget. The physical results were cumbersome, breakdown-prone, and esthetically unclear: a sound-controlled bubbling bed of mud; color-luminous, gas-filled tubes; plastic cutouts of Robert Crumb cartoons; artificial rain on artificial flowers; and a modular environmental Minimal sculpture in corrugated board. An exception was one work by Newton Harrison (a "shrimp farm" in the plaza); Harrison sees himself as a post-technological artist whose theme is simple survival (*Ill. 141*).

In spite of things like *A & T*, the dominant theme of the few years on either side of 1970 was movement away from the art object. In New York,

141. Newton Harrison, *Ecosystem of the Western Salt Works*, 1971. Mixed media. *Above:* Installation photo, Los Angeles County Museum of Art. *Below:* One of 96 bags of sea salt harvested from Pond #4.

it rode on the politics of an increasingly tough art world, on the honing down of Minimalism to logical systems, and on theoretical aspects of Duchamp's legacy. On the West Coast, the major deobjectification took place in Los Angeles, with the etherealization of aerospace-looking art; but, in Northern California, the Funk spirit still hung around. The only painter to *do* anything with the loosely based miasma of Funk is William Wiley, a once-prodigy of the California School of Fine Arts, whose style is an eclecticism of eclecticisms, distilled through a dry, good-natured wit. While a student, Wiley inhaled the ghosts of Still and Lobdell and drew from such disparate influences as Francis Bacon, H. C. Westermann, and the deified Duchamp: he became a *Wunderkind*, producing Abstract Expressionist paintings larded with diagonal stripes, cliffs, horizon lines, and Miró-esque traces of a human presence. In the early sixties, however, Wiley became "bored" (as artists are wont to say) with high-art pretentiousness and "serious" painting, and his work began to reveal deadpan humor, via bits of isometric drawing and stencil lettering. *Columbus Rerouted, III* (1962), for example, is a big, existential, irreverent painting that prefigures his own and his followers' evolution into Process art. Wiley, and a group of others, including Robert Arneson, constituted a "Sacramento Valley sensibility," scarcely concerned with hierarchies, quality judgments, and creative pain, and very concerned with magic, good friends, good times, and simple land, water, and air—a kind of matured hippie art, save for the technical virtuosities of Wiley, Arneson, and realist painter William Allen, and for the urbanity of the non-object stances of the younger artists from the University of California at Davis such as Steve Kaltenbach and Bruce Nauman.

Nauman is a Midwesterner, educated in art in rural California, who has lived in San Francisco, New York, and Los Angeles; his work, which launched itself from a base of inert, funky, post-Minimal sculpture (homely Fiberglas forms in dull colors and indifferent finishes), has been, for the most part, Duchampian and epistemological in nature: "How do we know what we know?" "How can we be certain that what we think we know is really what we do know?" "How do we know what art is supposed to do?" "Why *do* we want to know anything in the first place?" Sculpture for Nauman is clearly a non-visual experience; even his student work of about 1965–66 (coinciding, for instance, with the exceedingly visual Valentine-Alexander resin-casting down south) is concerned with the *idea* of things, as if they resided in a conceptual, gray-hued universe. Such attitudes translated themselves, in the late sixties, into literary-visual art, pictorial puns on *Waxing Hot, Eating My Words, Drill Team,* and *Bound to Fail.* Nauman's working procedure is dispassionate. "Bored" (also!) with having to spend long hours in his graduate-student studio, Nauman invented long-term projects for

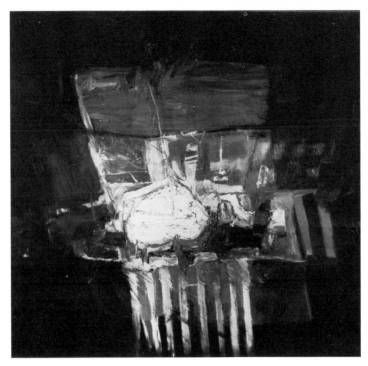

142. William Wiley, *Flag Song*, 1959. Oil on canvas, 61½ x 65½ inches. Private collection.

143. William Wiley, *Nodding Off with the Kernel*, 1970. Ink, 21⅞ x 30 inches.

144. Bruce Nauman, *Platform Made Up of Space Between Two Rectilinear Boxes on the Floor,* 1966. Fiberglass, 7 x 80 x 36 inches. Private collection.

himself—a jerry-built, homemade laboratory research, first into object-word dichotomies, then into kinesthetic perception ("I suppose it's dealing with psychological perception; it deals with how you locate yourself in space and then doing something to confuse that"[2]), and recently into Irwinesque reductive phenomena.

Nauman's art is faintly traditional in its passivity; two San Francisco artists, Terry Fox and Howard Fried, are the active tragedians of the school. Fox, drawing on long periods of hospitalization, with attendant overtones of death and decay, produces both "set" pieces (environmental sculptures of blackened timbers, lights, cord, mounds) and performances (an attempt at self-levitation, the leavening of bread dough). Fried is more complex and dense, carrying "approach-avoidance" to schizoid extremes (an interior vocabulary and systems of cross-references impenetrable to an outsider). His variety is incredible, ranging from small, compulsive ink-dot drawings to Kienholz-like tableaux (a set of bunk beds stuffed variously with bricks and straw), and videotapes and films of gritty dance/wrestling sequences. Both are psychic-combat cameramen.

Oddly, Vancouver, partially isolated from the rest of Canada as well as the West Coast below it, boasted, by 1968, a scene of cool art rapidly transforming into a mixed-media (electronics, theater) techno-art—in

fact, the city was the only place where such a hybrid sprouted with any enthusiasm. Canadian modern art before World War II is skimpy—the Group of Seven realists in the twenties being uniquely important— and the "cultural capital of Canada" shifted between Montreal and Toronto. Emily Carr, a "Canadian institution" landscape painter, was Vancouver's standard-bearer. Not until the early fifties did the Vancouver School of Art produce an "animistic school," including Jack Shadbolt (premier, eclectic), Don Jarvis, Lionel Thomas, Gordon Smith, and Bruno Cook, along with "a period of innocence" something like Los Angeles's of the same moment. One bright spot was the migration from Regina in 1959 of Roy Kiyooka, an energetic but erratic painter who taught at VSA and is generally credited with "infusing the city with a spirit necessary to create a new art." [3] By the early sixties, a Renaissance brewed, with the Vancouver Art Gallery's self-regeneration under Doris Shadbolt, and some promising *enfants terribles* enrolling at VSA. But Vancouver, Canadian and not American, benefited from an unusually active and enlightened form of government patronage, the Canada Council—founded in 1957 to fund artists' projects, no matter how "advanced." Michael Morris is a typical product of the ambience. He graduated from VSA in 1961, and, in London, hungrily assimilated heady British Pop (Blake, Joe Tilson, Eduardo Paolozzi). Back in Vancouver, Morris was haunted—like every regional artist—by a minor-league complex; his work is indicative of the freneticism of legitimacy, ranging from small configurations of commercial type, through overembellished geometry, to environments and videotapes—all of it with an art magazine "internationalism." Other artists of the period demonstrate the same stylistic transformations: Gary Lee-Nova (from Pop-geometric to film), Glenn Lewis, a ceramist/sculptor of delicate sexual wit, Claude Breeze (pure, acidic protest images), Gathie Falk (ceramic bric-a-brac to autobiographical performances), and Intermedia (a conglomerate of performance and electronic media).

Early in 1969, Iain Baxter, a bright, iconoclastic former zoologist, counselor, and recent arrival to art, founded the N.E. Thing Co., Ltd., an artistic alter-ego, specializing in Pop-Conceptual "takes" on nature, place, and art, via "ART" (Aesthetically Rejected Thing), "ACT" (Aesthetically Claimed Thing), inflatable Barnett Newman paintings, and the like. Baxter reflects the regional desire to be simultaneously hip and out from under New York art dialectics—in his case by carrying the modernistic cliché of "expanding" art into previously non-art areas to ridiculous, self-parodying extremes.

Vancouver, then, is a laboratory case of regionalism: substantial local energy, physically isolated from the mainstream but nominally connected by airplanes and media. In such places—the Vancouvers,

145. Emily Carr, *Mountain Forest*, 1936. Oil on canvas, 44 x 26⅞ inches. Collection of The Vancouver Art Gallery.

146. Michael Morris, *The Problem of Nothing*, 1966. Acrylic on canvas. Collection of The Vancouver Art Gallery.

147. Intermedia (Dave Rimmer, artist), *TV Wall Sculpture*, 1969. Mixed media, 40 x 10 x 2½ feet. Installation photo, The Vancouver Art Museum.

San Diegos, Portlands, Seattles, and, yes, San Franciscos and Los Angeleses—can we hope for anything more than jazzed-up melding of New York styles or self-conscious lampoons that aspire to lift the curse of provincialism?

Trade communication in Process art (materials in a near-to-raw state) and Concept art (idea-as-art, with a minimum of physical addenda) is direct, even over the distances between New York, San Francisco, Los Angeles, or Europe—since it's already coded for transmission: numerical specifications, charts, plans, words. Thus, Concept and Process art on the West Coast differ less by geographical class than by the individual artist's temperament (although the West Coast seems to have a preference for intimacy, transparency, and simplicity). At the moment, it's too early to grant to either form a solid link in a historical chain, or a confident quality-judgment—save to say that the *idea* of idea-as-art will, by increasing the suspicion that art

148. Ed Ruscha, *15120 Victory Boulevard* (Some Los Angeles Apartments series), 1965. Photograph.

149. William Wegman, *Good Luck*, 1972. Videotape.

150. Chris Burden, *Movie on the Way Down*, 1973. Performance, Oberlin College, Oberlin, Ohio.

objects are reactionary and/or worthless, modify the face of all physical art that follows. In Los Angeles, Conceptual art—proclaimed or not—arose as much out of the soothing banality of Pop as it did from the *nth* recycling of Duchamp. Ruscha, for instance, published fourteen books in ten years; among them *Royal Road Test* (a typewriter's "performance" in being dropped from a car at 90 m.p.h.), *Twenty-Six* (uniformly uniform) *Gas Stations, Some Los Angeles Apartments* (in all their garish tackiness), *Parking Lots* (aerial views), inane views of vacant lots (*Real Estate Opportunities*), and others. Ruscha's "information" (Conceptualist cant for photo-plus-caption) pioneered pseudo-thorough documentation of the obvious. *In extremis*, there are Barry Le Va, who began with "scatter pieces" of ball-bearings and felt fragments, and came to "body" art (once, he ran back and forth at full speed, colliding with a wall at either end, then made the sculpture of the empty, blood-spotted room enhanced by a tape-recording of his batterings), William Wegman, a vaudevillian with video, John Baldessari, a drier conceptual comic, and Chris Burden. Burden goes farthest: He "hijacked" a television interview program at knifepoint, manacled himself to an electrified garage floor, pounded a star-shaped stud into his chest, and had himself shot in the upper arm with a .22-caliber rifle. He asks, with a masochistically accusatory evenness, how far the artist—in a time of universal comfort and affluence—is willing to go to earn his identity. (Not surprisingly, most art school products are middle-class whites who suffer guilt about being aloof—by virtue of economics and their chosen profession—from the "real" struggles of the street and the world; they often attempt to assuage such feelings, as Burden does, in their art.)

The problem with Concept-Process art is, mainly, that it purloins the glamor and "toughness" of other disciplines, impressing an art audience with jargon, formulas, equipment, exotic effects, and minutiae. The difference between Concept-Process art and actual experiments in perceptual psychology or solipsist motor psychology is, simply, the public presentation of such phenomena. On the other hand, art could be, they say, one of the first signaling devices of a millennial change in human consciousness. Perhaps the dematerialization—physically and socially—of the avant-garde is the first necessary dissolution of old barriers preparatory to the advent of a "whole man." If even a fraction of that comes true, the meaning of the regional/mainstream ambiguity of West Coast art will be clear.

Notes

CHAPTER 1

1. Joseph Maschek, "New York Reviews" [of *California Color* at the Pace Gallery, New York, *Artforum*, January 1971, p. 72.
2. W. Baldinger, "Regional Accent: The Northwest," *Art in America*, January–February 1965, pp. 34–39.
3. Mark Tobey, "Japanese Traditions and Modern Art," *Art Journal*, Fall 1958, p. 21.
4. *San Francisco* [WPA Writers' Project] (New York: Hastings House, 1947), p. 112.
5. Stanton Macdonald-Wright, "Art News from Los Angeles: A Brief Discussion of the Development of the Arts in Southern California," *Art News*, October 1955, p. 8.
6. Quoted in Esther McCoy, *Five California Architects* (New York: Reinhold Publishing, 1960), p. 155.

CHAPTER 2

1. Arthur Millier, "Los Angeles Events," *Art Digest*, July 1, 1947, p. 6.
2. Quoted in Jules Langsner, "Art News from Los Angeles," *Art News*, February 1957, p. 20.
3. Jules Langsner, "Art News from Los Angeles," *Art News*, June 1956, p. 22.
4. Henry Hopkins, "Southern California," in *West Coast Now*, catalogue of an exhibition at the Portland Art Museum, Portland, Oregon, 1968.
5. Peter Plagens, "Los Angeles: The Ecology of Evil," *Artforum*, December 1972, p. 67.
6. Edward Roditi, "Los Angeles Art Market," *Arts*, April 1967, p. 51.

CHAPTER 3

1. Lawrence Ferlinghetti, "Bay Region Painting and Sculpture," *Art Digest*, August 1955, p. 26.
2. In 1926, the San Francisco Art Association moved to its present location on Russian Hill and changed its school's name to California School of Fine Arts. A subsequent name change—to the San Francisco Art Institute—was made in 1960. Since 1935, the SFAA has collaborated with the San Francisco Museum of Art in staging annual exhibitions (for a long time with separate showings of prints, drawings, and watercolors). For its centennial in 1971, the Art Institute and the Museum decided, much to their credit, to buck the trend to abandon competitive, juried shows, and staged a huge, statewide exhibition.

3. Douglas MacAgy, quoted in Mary Fuller McChesney, *A Period of Exploration: San Francisco, 1945–50*, catalogue of an exhibition at the Oakland Museum, Art Department, Oakland, California, 1973, p. 83.
4. Hubert Crehan, "Is There a California School?" *Art News*, January 1956, p. 65.
5. Patricia Still, Letter to *Artforum*, September 1964, p. 2.
6. Clyfford Still, quoted in McChesney, *Period of Exploration*, p. 36.
7. Quoted in Barbara Rose, *American Art Since 1900* (New York: Praeger Publishers, 1967), pp. 192–93.
8. Quoted in McChesney, *Period of Exploration*, p. 21.
9. Walter Hopps, *Frank Lobdell*, catalogue of an exhibition at the Pasadena Art Museum, Pasadena, California, 1966, p. 5.
10. E. C. Munro, "Art News from San Francisco," *Art News*, December 1959, p. 50.
11. Jorge Goya, quoted in Mary Fuller, "Was There a San Francisco School?" *Artforum*, January 1971, p. 48.
12. Gordon Cook, in an unpublished interview with Dan Tooker, 1972.

CHAPTER 4

1. Hubert Crehan, "Is There a California School?" *Art News*, January 1956, p. 33.
2. Sam Hunter, "The United States," in *Art Since 1945* (New York: Washington Square Press, 1961), p. 279.
3. Sam Hunter, "Seattle's Trend Is to the Right: 31st Annual," *Art News*, November 1, 1945, p. 25.
4. Gretchen T. Munson, "35th Annual: Seattle," *Art News*, November 1949, p. 52.
5. Sarah C. Faunce, "Mark Tobey: Painter or Prophet?" *Art News*, September 1962, p. 59.
6. Duane Zaloudek, in a conversation with the author, 1972.
7. *Ibid.*
8. Herschel B. Chipp, "Art News from San Francisco," *Art News*, September 1956, p. 18.

CHAPTER 5

1. Elmer Bischoff, quoted in Herschel B. Chipp, "Art News from San Francisco," *Art News*, March 1965, p. 12.
2. Hilton Kramer, "Pure and Impure Diebenkorn," *Arts*, December 1963, p. 46.
3. Richard Diebenkorn, quoted in Herschel B. Chipp, "Diebenkorn Paints a Picture," *Art News*, May 1957, p. 55.
4. Richard Diebenkorn, quoted in Jean Leymarie, *Art Since Mid-Century: The New Internationalism*, Vol. 2 (Greenwich, Conn.: New York Graphic, 1971), p. 151.
5. Wayne Thiebaud, quoted in Michael Compton, *Pop Art* (Movements of Modern Art) (London: Hamlyn Publishing, 1970), p. 151.
6. Gene Cooper, *Wayne Thiebaud*, catalogue of an exhibition at California State University, Long Beach, California, 1972, unpaginated.
7. Peter Plagens, Review, *Artforum*, December 1969, p. 74.

CHAPTER 6

1. Eugen Neuhaus, *The Art of the Exposition* (San Franicsco: Paul Elder and Co., 1915), p. 26.
2. Kenneth Rexroth, "Disengagement: The Art of the Beat Generation," in Thomas Parkinson, ed., *A Casebook of the Beats* (New York: Thomas Y. Crowell, 1961), p. 192.

3. Bruce Conner, in an unpublished interview with Dan Tooker, 1972.

4. Wally Hedrick, quoted in *Sixteen Americans*, catalogue of an exhibition at the Museum of Modern Art, New York, 1959, p. 13.

5. Philip Leider, "Bruce Conner: A New Sensibility," *Artforum*, November 1962, p. 36.

6. Maurice Tuchman, *Sculpture of the Sixties*, catalogue of an exhibition at the Los Angeles County Museum of Art, Los Angeles, 1967, p. 47.

7. Edward Kienholz, quoted in Arthur Secunda, "John Bernhardt, Charles Frazier, Edward Kienholz," *Artforum*, October 1962, p. 30.

8. Anita Ventura, "Manuel Neri," *Contemporary Sculpture Arts Yearbook 8* (New York: Art Digest, Inc., 1965), p. 138.

9. Jess Collins, quoted in Suzi Gablik and John Russell, *Pop Art Redefined* (New York: Praeger Publishers, 1969), p. 61.

CHAPTER 7

1. Joseph A. Pugliese, "Casting in the Bay Area," *Artforum*, September 1963, p. 11.

2. Billy Al Bengston, "Late Fifties at the Ferus," *Artforum*, January 1969, p. 34.

3. *Ibid.*, p. 35.

4. Barbara Rose, "Los Angeles: The Second City," *Art in America*, January 1966, pp. 110–15.

5. John Humphrey, *David Simpson*, catalogue of an exhibition of the San Francisco Museum of Art, San Francisco, 1967, p. 10.

6. Quoted in Peter Plagens, "Ed Moses: The Problem of Regionalism," *Artforum*, March 1972, p. 85.

7. Helene Winer, *Ed Moses: Some Early Work, Some Recent Work, Some Work in Progress*, catalogue of an exhibition at the Pomona College Art Gallery, Pomona, California, 1971, unpaginated.

CHAPTER 8

1. Jules Langsner, *Four Abstract Classicists*, catalogue of an exhibition at the Los Angeles County Museum of Art, Los Angeles, 1959, p. 10.

2. Charles Kessler, "Los Angeles: Four Abstract Classicists," *Arts*, December 1959, p. 23.

3. John McLaughlin, quoted in Jules Langsner, "Art News from Los Angeles," *Art News*, January 1964, p. 50.

4. Billy Al Bengston, quoted in Carol Lindsley, *Billy Al Bengston, Ed Ruscha*, catalogue of an exhibition at the Reese Palley Gallery, San Francisco, 1969, unpaginated.

5. Peter Plagens, "Larry Bell Reassessed," *Artforum*, October 1972, pp. 72–73.

6. Robert Irwin, quoted in *Transparency, Reflection, Light, Space: Four Artists*, catalogue of an exhibition at the UCLA Art Galleries, Los Angeles, 1971, p. 71.

7. James Turrell, quoted in *A Report on the Art and Technology Program of the Los Angeles County Museum of Art, 1967–71*, catalogue of an exhibition at the Los Angeles County Museum of Art, Los Angeles, 1971, p. 140.

8. Peter Plagens, "Michael Asher: The Thing of It Is . . ." *Artforum*, April 1972, pp. 76–77.

CHAPTER 9

1. Nancy Marmer, "Pop Art in California," in Lucy Lippard, *Pop Art* (New York: Praeger Publishers, 1966), p. 147.

2. Lucy Lippard, in *Kenneth Price and Robert Irwin*, catalogue of an exhibition at the

Los Angeles County Museum of Art, Los Angeles, unpaginated.

3. Peter Plagens, review, *Artforum*, March 1971, p. 71.

CHAPTER 10

1. Robert Morris, "The Art of Existence: Three Extra-Visual Artists," *Artforum*, January 1971, p. 28.
2. News release, Los Angeles County Museum of Art, Los Angeles, November 8, 1965.
3. Susan Abbott, "Gemini G.E.L.," *Made in California*, catalogue of an exhibition at the UCLA Art Galleries, Los Angeles, 1971, p. 13.
4. Admissions Bulletin, California Institute of the Arts, Valencia, California, 1973, p. 1.
5. Bulletin, California Institute of the Arts, Burbank, California, 1971, p. 4.

CHAPTER 11

1. Maurice Tuchman, *A Report on the Art and Technology Program at the Los Angeles County Museum of Art, 1967–71*, catalogue of an exhibition at the Los Angeles County Museum of Art, Los Angeles, 1971, p. 9.
2. Bruce Nauman, quoted in Joseph E. Young, "Los Angeles," *Art International*, Summer 1970, p. 113.
3. Thomas Garver, *The New Art of Vancouver*, catalogue of an exhibition at the Newport Harbor Art Museum, Newport Beach, California, 1969, p. 6.

Bibliography

Chapter 1

BOOKS

ADRIANI, BRUNO. *Pegot Waring*. New York: Nirendorf Editions, 1945.
HALE, DENNIS, and JONATHAN EISEN (eds.). *The California Dream*.
 New York: Macmillan, 1968.
HELM, McKINLEY. *Man of Fire*. New York: Harcourt, Brace, 1953.
McCOY, ESTHER. *Five California Architects*. New York: Reinhold
 Publishing, 1960.
O'CONNER, FRANCIS V. *The New Deal Art Projects: An Anthology of
 Memoirs*. Washington, D.C.: Smithsonian Institution, 1972.
OLDER, MRS. FREMONT. *San Francisco*. New York: Longmans, Green, 1961.
San Francisco [W.P.A. Writers' Project]. New York: Hastings House, 1947.

CATALOGUES

Arts of Southern California—XIV: Early Moderns, Long Beach Museum of
 Art, Long Beach, California, 1964.
California Centennial Exhibition of Art, Los Angeles County Museum
 of Art, Los Angeles, 1949.
California State Fair Art Exhibition, California State Fair, Sacramento,
 1951.
Contemporary Painting in the United States, Los Angeles County Museum
 of Art, Los Angeles, 1951.
Dan Lutz, Hatfield Galleries, Los Angeles, 1958.
Knud Merrild, 1894–1954, Los Angeles County Museum of Art,
 Los Angeles, 1959.
LANGSNER, JULES. *Man Ray*, Los Angeles County Museum of Art,
 Los Angeles, 1966.
MACDONALD-WRIGHT, STANTON. *Paintings by American Modernists*,
 Los Angeles County Museum of Art, Los Angeles, 1920.

ARTICLES

MACDONALD-WRIGHT, STANTON. "Art News from Los Angeles: A Brief Discussion of the Development of the Arts in Southern California, *Art News*, October 1955, p. 8.
MASCHEK, JOSEPH. "New York Reviews," *Artforum*, January 1971, p. 72.
MILLIER, ARTHUR. *Maynard Dixon, Painter of the West*. Tucson, 1945.

Chapter 2

CATALOGUES

Annual Exhibitions of Artists of Los Angeles and Vicinity, Los Angeles County Museum of Art, Los Angeles, 1950, 1951, 1952, 1953, 1954, 1955, 1956, 1957, 1958, 1959, 1960, 1961.
Los Angeles, 1972: A Panorama of Black Artists, Los Angeles County Museum of Art, Los Angeles, 1972.

ARTICLES

BENGSTON, BILLY AL ."Some Los Angeles Artists' Studios," *Art in America*, November 1970.
COPLANS, JOHN, "Los Angeles: The Scene," *Art News*, March 1965, pp. 28–29 +.
FEITELSON, LORSER. Letter, *Artforum*, September 1962, p. 2.
"Galleries in Los Angeles," *Studio International*, December 1963, pp. 260–62.
GOODALL, DONALD B. "Controversy on City-Sponsored Art Projects," *Art Digest*, April 1953, p. 11.
HAUPTMAN, WILLIAM. "The Suppression of Art in the McCarthy Decade," *Artforum*, October 1973, pp. 48–52.
LANGSNER, JULES. "America's Second Art City," *Art in America*, April 1963, pp. 127–31.
_____."Art News from Los Angeles," *Art News*, April 1950, pp. 50 +; October 1951, p. 50; June 1956, p. 22; February 1957, p. 20.
_____. "Los Angeles's Stormy All-City Show," *Art News*, December 1951, pp. 52 +.
_____. "Regional Annual Includes Large Group of Invited Pictures," *Art News*, June 1951, pp. 38 +.
_____. "Southern California Annual," *Art News*, Summer 1959, pp. 49 +
_____. "This Month in California," *Art News*, September 1949, p. 44.
MILLIER, ARTHUR. "Jury Gets Tough with Los Angeles Artists at Eighth Annual," *Art Digest*, June 1949, p. 12.
_____. "Los Angeles Artists Hold Exciting Regional," *Art Digest*, June 1948, p. 14.
_____. "Los Angeles Events," *Art Digest*, May 1, 1947, p. 8; July 1, 1947, p. 6; December 1, 1947, p. 8; March 15, 1949, p. 6; April 15, 1949, pp. 23 +.
NORDLAND, GERALD. "Collecting in Los Angeles," *Artforum*, Summer 1964, pp. 13 +.

PLAGENS, PETER. "Los Angeles: New Direction in the Galleries,"
 Artscanada, December 1967, Supplement 3.
————. "Los Angeles: The Ecology of Evil," *Artforum*, December 1972,
 pp. 67–78.
"Reaction and Censorship in Los Angeles: Seventh Annual All-City
 Exhibition," *Art Digest*, November 15, 1951, p. 9.
RODITI, EDWARD. "Los Angeles Art Market," *Arts*, April 1967, p. 51.
ROSE, BARBARA. "Los Angeles: The Second City," *Art in America*,
 January 1966, pp. 110–15.
SELDIS, HENRY J. "Los Angeles: The Rosenthal Affair," *Art Digest*,
 February 15, 1955, p. 15.
WHOLDEN, ROSALIND. "Los Angeles," *Arts*, February 1965, pp. 78–80.
WURDEMANN, HELEN. "Stroll on La Cienega," *Art in America*, October
 1965, pp. 115–18.

Chapter 3

BOOKS

McCHESNEY, MARY FULLER. "Bay Area Abstraction," unpublished ms.,
 1972.
ROSE, BARBARA. *American Art Since 1900*. New York: Praeger Publishers,
 1967.

CATALOGUES

Annual Exhibitions of Drawings and Prints, San Francisco Museum of Art,
 San Francisco, 1941 (5th), 1942 (6th) 1943 (7th), 1944 (8th), 1946
 (10th), 1947 (11th), 1948 (12th), 1949 (13th), 1950 (14th), 1951
 (15th), 1952 (16th), 1953 (17th), 1954 (18th), 1955 (19th), 1956 (20th).
Annual Exhibitions of Painting, California Palace of the Legion of Honor,
 San Francisco, 1947 (2d), 1948 (3d), 1950 (4th).
Annual Exhibitions of Watercolors, San Francisco Museum of Art, San
 Francisco, 1941 (5th), 1942 (6th), 1943 (7th), 1944 (8th), 1946 (10th),
 1947 (11th), 1948 (12th), 1949 (13th), 1950 (14th), 1951 (15th), 1952
 (16th), 1953 (17th), 1954 (18th), 1955 (19th), 1956 (20th).
Annual Exhibitions of Watercolors, Drawings and Prints, San Francisco
 Museum of Art, San Francisco, 1957 (21st), 1958 (22d), 1959 (23d).
ARNASON, H. H. *Sixty American Painters*, Walker Art Center, Minneapolis,
 1960.
Art and Artists, University of California, Berkeley, 1956.
Art Since 1950, Seattle World's Fair, Seattle, 1962.
Faralla, San Francisco Museum of Art, San Francisco, 1966.
Fifteen American Painters, Long Beach Museum of Art, Long Beach,
 California, 1957.
Fifty California Artists, Whitney Museum of American Art, New York,
 1962.
HOPPS, WALTER. *Frank Lobdell*, Pasadena Art Museum, Pasadena,
 California, 1966.
McCHESNEY, MARY FULLER. *A Period of Exploration: San Francisco,
 1945–50*, Oakland Museum, Art Department, Oakland, California, 1973.

Martin, Fred. *Wally Hedrick and Sam Tchakalian*, Newport Harbor Art
 Museum, Newport Beach, California, 1967.
Miller, Dorothy. *Sixteen Americans*, Museum of Modern Art, New York,
 1959.
Painters Behind Painters, California Palace of the Legion of Honor, San
 Francisco, 1967.
San Francisco Art Association Annual Exhibitions, San Francisco
 Museum of Art, San Francisco, 1940 (60th), 1941 (61st), 1942 (62d),
 1943 (63d), 1944 (64th), 1945 (65th), 1946 (66th), 1948 (67th), 1950
 (69th), 1951 (70th), 1952 (71st), 1953 (72d), 1954 (73d), 1955 (74th),
 1957 (76th), 1958 (77th), 1959 (78th), 1961 (80th), 1964 (83d), 1965
 (84th), 1966 (85th).
West Coast, 1954–69, Pasadena Art Museum, Pasadena, California, 1969.

ARTICLES

Ashton, Dore. "West Coast Artists Score in Painting," *Studio
 International*, February 1963, pp. 64–66.
"Bufano in the Open," *Newsweek*, October 23, 1944, pp. 105–6.
Chipp, Herschel B. "Art News from San Francisco," *Art News*, April
 1956, p. 20; June 1956, pp. 22 +; February 1957, p. 20; December 1957,
 p. 50; April 1958, p. 48; June 1959, p. 24.
————. "This Summer in San Francisco." *Art News*, June 1958, p. 48.
"Cleavage of Styles: Fair's Nationwide Exhibition," *Art News*, November
 1956, p. 50.
Crehan, Hubert. "Is There a California School?" *Art News*, January
 1956, pp. 32–35.
Culler, George D. "California Artists," *Art in America*, Fall 1962,
 pp. 84–89.
"Exhibition of Work of the Faculty of the California School of Fine Arts,"
 California Palace of the Legion of Honor Bulletin, October 1946.
Ferling, Lawrence. "Muralist Refregier and the Haunted Post Office,"
 Art Digest, April 15, 1953, p. 12.
Ferlinghetti, Lawrence. "Bay Region Painting and Sculpture," *Art
 Digest*, August 1955, p. 26.
————. "Seventy-fourth Annual at the San Francisco Museum," *Art
 Digest*, May 1, 1955.
Fried, Arthur. "San Francisco Region, 1947," *Art News*, June 1947,
 pp. 24–28 +.
Grissom, S. "San Francisco," *Arts*, May 1958, p. 20.
Loran, Erle, "Art News from San Francisco," *Art News*, January 1954,
 pp. 22–23; April 1950, pp. 50 +.
————. "State Fair," *Art News*, October 1951, pp. 52 +
McCawley, N. "Art News from San Francisco," *Art News*, May 1957,
 p. 50.
Munro, E. C. "Art News from San Francisco," *Art News*, December
 1959, p. 50.
"San Francisco Painters at Kaufmann Y.W.H.A.," *Art News*, March
 1954, p. 43.
Still, Patricia. Letter, *Artforum*, September 1964, p. 2.

Chapter 4

BOOKS

HUNTER, SAM. *Art Since 1945*. New York: Washington Square Press, 1961.

ROBERTS, COLLETTE. *Mark Tobey*. New York: Grove Press, 1959.

SCHIED, WIELAND. *Mark Tobey*. New York: Abrams, 1966.

CATALOGUES

Americans, 1942, Museum of Modern Art, New York, 1942.

Mark Tobey, Galerie Beyeler, Basel, Switzerland, 1970.

Mark Tobey Prints, Los Angeles County Museum of Art, Los Angeles, 1972.

Mark Tobey Retrospective, Dallas Museum of Fine Arts, Dallas, 1968.

Mark Tobey Retrospective, Seattle Art Museum, Seattle, 1959.

MICHELSON, ANNETTE. *Les monotypes de Tobey*, Galerie Jeanne Bucher, Paris, 1965.

Morris Graves Retrospective, Newport Harbor Art Museum, Newport Beach, California, 1963.

SEITZ, WILLIAM. *Mark Tobey*, Museum of Modern Art, New York, 1962.

Tobey, Hanover Gallery, London, 1968.

WILDER, MITCHELL. *The Artist's Environment: West Coast*, Amon Carter Museum of Western Art, Fort Worth, Texas, 1962.

ARTICLES

"Artists of Oregon," *Portland Museum Bulletin*, May 1954.

"Artists of Oregon: Drawings and Prints, 1956," *Portland Museum Bulletin*, October 1956.

BALDINGER, W. "Regional Accent: The Northwest," *Art in America*, January–February 1965, pp. 34–39.

CALLAHAN, KENNETH, "C. S. Price of Portland, Oregon," *Art News*, May 1951, pp. 21+.

"Carl Morris—A Decade of Painting," *Portland Museum Bulletin*, October 1956.

CHIPP, HERSCHEL B. "Pacific Coast Art at San Francisco Museum," *Art News*, September 1956, pp. 18+.

DETLIE, J. S. "Community Collaboration in the Fine Arts," *AIA Journal*, November 1956, p. 11.

FAUNCE, SARAH C. "Mark Tobey: Painter or Prophet?" *Art News*, September 1962, p. 59.

"Fourth All-Oregon Exhibition and Work of the Students of the Museum Art School," *Portland Museum Bulletin*, June 1946.

"Jack Wilkinson: Paintings," *Portland Museum Bulletin*, March 1954.

KOCH, N. "Portland," *Artforum*, June 1962, pp. 13–14.

"Louise Bunce Retrospective," *Portland Museum Bulletin*, March 1955.

MILLIER, ARTHUR. "The Pacific Coast Artists Are Stimulated by Its Diverse Climates," *Art Digest*, November 1, 1951.

MONTGOMERY, CHARLOTTE. "Artists of Oregon Seen in New Annual,"
 Art Digest, July 1, 1949.
MUNSON, GRETCHEN T. "Review of Mark Tobey Exhibition," *Art News*,
 November 1949, p. 52.
———. "35th Annual: Seattle," *Art News*, November 1949, p. 52.
REED, J. K. "Mystic Paintings of Man's Destiny," *Art Digest*, April 15, 1949,
 p. 24.
REXROTH, KENNETH. "Mark Tobey of Seattle, Washington," *Art News*,
 May 1951, pp. 16+.
"Seattle Honors Abstractions in the Thirty-sixth Annual," *Art Digest*,
 October 15, 1950, p. 12.
"Seattle's Trend Is to the Right: 31st Annual," *Art News*, November 1,
 1945, p. 25.
SELZ, PETER, and TOM ROBBINS. "The Pacific Northwest Today," *Art in
 America*, November 1968, pp. 98–101.
"Symbols and Fantasy: Exhibition of Local Painters and Sculptors," *Art
 News*, November 1954, p. 55.
TOBEY, MARK. "Japanese Traditions and Modern Art," *Art Journal*, Fall
 1958, p. 21.

Chapter 5

BOOKS

LEYMARIE, JEAN. *Art Since Mid-Century: The New Internationalism*. 2 vols.
 Greenwich, Conn.: New York Graphic, 1971.
SELDIS, HENRY J. *Rico Lebrun*. Greenwich, Conn.: New York Graphic, 1967.
SELDIS, HENRY J., and ULFERT WILKE. *The Sculpture of Jack Zajac*. Los
 Angeles: Galland Press, 1960.

CATALOGUES

Art Bank, San Francisco Art Institute, San Francisco, 1958.
COOPER, GENE. *Wayne Thiebaud*, California State University, Long
 Beach, California, 1972.
EITNER, LORENZ. *Drawings by Richard Diebenkorn*, Stanford University,
 Palo Alto, California, 1965.
HOPKINS, HENRY T. *Fifty Paintings by Thirty-seven Painters of the
 Los Angeles Area*, UCLA Art Galleries, 1960.
———. *John Paul Jones*, Los Angeles County Museum of Art, Los
 Angeles, 1965.
MILLS, PAUL. *David Park Memorial Exhibition: The University Years*,
 University of California, Berkeley, 1964.
———. *David Park Retrospective Exhibition*, Staempfli Gallery, New
 York, 1962.
New Paintings by Richard Diebenkorn, Los Angeles County Museum of
 Art, Los Angeles, 1969.
NORDLAND, GERALD. *Richard Diebenkorn*, Washington Gallery of Modern
 Art, Washington, D.C., 1964.

Rico Lebrun: Drawings, University of California Press, Berkeley, 1961.
Six Printmakers of the Bay Area, Achenbach Foundation, San Francisco, 1962.
Tribute to Francis de Erderly, Los Angeles County Art Institute, Los Angeles, 1959.

ARTICLES

CHIPP, HERSCHEL B. "Art News from San Francisco," Art News, March 1956, p. 12.
———. "Diebenkorn Paints a Picture," Art News, May 1957, p. 55.
"Figure Painters in California," Arts, December 1957, p. 26.
KRAMER, HILTON. "Pure and Impure Diebenkorn," Arts, December 1963, p. 46.
LORAN, ERLE. "Joint Show of the Latest Work of Elmer Bischoff, David Park, and Hassel Smith," Art News, September 1949, pp. 45+.
METCALF, KATHERINE. "Art News from San Francisco," Art News, February 1946.
PLAGENS, PETER. Review, Artforum, December 1969, p. 74.

Chapter 6

BOOKS

COOK, BRUCE. The Beat Generation. New York: Scribner's 1971.
NEUHAUS, EUGEN. The Art of the Exposition. San Francisco: Paul Elder and Co., 1915.
PARKINSON, THOMAS (ed.). A Casebook on the Beats. New York: Thomas Y. Crowell, 1961.
RIGNEY, FRANCIS J., and DOUGLAS L. SMITH. The Real Bohemia. New York: Basic Books, 1961.
TOOKER, DAN. "Interviews with Bay Area Artists," unpublished ms., 1972.

CATALOGUES

Assemblage in Southern California, University of California, Irvine, 1968.
HULTEN, K. G. PONTUS. The Machine: As Seen at the End of the Machine Age, Museum of Modern Art, New York, 1968.
RUBIN, WILLIAM S. Dada, Surrealism and Their Heritage, Museum of Modern Art, New York, 1968.
SEITZ, WILLIAM. The Art of Assemblage, Museum of Modern Art, New York, 1961.
SELZ, PETER. Funk, University Art Museum, Berkeley, 1967.
SIGFRIED, JOAN. Bruce Conner, Institute of Contemporary Art, University of Pennsylvania, Philadelphia, 1967.
TUCHMAN, MAURICE. Edward Kienholz, Los Angeles County Museum of Art, Los Angeles, 1966.
Wallace Berman. Los Angeles County Museum of Art, Los Angeles, 1968.

ARTICLES

"Art Groups Fight to Save L.A. Towers: Bizarre Structures in Suburban Watts," *Architectural Forum*, July 1959, pp. 9+.

FERLING, LAWRENCE. "CSFA Saved," *Art Digest*, August 1954, pp. 16–17.

LANGSNER, JULES. "Art News from Los Angeles," *Art News*, May 1962, pp 46+.

LEIDER, PHILIP. "Bruce Conner: A New Sensibility," *Artforum*, November 1962, p. 36.

MONTE, JAMES. "Funk at U.C. Berkeley," *Artforum*, Summer 1967.

————. "Polychrome Sculpture," *Artforum*, November 1964.

PARIS, HAROLD. "Sweet Land of Fun," and PETER SELZ, "Funk Art," *Art in America*, March 1967, pp. 92–98.

SECUNDA, ARTHUR. "John Bernhardt, Charles Frazier, Edward Kienholz," *Artforum*, October 1962, p. 30.

SELZ, PETER, with BRENDA RICHARDSON. "California Ceramics," *Art in America*, May 1969.

VENTURA, ANITA. "Bay Climate." *Arts*, December 1963, pp. 29–33.

————. "Manuel Neri," *Contemporary Sculpture: Arts Yearbook 8*, New York: The Art Digest, Inc., 1965, p. 138.

Chapter 7

CATALOGUES

Annual Southern California Exhibitions, Long Beach Museum of Art, Long Beach, California, 1963 (1st), 1964 (2d), 1965 (3d), 1966 (4th), 1967 (5th), 1968 (6th), 1969 (7th), 1970 (8th), 1971 (9th), 1972 (10th).

Arts of Southern California—II: Painting, Long Beach Museum of Art, Long Beach, California, 1958.

Arts of Southern California—VIII: Drawing, Long Beach Museum of Art Long Beach, California, 1960.

Arts of Southern California—XIII: Painting, Long Beach Museum of Art, Long Beach, California, 1963.

Arts of Southern California—XVII: Painting: The Introspective Image, Long Beach Museum of Art, Long Beach, California, 1966.

The Ceramic Work of Gertrude and Otto Natzler, Los Angeles County Museum of Art, Los Angeles, 1966.

COPLANS, JOHN. *Abstract Expressionist Ceramics*, University of California, Irvine, 1968.

————. *John Mason: Sculpture*, Los Angeles County Museum of Art, Los Angeles, 1966.

Five Younger Los Angeles Artists, Los Angeles County Museum of Art, Los Angeles, 1965.

Francis, Kanemitsu, Moses, Wayne, Downey Museum of Art, Downey, California, 1969.

HUMPHREY, JOHN. *David Simpson*, San Francisco Museum of Art, San Francisco, 1967.

MONTE, JAMES. *Late Fifties at the Ferus*, Los Angeles County Museum of Art, Los Angeles, 1968.

NORDLAND, GERALD. *Arts of Southern California—XII: Sculpture*, Long Beach Museum of Art, Long Beach, California, 1962.

PAALEN, WOLFGANG, *Dynaton, 1951*, San Francisco Museum of Art, San Francisco, 1951.

Pacific Coast Invitational, Santa Barbara Museum of Art, Santa Barbara, California, 1962.

Peter Voulkos: Sculpture, Los Angeles County Museum of Art, Los Angeles, 1965.

Robert Thomas, University of California, Santa Barbara, 1966.

Sam Francis, Klipstein & Kornfeld, Bern, Switzerland.

Sixty-two Works of Art from Santa Barbara and Vicinity, Santa Barbara Museum of Art, Santa Barbara, California, 1965.

Some Aspects of California Painting and Sculpture, La Jolla Art Museum, La Jolla, California, 1965.

The West Coast Now, Portland Art Museum, Portland, Oregon, 1968.

WINER, HELENE. *Ed Moses: Some Early Work, Some Recent Work, Some Work in Progress*, Pomona College Art Gallery, Pomona, California, 1971.

ARTICLES

"Art Today," *Art News*, May 1952.

BENGSTON, BILLY AL. "Late Fifties at the Ferus," *Artforum*, January 1969, p. 34.

BOGAT, R. "Fifty California Artists," *Artforum*, December 1962, p. 23.

"California Sculpture Today: Special Issue," *Artforum*, September 1963.

CHERRY, HERMAN. "Los Angeles Revisited," *Arts*, March 1956, pp. 18+.

COPLANS, JOHN. "Voulkos: Retrospective Exhibition at Los Angeles County Museum of Art," *Art News*, Summer 1965, pp. 9+.

EMANUEL, J. "San Francisco," *Artscanada*, March 1967, Supplement 6.

FRANKENSTEIN, ALFRED. "Far and Wide in San Francisco," *Art in America*, Winter 1960, pp. 124+.

GIAMBRUNI, H. "Abstract Expressionist Ceramics," *Craft Horizons*, November 1966, pp. 25+.

LANGSNER, JULES. "Art News from Los Angeles," *Art News*, June 1956, pp. 22+; February 1957, p. 20; May 1957, p. 50; December 1957, p. 51; April 1958, p. 48; October 1958, p. 44; April 1959, p. 48; February 1960, p. 47; February 1961, p. 53; January 1962, p. 52; February, 1962, pp. 48+; Summer 1962, p. 45; October 1962, pp. 60+; December 1962, p. 22; January 1964, pp. 50+.

————. "Brouhaha 1960," *Art News*, September 1960, p. 51.

————. "Fifty Paintings by Thirty-seven Painters of the Los Angeles Area at U.C.L.A.," *Art News*, May 1960, p. 48.

————. "Fortieth Annual California Watercolor Society Exhibition at the Los Angeles County Museum," *Art News*, December 1960, p. 46.

————. "Trends and Anti-Trends," *Art News*, June 1958, p. 50.

MAGLOFF, J. "Art News from San Francisco," *Art News*, January 1964, pp. 51–52; March 1964, p. 20.

METCALF, KATHERINE. "Art News from San Francisco," *Art News*, Summer 1966, p. 55.

NORDLAND, GERALD. "Los Angeles Overture," *Arts*, October 1962, pp. 46–47.

————. "West Coast in Review," *Arts*, December 1961, pp. 64–65.

PERKINS, CONSTANCE. "Los Angeles: The Way You Look at It," *Art in America*, March 1966, pp. 112–18.

PLAGENS, PETER. "Ed Moses: The Problem of Regionalism," *Artforum*, March 1972, p. 85.

PUGLIESE, JOSEPH A. "Casting in the Bay Area," *Artforum*, September 1963, p. 11.

"Recent Art of the West Coast," *Art in America*, February 1955, pp. 62–71.

SCOTT, R. W. "Q & A: San Francisco," *Art in America*, Summer 1960, p. 136.

SELDIS, HENRY J. "Southern California," *Art in America*, Winter 1960, pp. 56–59.

————. "Southern California Roundup," *Art Digest*, January 1, 1955, p. 14.

SELZ, PETER. "Los Angeles," *Arts*, February 1958, pp. 20–21.

VENTURA, ANITA. "Arts of San Francisco at the San Francisco Museum," *Arts*, October 1964, p. 23.

————." Prospect Over the Bay Area," *Arts*, May 1963, pp. 19–21.

WHOLDEN, ROSALIND. "Paint and Fable," *Arts*, March 1964, pp. 39–41.

WURDEMAN, HELEN. "Variety in Los Angeles," *Art in America*, Summer 1960.

Chapter 8

CATALOGUES

BUTLER, LEROY. *Looking West, 1970*, Joslyn Art Museum, Omaha, 1970.

California Art Festival, Lytton Center of the Visual Arts, Los Angeles, 1967.

Color, UCLA Art Galleries, Los Angeles, 1970.

COPLANS, JOHN. *Serial Imagery*, Pasadena Art Museum, Pasadena, California, 1968.

GOODRICH, LLOYD. *Young America, 1965*, Whitney Museum of American Art, New York, 1965.

LANGSNER, JULES. *Four Abstract Classicists*, Los Angeles County Museum of Art, Los Angeles, 1959.

LEIDER, PHILIP, and LUCY LIPPARD. *Robert Irwin and Kenneth Price*, Los Angeles County Museum of Art, Los Angeles, 1966.

LICHT, JENNIFER. *Spaces*, Museum of Modern Art, New York, 1969.

LINDSLEY, CAROL. *Billy Al Bengston, Ed Ruscha*, Reese Palley Gallery, San Francisco, 1969.

TUCHMAN, MAURICE. *A Report on the Art and Technology Program of the Los Angeles County Museum of Art, 1967–71*, Los Angeles County Museum of Art, Los Angeles, 1971.

WIGHT, FREDERICK. *Transparency, Reflection, Light, Space: Four Artists*, UCLA Art Galleries, Los Angeles, 1971.

ARTICLES

COPLANS, JOHN. "Art News from Los Angeles," *Art News*, January 1965, p. 21; December 1965, p. 52.

_____. "Los Angeles: Object Lesson," *Art News*, January 1966, p. 40.
DANIELI, FIDEL. "Art News from Los Angeles," *Art News*, March 1966,
 pp. 20+.
_____. "Bell's Progress," *Artforum*, Summer 1967, pp. 68–71.
"Functionists West: A Group Show," *Art News*, November 1952, p. 50.
HOTALING, ED. "Los Angeles," *Art News*, September 1970, p. 62.
KESSLER, CHARLES. "Los Angeles: Four Abstract Classicists," *Arts*,
 December 1959, p. 23.
LANGSNER, JULES. "Art News from Los Angeles," *Art News*, January 1964,
 p. 50.
LEIDER, PHILIP. "West Coast: Three Images," *Artforum*, June 1963,
 pp. 21–25.
LEOPOLD, MICHAEL. "Los Angeles," *Art News*, September 1970, p. 62.
LINDSLEY, CAROL. "Plastics into Art," *Art in America*, May 1968.
"Los Angeles," *Artscanada*, February 1967, Supplement 5.
PLAGENS, PETER. "Larry Bell Reassessed," *Artforum*, October 1972,
 pp. 72–73.
_____. "Michael Asher: The Thing of It Is . . ." *Artforum*, April 1972,
 pp. 76–77.
SECUNDA, ARTHUR. "Los Angeles," *Arts*, November 1966, pp. 50–51.
SELZ, PETER, and JANE LIVINGSTON. "Second Generation in Los Angeles,"
 Art in America, January 1969, pp. 92–97.
"Special Issue," *Art in America*, June 1964.
TERBELL, MELINDA. "Los Angeles," *Arts*, November 1970, p. 53.
WURDEMANN, HELEN. "Los Angeles—Success Abroad," *Art in America*,
 March–April 1961, p. 135.

Chapter 9

BOOKS

COMPTON, MICHAEL. *Pop Art*. Movements of Modern Art. London: Hamlyn
 Publishing, 1970.
LIPPARD, LUCY. *Pop Art*. New York: Praeger Publishers, 1967.
RUSCHA, EDWARD. *Crackers*. Los Angeles: Heavy Industry Publications,
 1969.
_____. *A Few Palm Trees*. Los Angeles: Heavy Industry Publications,
 1968.
_____. *Nine Swimming Pools and a Broken Glass*. Los Angeles: Heavy
 Industry Publications, 1968.
_____. *Some Los Angeles Apartments*. Los Angeles: Heavy Industry
 Publications, 1965.
_____. *Various Small Fires and Milk*. Los Angeles: Heavy Industry
 Publications, 1964.
RUSSELL, JOHN, and SUZI GABLICK (eds.). *Pop Art Redefined*. New York:
 Praeger Publishers, 1969.

CATALOGUES

ALLOWAY, LAWRENCE. *Six Painters and the Object*, Solomon R.
 Guggenheim Museum, New York, 1963.

BREWER, DONALD. *Other Landscapes and Shadowland*, USC, Los Angeles, 1971.
COPLANS, JOHN. *Pop Art U.S.A.*, Oakland Museum, Oakland, California, 1963.
————. *Wayne Thiebaud*, Pasadena Art Museum, Pasadena, California, 1968.
Edward Ruscha, Iolas Gallery, New York, 1970.
Six More, Los Angeles County Museum of Art, Los Angeles, 1963.

ARTICLES

COPLANS, JOHN. "Art News from Los Angeles," *Art News*, February 1965, p. 51.
LANGSNER, JULES. "Art News from Los Angeles," *Art News*, Summer 1963, p. 47.
MAGLOFF, J. Review, *Art News*, April 1964, pp. 20+.
NORDLAND, GERALD. "Pop Goes the West," *Arts*, February 1963, pp. 60–62.
PLAGENS, PETER. Review, *Artforum*, December 1969, p. 74.
————. Review, *Artforum*, March 1971, p. 71.
WEBER, J. W. Letter, *Arts*, Summer 1967, p. 7.
WHOLDEN, ROSALIND. "Sowing Contention from Greener Pastures," *Arts*, November 1963, pp. 40–42.

Chapter 10

CATALOGUES

Admissions Bulletins, California Institute of the Arts, Valencia, 1971–72, 1972–73.
Made in California, UCLA Art Galleries, Los Angeles, 1971.
TUCHMAN, MAURICE. *American Sculpture of the Sixties*, Los Angeles County Museum of Art, Los Angeles, 1967.

ARTICLES

ANTIN, DAVID. "Art and the Corporations," *Art News*, September 1971, pp. 22–26+.
BAKER, ELIZABETH C. "Los Angeles, 1971," *Art News*, September 1971, pp. 27–39.
BURNHAM, JACK. "Corporate Art," *Artforum*, October 1971, pp. 66–71.
"California, 1970: Special Issue," *Arts*, Summer 1970.
CARPENTER, K. "San Francisco," *Artscanada*, June–July 1967, Supplement 9, unpaginated.
KOSTOFF, S. "Three New Museums: West Coast Report," *Art in America*, January 1968, pp. 106–7.
MORRIS, ROBERT. "The Art of Existence: Three Extra-Visual Artists," *Artforum*, January 1971, pp. 28–33.
SELZ, PETER, with HENRY J. SELDIS. "Cal Arts," *Art in America*, March 1969, pp. 107–9.
SELZ, PETER, with WILLIAM WILSON. "Los Angeles: A View from the Studios," *Art in America*, November 1968, pp. 98–101.
ZACK, DAVID. "San Francisco," *Art News*, September 1969, p. 25; January 1970, p. 24.

Chapter 11

BOOKS

BATTCOCK, GREGORY. *The New Art*. New York: Dutton, 1966.
ROSENBERG, HAROLD. *The Anxious Object*. New York: Horizon Press, 1964.
————. *Artworks and Packages*. New York: Horizon Press, 1969.
————. *The De-definition of Art*. New York: Horizon Press, 1972.

CATALOGUES

ADLER, SEBASTIAN. *10*, Contemporary Arts Museum, Houston, 1972.
Advertising brochure, Environmental Communications, Venice, California, 1972.
Biennial of Canadian Painting, National Gallery of Canada, Ottawa, 1959, 1968.
Canadian Painting, National Gallery of Canada, Ottawa, 1963.
Contemporary Arts Council New Talent Awards, Los Angeles County Museum of Art, Los Angeles, 1972.
GARVER, THOMAS. *The New Art of Vancouver*, Newport Harbor Art Museum, Newport Beach, California, 1969.
LIVINGSTON, JANE, and MARCIA TUCKER. *Bruce Nauman*, Los Angeles County Museum of Art, Los Angeles, 1972.
RICHARDSON, BRENDA. *William T. Wiley*, University Art Museum, Berkeley, 1971.
Scott Grieger, Los Angeles County Museum of Art, Los Angeles, 1972.
Six Touring Exhibitions, San Francisco Art Institute, San Francisco, 1968.
Stephan von Huene, Los Angeles County Museum of Art, Los Angeles, 1969.
Twelve Touring Exhibitions, San Francisco Art Institute, San Francisco, 1970.
Twenty-four Young Los Angeles Artists, Los Angeles County Museum of Art, Los Angeles, 1971.

ARTICLES

ANGLIN, P. M. "Entente Cordiale in San Francisco," *Artscanada*, August 1968, pp. 4–8.
BALKIND, ALVIN. "Vancouver," *Artforum*, December 1967, p. 64.
BALLANTINE, M. "New Deal for the Vancouver Art Gallery," *Canadian Art*, March 1965, pp. 42–43.
BUCKLEY, P. "Keeping It Together in Vancouver," *Artscanada*, June 1971, pp. 39–43.
CHANDLER, N. "Incoherent Thoughts on Concrete Poetry," *Artscanada*, August 1969, pp. 11–13.
CHIPP, HERSCHEL B. "Art News from San Francisco," *Art News*, October 1960, pp. 50+.
EMERY, T. "Letter from the West Coast," *Canadian Art*, March 1966, p. 53.
FINLAYSON, D. "Vancouver," *Canadian Art*, November 1963, p. 323; January 1964, p. 17.
FRASER, J. "Collage Show," *Artscanada*, June 1971, p. 80.

HUBBARD, R. H. "Climate for the Arts," *Canadian Art*, March 1965, pp. 105+.

KYLE, J. "New Alchemy," *Artscanada*, June 1968, pp. 10–21.

LANGSNER, JULES. "Kinetics in Los Angeles," *Art in America*, May 1967, pp. 107–9.

LEIDER, PHILIP. "Vancouver: Scene with No Scene," *Artscanada*, June–July 1967, pp. 6–7.

LIPPARD, LUCY. "Vancouver," *Art News*, September 1968, pp. 26+.

LIVINGSTON, JANE. "Los Angeles: Three Reconnoitering Artists," *Art in America*, May 1971.

LORD, BARRY. "Canada: The Stir in Vancouver," *Art in America*, May 1968, pp. 117–19.

————. "Vancouver," *Artscanada*, April 1968, p. 48.

LOWNDES, J. "Spectrum, '68," *Artscanada*, October 1968, p. 38.

————. "Vancouver," *Artscanada*, February 1970, p. 47.

McNAIRN, I. "Present Directions," *Canadian Art*, May 1962, p. 176.

"New West Coast Group Holds First Art Exhibition," *Canadian Art*, March 1949, p. 127.

"Outdoor Sculpture in Vancouver," *Canadian Art*, November 1958, p. 300.

PINNEY, M. "Kiyooka's *Stoned Gloves* and George Sawchuck," *Artscanada*, February 1971, p. 50.

————. "Vancouver," *Artscanada*, August 1968, pp. 33–34; December 1968, pp. 82–83.

RAFFAELE, JOSEPH, and ELIZABETH C. BAKER. "Way Out West: Interviews with Four San Francisco Artists," *Art News*, Summer 1967.

RICHARDSON, BRENDA. "Bay Area Reports," *Arts*, November 1970, p. 54.

ROBINSON, B. "New Work by Daglish, Goldberg, and Morris," *Artscanada*, April 1971, p. 80.

ROGATNICK, ABRAHAM. "West Coast," *Canadian Art*, November 1971, pp. 422–23.

SELZ, PETER, and ALVIN BALKIND. "Vancouver: Scene and Unscene," *Art in America*, January 1970, pp. 122–26.

SHADBOLT, DORIS. "Vancouver Art Gallery," *Artscanada*, February 1969, pp. 37–38.

SILCOX, DAVID. "A Note on the Canada Council," *Artforum*, October 1967, p. 44.

SIMMINS, R. "Radical Vancouver Show," *Artscanada*, August–September 1967, Supplement 4.

TERBELL, MELINDA, "Los Angeles," *Arts*, February 1971, p. 45.

THOMPSON, D. "Canadian Scene," *Studio International*, October 1968, pp. 152–57.

TOPPING, C. "Electromedia in Vancouver," *Artscanada*, November 1967, Supplement 3.

"Vancouver," *Artscanada*, February 1967, Supplement 4; June–July 1967, Supplement 4.

YOUNG, JOSEPH. "Los Angeles Letter," *Art International*, September 1970, pp. 112–13.

Index

Italic page numbers refer to illustrations.